PRAISE FOR LICENSING ART 101

Just wanted you to know that I've bought and read your book and thought it was fabulous! You have so much specific information in there that it goes beyond helpful. You told me things I didn't even know I didn't know! Thanks so much for making the effort, and I hope it is tremendously successful for you. *J C*

Bravo. *Licensing Art 101* by Michael Woodward is without a doubt the most comprehensive and entertaining "how to" book I have had the opportunity to read. Well thought out, well written, well organized and full of useful information that is easy to comprehend and apply in the art licensing market. Not only does the book contain information about the business, but it takes the "How to" genre to new heights with actual "contacts" within the business. I have recommended the book to every artist (or would-be artist) I know. Congratulations and thank you. *D M*

Michael Woodward's book is an eye-opener for the working artist who has a desire to license their art. Michael's vast experience in the world of art licensing shines through on every page. If you apply only half of what he has to offer, the door to the art licensing world will open wide to your artistic endeavors. *M H*

Licensing Art 101 is a real eye-opener for today's artist. No matter how far along in your career you are, this book has everything to start or to improve an already existing business system. It is the best, most complete, easy-to-understand art business manual available for the visual artist today. *C I*

I have licensed work for 12 years and I was very impressed with the breadth and depth of this book. It is informative and well presented. If you are serious about becoming a professional licensor, *Licensing Art 101* is definitely a good investment. *H B*

Licensing Art 101 by Michael Woodward has been the most helpful book since I began my art journey. The book allows beginners to understand the do's and don'ts, the legalities, the fee structures, the importance of copyright, and more. I found it especially helpful that he included so many wonderful contacts and resources in the book. They have led to many answered questions and much helpful advice. I highly recommend this book to anyone who is beginning the process of licensing art. *C S*

For artists seriously thinking of licensing their artwork, *Licensing Art 101* is the book to get. It is a comprehensive, easy-to-read, no-nonsense guide that is packed with practical tips and advice. This book really helped boost my confidence level when dealing with potential licensors. After 25 years in the business, Michael Woodward knows his stuff. He literally takes you by the hand and shows you how the whole process works! Michael, thank you for sharing your invaluable knowledge with me and the countless artists out there struggling to "make it." *C Z*

What a blessing you are for those of us who aren't living in New York City, where information seems to be more available. (I lived there for 16 years, thank goodness.) Just for the record, I want you to know that since I ordered your book (at Barnes and Noble), I see that they now carry them regularly! I've been a children's book illustrator for 25 years, making enough money doing educational work to support myself while I do trade books. Anyway, I've been trying to educate myself about other markets, and have been learning about the surface design arena, which is very tied into licensing. I just want to thank you for your efforts to reach out to artists about an important aspect of the publishing world. You are helping people like me gain access to important knowledge and tools to be better businesspeople, and more effective bread-winners! Thank you for your tremendous service to all of us. *R C*

LICENSING ART 101

101

THIRD EDITION

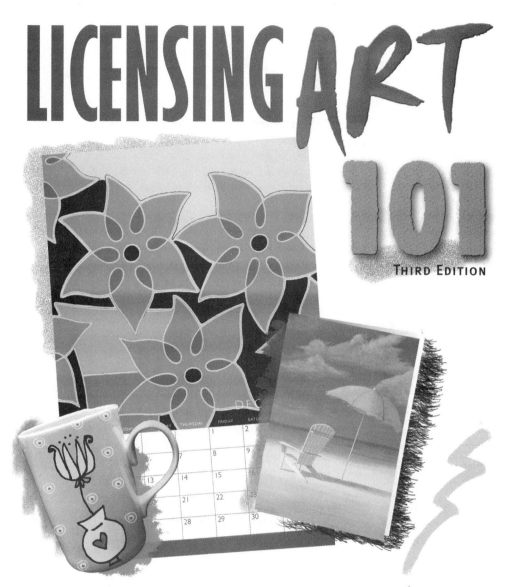

BY MICHAEL WOODWARD

To Theresa

Michael Woodward

AN Art Network

LICENSING ART 101, PUBLISHING AND LICENSING YOUR ARTWORK FOR PROFIT, THIRD EDITION

Third Edition July 2007
Copyright 2007 by Michael Woodward
Cover and interior design by Laura Ottina Davis
Edited by Constance Smith
Cover artwork: *Pink Flowers* © Kayvene
 Daisy in Yellow Vase © Maria Pezzano
 The Perfect Office © Lin Seslar

Published by ArtNetwork, PO Box 1360, Nevada City, CA 95959-1360 (800) 383 0677 (530) 470 0862
(530) 470 0256 Fax www.artmarketing.com <info@artmarketing.com>

The author, Michael Woodward, can be contacted at 7350 S Tamiami Trail #227, Sarasota, FL 34231
(941) 966 8912 www.licensingcourse.com <michaelwoodward@mac.com>

ArtNetwork was created in 1986 with the idea of teaching fine artists how to earn a living from their creations. In addition to publishing business books for artists, ArtNetwork also has a myriad of mailing lists—which we use to market our products—available for rent to artists and art world professionals. See our web site for details.

Publisher's Cataloging-in-Publication

Woodward, Michael.
 Licensing art 101 : publishing and licensing your artwork for
 profit / Michael Woodward. -- 3rd ed. -- Nevada City, CA :
 ArtNetwork, 2007.
 p. ; cm.
 (101 series)
 ISBN-13: 978-0-940899-84-1 ISBN-10: 0-940899-84-1
First edition published in 2002 as: Art licensing 101.
 Includes index.

 1. Art--United States--Marketing. 2. Art--United States--
Reproduction. 3. Copyright--Art--United States. 4. Art publishing--
United States. I. Title.

N8600 .W66 2006
706/.8/8--dc22 0603

Disclaimer: While the publisher and author have made every reasonable attempt to obtain accurate information and verify same, occasional address and telephone number changes are inevitable, as well as other discrepancies. We assume no liability for errors or omissions in editorial listings. Should you discover any changes, please write the publisher so that corrections may be made in future printings.

Printed and bound in the United States of America

Distributed to the trade in the United States by Consortium Book Sales and Distribution

FROM THE PUBLISHER

When I started in the art business some 23 years ago as an art rep in the San Francisco Bay Area, I knew nothing about the licensing and publishing industry. Though I had purchased a few posters, I didn't know "where they came from." Looking back, I find that odd; yet, as I talk to artists today, I realize they know less than I did back then!

This topic—licensing and publishing—created so much interest at ArtExpo NY 2000 that there was a standing-room-only crowd of 500 people at a seminar on the subject. I knew then that it was a topic that needed to be addressed more thoroughly—in book format. After all, publishing and licensing is a vast part of the art market.

In this book, we not only teach you how to approach the licensing and publishing marketplace, but we also have names of professionals working in that marketplace. The resource section has over 300 listings.

A final word: If you don't own our other books—*Art Marketing 101, Art Office, Internet 101, Selling Art 101* and *A Gallery without Walls*, you are missing some necessary tools to improve your art business.

I encourage you to *use* this book, refer back to it, keep it at hand, write in the margins, take notes, put paper clips and Post-it Notes on pages you'll need to refer to again.

I wish you the best of times with your career.

Constance Smith

ACKNOWLEDGEMENTS

I'd like to thank Constance Smith, my publisher and editor, who has labored long and hard editing this material and making significant contributions, without which this book would have been incomplete. I would also like to thank Janet, who encouraged me to start this project and who took on more than her fair share of work to give me the space to write.

DEDICATION

This book is dedicated to all artists—past, present and future—who enrich our lives through their artistic endeavors. I sincerely hope this book will help them improve their income and enjoy a richer, fuller life, in what has become one of the most exciting industries on the planet. I hope in some small way my contribution will make a difference. I dedicate this book to Stewart, Neil, John and Ray—good friends no longer with us but not forgotten.

Michael Woodward

Table of Contents

CHAPTER 3 LEGAL ASPECTS

CHAPTER 4 BUSINESS PRACTICES

CHAPTER 5 PRESENTATIONS

CHAPTER 10 CONTACTS

Introduction

All you have to do is look around you. Our world is full of printed imagery. Licensing is a $175-billion industry. It has grown enormously since I first entered it in the early '70s. America has thousands of manufacturers and publishers, from greeting cards and fine art prints to furniture, pottery and children's apparel, all requiring art and design in some form.

This book is aimed at those artists who are serious about making money from their art. An artist considering a move into the licensing industry needs to understand its foundations. Licensing is granting licensees/publishers/manufacturers permission to use your work in return for a fee or royalty. If you want to make a better living, licensing can give you the opportunity to make $50,000 a year or more. The key to success in this industry is producing art with a wide range of appeal that fits a particular market or product category.

You have in your hands the necessary tool and information to set in motion your own licensing program by which to increase your income substantially. To succeed, you will need 100% determination, perseverance and a degree of talent.

With this in mind, let's get started down the road to licensing success!

Chapter 1

The Licensing Industry

What is licensing?

How the market operates

Terminology

Royalties

Property sectors

Art and design sector

Art and design licenses

One must act in painting as in life, directly.
Pablo Picasso

WHAT IS LICENSING?

Licensing is granting the right to a licensee, publisher or manufacturer to reproduce your artwork on a particular product in return for a fee or royalty.

The licensing industry is a $175-billion industry, and growing. That is a huge increase from 20 years ago, when it was estimated to be a $10-billion industry worldwide.

Licensing is the business of leasing a copyrighted or trademarked "property," in this case a work of art, by means of a contractual agreement (a license), for a specific product (or promotion or service), for a specific time period, in an agreed-upon territory, for an agreed-upon fee or royalty.

Artists, illustrators and photographers have the opportunity of enhancing their incomes and reputations by licensing their work for many products, including greeting cards, prints, posters, gifts, stationery, T-shirts, collector plates, furniture—literally hundreds of items. Licensing is an excellent way to build awareness nationally and internationally, thereby increasing the collectibility of your art and, hopefully, the prices of your originals.

Licensing is now used extensively to create revenue streams for sports, fashion, entertainment, corporate brands, music, charities, publishing, games, and celebrities, as well as the subject of this book—art and design licensing.

Museums, many of which frowned upon licensing in the past as "too commercial," are now licensing art in their collections—Monet, Warhol and Mondrian, to name a few.

For an individual artist, the question is, "How can I introduce my work to the licensing marketplace?" This book will guide you through that process by showing you how to study the marketplace and how to create effective presentations that focus on specific products and potential licensees.

Artwork chosen by licensees (publishers and manufacturers) must have wide consumer appeal and stand up against the competition. Licensees are looking for that "extra something" in a work of art that gives it broad-range consumer appeal. The higher the print or product run, the wider the appeal must be. The more product that is sold, the higher the royalties that are generated for you, the artist.

HOW THE MARKET OPERATES

The marketability of your artwork, or the product produced from your artwork, essentially has to bring a certain amount of revenue for commercial viability. The publisher makes a profit, the artist makes a royalty, the consumer is happy.

Marketability is one of the most fundamental and important facets of this business. You—the artist—must understand this fully to have any chance of success. You may produce some innovative and radical new work, but is there a market? More importantly, does a publisher have a market for it?

You will need to learn about each publisher's needs and who their customers are. If you don't do your research, you may be pitching to the wrong publisher.

You will also need to learn about what is selling in the marketplace. More importantly, you must learn what doesn't sell. A publisher will continue to use your work if it continues to sell. You will need to keep updated on what is happening in the sector of the industry you wish to target by reading magazines and visiting trade shows and retail outlets.

▸ Respect requests from your licensee/publisher. They are assuming the financial risk of reproduction of your artwork.

▸ Don't change agents/licensees/publishers without a very good reason. It takes time to promote any given artist. If they are doing absolutely nothing, yet keep promising to, maybe it is time to change, but talk to them first.

▸ Work together—like butter and popcorn. Make efforts to help your agent/licensee/publisher. Visit their offices; offer some assistance. Send them a card on their birthday—maybe even to the accountant so she will pay your royalty checks on time!

COMMERCIALISM

Despite the lure of making lots of money from licensing art, many fine artists are reluctant to jump into the business. A lack of industry knowledge, coupled with concern over damaging their status in the fine-art market, can prevent artists from pursuing a successful licensing career. What artists inevitably find out is that through licensing, their original work can actually become more recognized. If handled properly, licensing will enhance one's reputation.

Licensing your art is a commercial exercise to earn you a better living. Many artists forget this simple fact. While it is important to be creative and original, this approach must be tempered with ensuring that your work is commercially viable.

▸ Create your artwork in sets of a minimum of four images that "go together."

▸ Create your artwork in a 3:4 ratio that would fit 9x12″ or 18x24″—two very common reproduction sizes—or 6x9″, a common book size.

To learn more about a business, purchase copies of some of the magazines listed in the appendix. Decide which ones will help you the most in your business, then subscribe!

BE FOREWARNED

▸ Are you overly protective of your work? Many publishers want to crop artwork; perhaps you don't want it cropped.

▸ Do not expect to have much involvement in the actual printing process. You can ask for certain rights, but ultimately the publisher will have rule.

▸ Know why you want to publish before you proceed. Is money your bottom line? Promotion? Publicity? Fame?

▸ Publishers might start suggesting what subjects to paint. Are you against such suggestions?

STYLES AND THEMES

Style is very important to licensees/publishers/manufacturers. Some prefer traditional, some prefer contemporary styles; pastel, crayon, watercolor, oil, and acrylic artworks are all used by licensees. When reviewing artwork, they will only want to see specific styles of art that fit into their product line. You will need to study each licensee's catalog or web site to gauge what kind of artwork they use and the treatment thereof.

Another major factor is to establish a theme you can follow for a length of time. Some artists are versatile and can paint wildlife scenes, landscapes, seascapes, and even figurative work. You need to decide which market you are aiming for at the outset.

▸ Are you considering the print industry?

▸ Do you want to establish a group of collectors, who, once they've bought a limited-edition print, become collectors of your work and buy more?

As your reputation grows, so does your market. If, however, you suddenly change your subject matter, say, from African wildlife to seascapes, even though the work may be exquisite, it confuses your buyer. Your collectors of African wildlife collect wildlife. Your publisher would have to begin anew, establishing a market for a seascape client-base.

Galleries often specialize in the limited-edition market too. If you have 100 galleries buying your African wildlife prints and you change to seascapes, then you might lose your entire gallery-base. The publisher then has to start over to promote your new artwork—building a new gallery-base. Your royalties will probably be nonexistent for awhile, if you're even lucky enough to continue with the same publisher.

Artists who are aiming at greeting cards and gift stationery can afford to be a little more versatile. You will see in card stores that if you establish a strong style and

theme, an entire section of a rack of cards can be devoted to your work. If the card range is successful, the art is then used to create other gift products, thereby increasing your earning potential enormously.

It is important, then, to understand your personal "voice" in order to understand the market for which it will be appropriate. Define your work. What are you best at? What markets interest you? Visit retail outlets, department stores, galleries, frame shops—every outlet that sells the products you feel your work is best suited for. Take notes. Learn all you can about where your voice will fit.

TRENDS

Trends have become increasingly important in recent years, and it is imperative, if you want to enter the print market, that you become aware of the major trends and color palettes the retail buyers are looking for. The framed print and alternate wall-décor market has become far more sophisticated now with fabulous framing treatments and innovative matting as well as creating three-dimensional wall art using metal, wood and ceramics. More on this important topic later.

To create a collector base, stay with one subject and master it. When you have achieved a level of success, that's the time to experiment.

TERMINOLOGY

BRAND

A product with a distinctiveness in its design or logo

FLAT FEE

A onetime fee (with no royalties) paid by a licensee for the use of artwork

GUARANTEES AND ADVANCES

A guarantee is the minimum monetary payment that the artist/licensor receives for the term of a given license. A guarantee is usually in the form of a nonrefundable advance, invoiced at the outset. Guarantees can also be in the form of a yearly minimum for each year of the license, provided the artist creates a specified number of designs each year. Example: A greeting card publisher wants an artist exclusively for cards. He may offer the artist a guarantee of $15,000 per year minimum for providing 50 card designs (against a royalty of 5% of sales).

INTELLECTUAL PROPERTY/PROPERTY

The "right" in a particular artwork or design (or trademark) that is owned by the artist or held in trust by an agent.

LICENSEE

A licensee is anyone, usually a manufacturer or publisher, who obtains permission from the owner/licensor/owner's agent for the right to use the property. The licensee then manufactures a specific product to sell in the marketplace to consumers.

LICENSING AGENT

Licensing agents often specialize in a sector of the industry. (See page 21 for definitions of some sectors.) They assume such duties as finding licensees, negotiating fees, issuing licenses, securing product approval, and collecting and accounting of fees and royalties received from product sales generated by the licensee.

Some licensing agents handle many properties, including trademarks such as Coca-Cola or Harley-Davidson, which are licensed to manufacturers for stationery, mugs, apparel and a host of gift ware products, as well as TV properties such as The Simpsons, Rugrats, Sesame Street, etc. Art is often just one of many types of properties an agent might handle.

LICENSING CONSULTANT

Licensing consultants support manufacturers by aiding them in the evaluation of a property, developing the implementation of a licensing strategy, etc. Usually they work for the licensee on a commission basis. A consultant can also work for a

licensor (owner of a property), a major artist, museum or the estate of a deceased artist to help design a strategy to build a licensing program.

LICENSOR

A licensor can be the artist or her agent who is authorized to grant licenses on the property (artwork). The licensor can also be the "owner" of a particular "property."

MANUFACTURER

See Licensee above.

PRODUCT DEVELOPERS

Product developers start with prototypes and follow through the assembly and packaging stages. They usually work for the manufacturer. There are, however, freelance specialists who produce innovative packaging ideas, which they sell to manufacturers.

PUBLISHER

See Licensee above. Publishers usually print posters, greeting cards, and books.

SUB-LICENSE

If you agree to a clause allowing your licensee to "sub-license," you give permission to your licensee to license the art he has licensed from you (often without any additional approval from you). Many manufacturers/licensees now have their own licensing operations; this is a way that they can earn extra revenue. They will receive 50% of your royalty if they license your art to another manufacturer. This could cause you conflicts, as you may be actively licensing your work as well as the licensee. Avoid a sub-license in a contract unless you particularly want the licensee to be your agent. Some publishers do a very good job of licensing their artists' work. For some, however, licensing is just a sideline business and, therefore, they are not as proactive as a full-time licensing agency.

TRADEMARK

A trademark is any word, name or design (or combination thereof), usually in the form of a logo or unique symbol. To protect this design for your own usage, you must legally register it. (See page 88 for more details.)

TRADE PRICE

Trade price is the wholesale price of a product, i.e., the price a licensee/publisher/ manufacturer gets for the product. This is the price on which the royalties are paid, and it is sometimes referred to as the "net selling price."

In order to license your work, you have to think like a marketer or merchandiser. You need to understand consumers, their purchasing patterns and their desires.

ROYALTIES

A royalty is a fee the licensor charges the licensee and is based on the wholesale or net selling price.

TYPICAL ROYALTIES

Calendars...5-10%

Commercial prints ...7-10%

Fabric...5-10%

Gift wrap ...3-5%

Greeting cards .. 4-8%

Limited editions..................10-15% (20% for top names)

Mugs.. 5%

Postcards ...3-5%

Posters...7-10%

Sheets..5-8%

Shower curtains...6-8%

Stationery and gift products4-6%

Textiles.. 5-10%

Towels..4-8%

T-shirts ..8-10%

Various household items4-8%

Wallpaper...5-10%

Watches ...6-8%

To be successful, artists must envision how their images will look on a final product.

ART AND DESIGN

Mary Engelbreit, Todd Parr, Wyland, Lassen, Kinkade, Anne Geddes and many other artists

CHARACTER AND ENTERTAINMENT

TV series - Celebrity Poker, Queer Eye for the Straight Guy

Animated series - Teletubbies, Rugrats, The Simpsons, South Park

Movies - Star Wars, Toy Story, Harry Potter, Lord of the Rings

Legends - Monroe, Elvis, James Dean, The Beatles

Music - Madonna, Rolling Stones, Britney Spears

SPORTS

Events - Olympics, The World Cup, Wimbledon, US Open Golf, NASCAR

Individual sporting personalities - Michael Jordan, Arnold Palmer

Leagues - NFL, NHL, NBA, Major League Baseball

Other - The World Wrestling Federation

FASHION

Ralph Lauren, Polo, Calvin Klein, Donna Karan

TRADEMARKS AND BRANDS

Auto industry - Jeep, Cadillac, Harley-Davidson

Food - Pizza Hut, McDonalds

Drink - Coca-Cola, Budweiser

CHARITY/NONPROFIT ORGANIZATIONS

National Wildlife Federation, Sierra Club

COLLEGIATE

The collegiate licensing program is a consortium of more than 60 American universities, including Georgetown, Michigan, North Carolina and Duke. This program is marketed throughout the world as the "U.S. College Collection."

PROPERTY SECTORS

The licensing industry is made up of several sectors.

ART AND DESIGN SECTOR

The art and design sector is the sector we will be covering in this book. It includes artists you might be familiar with: Thomas Kinkade, Christian Riese Lassen, Anne Geddes and Mary Engelbreit, as well as other lesser-known artists, illustrators and designers.

Within this main sector are various subdivisions. Billions of dollars' worth of products are produced and sold each year through the art and design sector. In 1999, it was estimated that 10% of the entire licensing industry came from the art and design sector. The potential market is enormous. The art and design sector can be less time-sensitive than the TV, movie and sports sectors and therefore can have long-term appeal. Since it is often more generic than the other categories, it has massive appeal. Included in this category is the ever-growing licensing done by museums. For museums, this is what keeps their doors open—profits from their licensing deals.

A licensee has a blank product onto which he must put a design to attract a consumer. The licensee's job is to find art that the consumer will buy. The more popular the design, the more product will be sold.

It remains for you, the artist, to create art that will sell product in sufficient quantity to give the licensee a good profit and thereby give you a reasonable return in the form of royalties.

PRODUCT CATEGORIES

Paper products – greeting cards, stationery, calendars, note cards, limited-edition prints, posters, gift bags, gift boxes, bookmarks, etc.

Apparel – T-shirts, sweatshirts, children's clothing

Gift products – Cushions, stitch kits, rubber stamps, jigsaw puzzles, coasters and trays, magnets, tableware, kitchenware, porcelain products, mouse pads

Novelties – Balloons, party ware

Miscellaneous – CD inserts and cassettes, tote bags, plush toys, figurines, photograph albums, textiles, wall hangings, lamp shades, wallpaper

Dozens of other products are enhanced by designs and art.

ART AND DESIGN LICENSES

Essentially, there are three types of art and design licensing:

▸ Individual

▸ Artist brand

▸ Art-as-brand

INDIVIDUAL LICENSE

Every year, major publishers and manufacturers of stationery, greeting cards, jigsaw puzzles, calendars, etc. replace many of their designs to keep the range fresh and innovative. If you add up the total number of design requirements of all the greeting card companies, it is phenomenal.

An individual license is a simple license in the form of a license/invoice (see pages 68-70) granting a licensee the rights to reproduce a single design or a small group of designs for a particular product. Because the transaction is quite small, a simple invoice can act as your full agreement with the licensee. This system can typically be used for greeting cards, jigsaw puzzles and note cards.

For fine art prints and other products, it is better to have an agreement that defines the terms in greater detail. Since most artists usually don't have written agreements available, a licensee/publisher will often provide their own agreement, which can be full of legal jargon, and on closer examination by an expert eye might reveal clauses that can be detrimental to your rights. I have included a basic agreement (pages 72-73) to help you.

I advise you to use both a license/invoice for the advance and a license agreement, which should be signed by both parties.

INDIVIDUAL LICENSES

A greeting-card publisher sees your artwork on Christmas themes. She reviews 12 designs from your portfolio and chooses three to publish. You license/invoice her for $350—a flat fee for greeting-card rights, North America only, three years for each design (a total of $1050). These three designs will be used among some 200 card designs for the following year by the publisher. (Flat fees generally vary from $250 - $800.)

℧

A calendar manufacturer chooses 12 designs from your artwork to use as a calendar for a specific year (usually chosen two years in advance of publication). He agrees to pay you an advance of $2400 against a royalty of 8% on sales.

Anne Geddes has consistently produced innovative photographs. She now has one of the most successful photographic licensing programs in the world. With this type of license, the art style is the main feature, but the artist's name also becomes recognized.

ARTIST BRAND LICENSE

Artist brand licensing is used when an artist's name, as well as her artwork, becomes recognized.

By way of example, I will give a typical scenario: A licensee loves your work so much that he wants to feature you as a named artist—the product will bear your signature or name as a logo. He wants an exclusive agreement for greeting cards, address books, journals and perhaps a few more products. His investment to turn your work into product is substantial. He will want you to sign a three- or even five-year contract. A typical advance would be $5,000 against a minimum guaranteed payment of $10,000 for the first year. Years two, three, four and five could be $25,000 minimum guaranteed, or more, if the projected sales justify it. Recently, however, as budgets have become tighter, many publishers will not pay advances or guarantees. In these cases, you can often negotiate a slightly higher royalty.

Recent successes are artists such as Mary Engelbreit, Christian Riese Lassen, Thomas Kinkade, and Anne Geddes.

ART-AS-BRAND LICENSE

Art-as-brand is closely associated with artist brand license, except that it's not the artist and her work but the artwork itself that becomes the brand. A classic example is "Forever Friends," which became one of the major phenomena of the '90s in the UK. Andrew Brownsword is now one of the richest men in the UK, all from a few drawings of cuddly teddy bears. He was absolutely brilliant in building a teddy bear concept into one of the major brands in the greeting card business, with a turnover of tens of millions. He created a range of gift ware, plush toys, mugs, pencils, pencil sharpeners, stationery, Valentine gifts and Christmas gifts—produced by the thousands. It has been one of the most successful art-as-brand licenses of the last 20 years and is now owned by Hallmark.

For artist brand and art-as-brand licensing, it is essential to have a detailed contract for the transaction as there are many legal implications. This is where you need the services of an intellectual property lawyer to make sure the agreement is a good one. The alternative is to have an agent negotiate the deal for you.

In the mid-'80s, I art-directed a series of photographs using young children in '50s-style clothing. We did the photo shoot at an old railway station in the heart of Yorkshire, UK, which was used in the film *Fairies*. We produced a group of six images and then sold them to a major European publisher of prints, calendars, posters, postcards and greeting cards. We also sold them as T-shirts, jigsaw puzzles and a few other products. I showed the range to our Japanese agent, and similar products were licensed in Japan for many years. Over $75,000 in royalties came from just six designs, proving that the right style of work can produce great results.

WEB SITES

Spend time on the Internet and study how successful artists operate their business. They all share information about their careers and the licensing industry.

www.maryengelbreit.com
Download Getting Started; click on "For Artists" at the bottom of the main page.

www.tracyporter.com

www.swirlygirl.com
Shows the artwork of Christina Miller, an artist who is just beginning to be successful. Her site contains some very practical information about the licensing industry.

www.kathydavis.com/advice

www.annegeddes.com

www.guybuffet.com
A highly successful artist whose work appears on clothing and kitchen accessories. Famous for his chef series.

www.paulbrent.com
Another very successful artist with over 50 licensees and 300 prints in production.

www.clydebutcher.com
Florida photographer producing much of his own product as limited editions and posters.

THREE SUCCESS STORIES

Christian Riese Lassen

Lassen is a successful artist who runs his own licensing company from Honolulu. He has a small, dedicated team of licensing professionals who work on new licensing deals around the globe. Presently he has 70 licensees producing hundreds of products. These products generate around $100 million in retail sales annually. The product range includes: music boxes, checkbook covers, stained glass windows, beach towels, surfboards, T-shirts, figurines, collector plates, house wares, spring water, and more. His company also owns galleries in Hawaii and Las Vegas, with outlets in Japan and Australia. This is an example of what can be done with a unique style of artwork. www.lassenart.com

Thomas Kinkade

Thomas Kinkade is America's most collected living artist, with dealerships and galleries throughout the US, Canada and the UK. His licensing program generates millions of dollars each year. Visit his web site—www.thomaskinkade.com or www.thomaskinkadecompany.com—to see a superb merchandising program.

Mary Engelbreit

Engelbreit was successful in the '90s with a number of designs appearing on greeting cards, calendars, stationery, table mats, and more. Since 1996, she has had her own magazine—*Home Companion*—as well as her own store in her hometown of St Louis, Missouri. Engelbreit's work is licensed to more than 40 manufacturers with more than 6500 products. She has a deal to illustrate 20 children's books over the next few years.

ACTION PLAN

In what particular theme do you work?

Define your style of artwork:

Is your style commercial? ❑ Yes ❑ No

If no, how can you make it more commercial?

On what products would your work look best?

Have you researched these products in stores and magazines? ❑ Yes ❑ No

What magazines have you read to familiarize yourself with licensing?

How many pieces of artwork do you have available for licensing?

Have you studied market trends? ❑ Yes ❑ No

Chapter 2
Marketplaces

Art does not reproduce the visible; rather, it makes visible.
Paul Klee

PRODUCT CATEGORIES

While this is not a full list, it will give you an idea of the broad range of products on which licensees pay royalties. It will also give you an indication of why the market is so vast and how much scope there is.

PRODUCTS

Address books	Baby wear	Balloons
Bath accessories	Bedding	Bookmarks
Books	Calendars	Cassette covers
CD inserts	Children's books	Christmas cards
Clocks	Clothing	Coffee mugs
Collector plates	Confectionery	Diaries
Dinnerware	Figurines	Framed prints
Frames	Gift bags	Gift boxes
Gift wrap	Gift ware	Greeting cards
Jewelry	Jigsaw puzzles	Journals
Key rings	Kitchen textiles	Lamp shades
Limited editions	Linens	Luggage
Magnets	Melamine mugs	Musical boxes
Needlework kits	Paper tableware	Party note cards
Pencils	Pet products	Phone cards
Photograph albums	Pillows	Place mats
Plaques	Plates	Playing cards
Porcelain items	Postcards	Posters
Pottery	Prints	Rugs
Scarves	Screen savers	Stamps
Stationery	Stickers	Sweatshirts
Table mats	Tableware	Tea
Textiles	Ties	Tiles
Tinware	Toiletries	Towels
Toys	Trading cards	Transfers
Trays	Trinket boxes	T-shirts
Valentine gift lines	Wall decor	Wall hangings

Adapt a long-term outlook for your licensing career.

GREETING CARDS

The greeting-card industry is a multi-billion-dollar industry, with such companies as Hallmark, American Greetings, Recycled Paper Products and CR Gibson dominating the business. There are many other medium-sized companies such as Design Design, Marian Heath Greetings and Leanin' Tree that are very successful. There are also many smaller companies specializing in a particular style, some of which are owner-/artist-run or small partnerships.

Greeting cards can be a good starting point for artists beginning to license their art. It is a good bread-and-butter category, one which should not be ignored. Some publishers even put a small bio on the back of each card—great PR for an artist. You will also be able to buy your own cards at wholesale and use them as publicity material.

One of the most important tasks in becoming a good greeting-card artist is to understand how cards are displayed. This may seem obvious, but it is often overlooked. Cards normally appear in racks. The top third of the card is what the customer sees. Out of the hundreds and hundreds of designs available, does the top third of the card you've designed give the buyer a good idea of what the card's sentiment is, or the occasion?

WHAT MAKES A PERSON PICK A PARTICULAR CARD?

Go out and buy a card for an imaginary occasion. See how you respond to certain designs. Why did you choose the one you did? Designers need to consider who the buyer and recipient of the card will be and what occasion the card is for.

Get to know each greeting-card publisher's range before you submit work. In most cases, they will have particular criteria that have to be adhered to: preferred paper stock, sizes, proportions, subject matter, color, media. Some specialize in humor, others are strictly contemporary, while others are very traditional.

SUBMISSIONS

To submit to a publisher, you will need to prepare at least six to 12 examples. If you send 24 designs and they like the overall style, they may choose six to 12 to publish.

Style is very important to greeting-card publishers, and they are on the lookout for artists who have an original way of looking at subjects that have been done a thousand times before. In some ways, nothing appears to be original in the card market, but the way the work is executed can give a worn-out theme a fresh, new appearance.

The small, specialized greeting-card companies produce beautiful cards. Invariably the print runs are quite small initially. They don't have the budgets of the large multinationals. These small companies can, however, be a good starting point,

Over 2.6 billion Christmas cards are sent anually in the United States. Hallmark alone has over 2300 designs. Over 80 million graduation cards were sold in 1996.

particularly if your work fits into their niche market. Royalties are generally 4-8%, often with no advance or one that is small. Quite often publishers will offer a flat fee.

CARD MOCK-UPS

These days it's very easy to do laser mock-ups of cards on your own color printer. This is by far the best type of presentation to a greeting-card publisher. It will also help you see what a group of cards looks like together. Look at the colors. When they're all laid out together, is there enough contrast in the range? What is showing in the top third of the card?

FORMAT

▸ Size is not so relevant; proportions are. Since most cards are 5x7˝, you can't go wrong if your art is created in this size, or a proportionate size.

▸ Only 5 - 10% of cards created fall into unusual formats. While there are possibilities in this slightly more niche market, many publishers won't print anything other than standard-size cards.

LATEST TRENDS IN CARDS

In the last few years, handmade cards created by artists have inspired some of the more innovative publishers to publish cards with an embellished, handmade look. These can include cut-outs, tip-ons (separate pieces added to create a dimensional effect), jewels, fabric, feathers, glitter, etc. In the past it was impossible to mass-produce this kind of product at an affordable price. However, Chinese manufacturers can now produce elaborate work, allowing US and European publishers to produce "handmade"-looking lines.

CARD RESOURCES

Greeting Card Association
1156 15th St NW #900, Washington, DC 20005 (877) 480 4585
(202) 393 1778 www.greetingcard.org
Download a free copy (PDF) of the Artist's Guidelines from their web site (under Business Resources). Written by Joanne Fink, a well-regarded and highly successful colleague, it is an indispensable guide for any artist who wants to pursue this market.

Greeting Card Association
www.greetingcardassociation.org.uk
The UK card industry is worth about $2 billion.

National Stationery Show

George Little Management (800) 222 SHOW www.glmshows.com
Held in mid-May in New York City. A major event covering gifts, stationery,
greeting cards and many other products.

Hallmark Cards Inc

2501 McGee St, Kansas City, MO 64108 www.hallmark.com
Distribution in over 42,000 US retail stores. Sales over $4 billion.

PRINTS

Success in the print market depends on whether you are with a publisher who has good

As in all markets, publishers want professionalism, reliability and a regular supply of work to review from artists they represent. A publisher is trying to create a print with a strong theme or identity.

There are several subcategories in the print marketplace:

- Mass-market posters and prints
- High-end prints
- Limited-edition lithos
- Silk screen limited editions
- Giclées (pronounced zhee-clay)

A lithograph print (otherwise known as a litho print) uses a four- to six-color process on an offset litho printer, making a reproduction of an image from four basic colors of ink: yellow, magenta, cyan and black. An extra color or two can be printed to enhance the reproduction quality. Color separations are made from a transparency of the original artwork using halftone screens and filters to separate each color (a printing plate can be made for each color). When paper is passed through the machine, it basically prints one color on top of the other to create a reproduction of the image. If you look at the printed image under a magnifying glass, you can see dots. Much of the printed imagery available—greeting cards, calendars, posters, stationery—is created using this process.

MASS-MARKET POSTERS AND PRINTS

Sometimes referred to as mass-produced lithos, these prints sell at low prices to frame shops, department stores, chain stores, gift shops, home furnishing stores, boutiques, and even dollar stores. You may have worked at an office where salesmen have sold them door-to-door. Retail prices range from $5-100, often including the frame. In many cases, the frame costs far more than the print. The print can cost the retailer as little as 25¢ for a 10x8″.

The print market can help an artist become well known, not only in the US but in Europe as well.

This market can be difficult for fine artists, as some publishers try to license work very inexpensively, sometimes offering flat fees only. Quite often, publishers have to sell a vast number of prints for an artist to see any substantial amounts of money if a royalty deal is agreed upon.

To ensure that you are getting a decent deal with the publisher, you need to inquire what his selling prices are and what quantities he sells. The trade price given may be $3, but what discount does he give for large orders? The actual selling price could be as low as 25¢. For instance: The publisher makes a large sale of 5000 prints. The purchaser, a framer, pays only 25¢ per print. He then frames the print and sells it in quantity to a retail store for $15. The print itself makes up very little of the cost. Since the artist is paid by the publisher on the publisher's selling price, the artist receives only 10% of 5000 x 25¢, or a total of $125.

If the artwork was licensed to a higher-end print publisher who only sold 2500 copies of the print at $4, at 10% that would be $1000 for the artist—a huge difference in royalties. Recently, the low- to mid-end market has been choosing a much higher standard of decorative art as retailers' demands for quality increase. This is a market that should not be ignored.

This market can be quite lucrative if you choose a well-established publisher and you are on a royalty arrangement. My first deal in this market, nearly 20 years ago, emphasizes this point. I sold the rights to a series of images, which were quite different from anything else on the market at the time. The publisher refused to pay a royalty as he felt he was taking a big risk. I ended up doing a deal for around $300 per image (for world print rights). They sold tens of thousands and had massive success. My company and the artist didn't receive one additional cent over the initial $300. Had we insisted on a royalty arrangement, we would have earned thousands of dollars. It is important always to require a royalty. The only alternative to a royalty, if the publisher refuses and you still want to do a deal, is to insist on a fixed-quantity print run. That way, if he wants to print more, he has to come back to you and pay you again for each new print run.

Ask for an advance against a royalty: $100-250 against 10%.

High-end prints

High-end prints are better-quality lithographic reproduction prints that are printed on good-quality paper, reserved for high-end art with unlimited print runs. These can be sold (framed or unframed) in high-end frame and gallery shops, as well as home furnishing stores. Styles vary enormously. There are dozens of publishers in this marketplace. It is still regarded as a mass-market product, but the emphasis is on a much higher quality of product. Pictures are often framed nicely with unusual mats, adding value to the product. However, as the demand for better-quality art grows, major chains including Wal*Mart are now offering this kind of product online. Publishers have to discount their prices with hopes of creating large-volume orders.

The lines between mid-tier and high-end appear to be fading more and more as mass-market retailers like Bed Bath & Beyond, Linens and Things, Target, Kohl's and other chains develop their own framed print lines. These chains demand huge discounts; you will see much higher-quality work in their stores because major publishers see this as an important market. While the selling price can be low, large sales volumes can be achieved. Though you may feel that this is not where you want your work to be, it is how the market now operates. Once your work is in print, it can be purchased by any major retailer, either directly from the publisher or via one of the huge framers who dominate this industry.

Photographing a painting that has a great deal of texture can be difficult, making it hard to get a good-quality print. Light catching the texture causes a "flair."

35

Many publishers have websites. An investment of time there will pay off in the future. Spend some time researching:

millpond.com
greenwichworkshop.com
artinmotion.com
bmcgaw.com

No publisher wants to promote an artist and spend huge amounts on PR only to have the artist move to competing publishers.

LIMITED-EDITION LITHOS

Limited-edition lithos vary in edition quantity but usually range from 50–950 copies. Retail prices vary from around $50 for small prints to as much as $750, and even more for well-known artists. The average price, however, is $75-350, depending on the dimensional size and quantity of prints in the edition.

As in other print markets, publishers are looking for a consistent quality of art from an artist. They also require a steady flow of work to choose from. The investment is high for publishers in this category, so they must choose reliable artists who understand and accept the long-term implications of producing limited editions. It often means that this type of contract comes after you have "put your time in" the industry—after you have a reputation.

In this market, the publisher will usually produce glossy catalogs, instigate PR and advertise extensively—always with a view to a long-term investment. Artists such as Robert Bateman, John Seerey-Lester, Carl Brenders, Douglas Hoffman, Robert Heindel and Simon Bull have created a great collectors' market via their respective publishers.

You will need to provide an extensive body of work, not just 10-12 pieces. Publishers like to see at least 20 pieces so they can assess the consistency of quality and style before accepting an artist to publish. Initially, select five to six of your best pieces to submit. You will then have more to show at a later date if requested.

Limited-edition contracts are usually royalty-based, as well as exclusive. Many publishers heavily promote the artist by producing special advertising campaigns and brochures. Promotion like this also helps to build the artist's profile and reputation and can lead to higher prices for originals.

PROTECTING YOUR RIGHTS

The only problem you might encounter is how to protect yourself if the publisher doesn't push the work enough—if he backs off a particular edition, leaving you tied to an exclusive deal with no income.

▸ One good way to protect yourself is to ask if the publisher can publish a series—at least four to six per year.

▸ Limit the contract to three years, with an option to renew at the end of three years. This way you don't tie yourself for a long period with a publisher who isn't doing well for you.

▸ After the second year, have a minimum-income figure written into the contract. You can terminate if the income drops below that amount.

▸ You need to be flexible if this is your first publishing agreement. It is important to have an "out" if things go wrong. Exclusive contracts are quite often necessary, but the publisher must allow you some protection if things don't work out.

SILK SCREEN LIMITED EDITIONS

This market is for the fine artist who sells his originals to galleries and may already have a reputation and following. It is tough to find a publisher in this market because they are looking for exceptional talent. The promotional costs in the first few years are considerable, so publishers in this market usually require exclusive contracts.

Silk screens are produced with an average of 15 colors—up to as many as 100 colors for special works of art. The edition quantity can vary enormously, from 15-295 and even more.

POTENTIAL INCOME

Some publishers may pay you up front for an edition; however, the royalty rate may then be lower. In the following example, you might earn $2000. Depending on your cash flow, this could actually be quite a good deal, as you are guaranteed this amount even if the edition doesn't sell out.

295 (edition size) x $90 average sales price (allowing for discounts) = $26,550
Royalty rate of 10% = $2655 royalty
Upfront payment offered: $2000

As the reputation of the artist grows, particularly when editions sell out quickly, she may be able to negotiate higher percentages—in the range of 15-20%. As success builds, the price for the editions will also increase dramatically. Some limited editions for well-known artists can command thousands of dollars.

GICLÉES

Giclée printing is a relatively new process for the art world. While it's been around for almost 20 years, it's only recently become widely accepted. Giclée comes from the French word for "splatter," which is more or less how the ink is applied to the paper. In the early days, many people had reservations about the longevity of the prints, mostly due to the quality of the ink. In recent years, better inks and papers have been developed. Many firms in the US and Europe offer high-quality prints. The beauty of the giclée process is that you can print one at a time, thereby reducing the up front output of money drastically.

Quite a number of publishers are now selling giclées. In terms of reproduction quality, they are regarded by many to be as good as a silk screen. There are, however, many high-end publishers who are still suspicious of this process—they continue to regard giclées with contempt. Giclées are gradually changing the whole picture of the publishing industry, as they allow individual artists to publish limited editions at extremely low costs, empowering themselves as self-published artists.

Giclées can be produced on canvas as well as different types of paper, in sizes up to around 50 inches.

Read more about giclées in Chapter 7.

To produce a typical medium-sized print can cost as little as $50. The initial setup and scanning charges are normally around $100. It is possible to get smaller prints done for as little as $25.

Many mainstream print and poster publishers are now offering a high-end giclée line, particularly on canvas. This is a growing market. Retail prices of giclées can vary enormously. Limited editions sell from as low as $200 to several thousand dollars for the work of well-known and highly-collected artists. Open-edition giclées are now being produced in ever increasing numbers. Furniture stores offer many levels of these products. With Chinese imports on the rise in this market, the pricing disparity can be quite staggering. A 36x24″ framed canvas can range from $200-700+. Price depends on the source of production, quality of framing and quality of art. The lines between high- and low-end giclée prints are becoming more and more blurred and can be very confusing for beginning buyers.

GETTING STARTED WITH FINE ART GICLÉE PRINTING

by Trulee Jameson

"Which painting should I make a giclée of first?" We're asked this question often. After viewing hundreds of artists' portfolios, we've found it's best to ask another question: "Of all your work, which one would be the most painful to part with?" This piece may not be the one you "like" best, but you do feel emotionally attached to it. It may be your spouse's favorite, or the painting most coveted by close friends. Printing a giclée of this favored work will offer

Numerous rewards

At ArtSource Studio, we enjoy introducing artists to the many creative and financial advantages of giclée prints. While the giclée process is still relatively new, acceptance in the fine-art marketplace is growing rapidly. Giclée prints on canvas or fine-art papers are displayed in galleries and museums worldwide. Many museums in the US and abroad have either mounted exhibits of giclées or purchased them for their permanent collection. Many distinguished photographers and artists—Andrew Wyeth, Jamie Wyeth, and Richard Avedon— have produced giclée prints.

Low cost

Setup is much less expensive for giclée than for offset prints, as no plates need to be generated. While traditional printing methods demand upfront investment for large runs, digital prints can be run "on demand" with little up front cost.

Color quality

Giclée printing offers a wider color gamut than with traditional presses, allowing for higher-quality reproduction of the unusual pigments and glazes artists like to use. While the latest giclée printers use six or more colors, traditional printing is limited to four colors. At ArtSource Studio we print with eight colors, using only Hexachrome pigment inks. No screen or other mechanical devices are used, so there is no visible dot screen pattern. The image has all the tonalities and hues of the original painting.

Longevity

Giclée printers use water-soluble pigments rather than the dye-based or solvent inks used in traditional photographic printing. Giclée pigments match original pigment-based media and remain true for over 100 years. A protective UV coating is also applied. This is a significant advantage over printing with dye-based inks, which are highly susceptible to ozone and fading.

Flexibility

This new inkjet technology prints better on a wider range of substrates than traditional press methods. Different sizes can also be printed on demand to accommodate the market.

ⵡ

ArtSource Studio, 1644 Hawthorne St, Sarasota, FL 34239 (941) 366 7030 www.artsourcestudio.com

CALENDARS

Calendar publishers are usually looking for a concept as well as quality in execution. A hot idea will get you in the door fast.

Calendars are a multi-billion-dollar industry. They come in many sizes and shapes. Some popular calendars from previous years were inspirational or humorous: Ansel Adams, Magic Eyes, Sierra Wilderness, cats, Mary Engelbreit, angels, Anne Geddes, Dilbert: Ask Me How My Day Went, Disney Days, Far Side Desk Calendar, Friends, Georgia O'Keeffe, Goosebumps, Life's Little Instruction Calendar, The Muppets, rottweilers, Winnie-the-Pooh.

If you have an idea for a 2010 calendar, contact publishers no later than the early fall of 2008. Prepare a letter that describes your calendar concept and includes final art reproductions of exactly how the calendar will look. With such great computer output these days, this is no longer a difficult task. Send your query to the publishers who have existing categories of calendar styles that are a good fit for your work. If you don't hear back from them within 45 days, make a follow-up call.

Most publishers have specific policies regarding the sale and distribution of calendars to retailers and the discounts these retailers expect to receive. Negotiating terms as an artist will be difficult. With respect to advances, you most likely will have to go with their terms. You should be able to command a 5-10% royalty. Photography generally dominates the calendar market. Research publishers and their preferred themes before sending submissions so you don't waste their time and yours. If you target them with a well-executed calendar concept that fits into their existing categories, you will have a better chance of getting your work into the review process.

CALENDAR RESOURCES

Calendar Association
214 N Hale St, Wheaton, IL 60187 (630) 579 3264
www.calendarassociation.org
They publish a book called *Publishing and Marketing Your Calendar*.

Lulu
www.lulu.com/help/book/print/406

ArtNetwork
www.artmarketing.com
Mailing list of calendar publishers

COLLECTOR PLATES

While the multi-million-dollar plate market has had a hard time recently, it is still a lucrative market. Companies such as Franklin Mint appear to have stopped making collector plates since the bottom fell out of the market a few years ago. The "limited edition" plate business got a bad name when hype about the future rise in value attracted a lot of gullible but well-meaning collectors. While some plates did see substantial increases in value, as a whole the majority did not. Even though bad publicity damaged the market, companies such as Bradford Exchange, Lenox and Danbury Mint are still producing but concentrating on other "collectibles" such as jewelry, model cars, plaques, etc. While there are still opportunities, it is tough because the current market relies more and more on names such as Kinkade and Sandra Kuch as well as film and TV characters.

Approaching these companies is not difficult. Coming up with a quality concept, however, which will sell and stand out from the crowd is becoming more and more difficult.

Royalties vary from 1-5%. With the massive quantities sold, these low royalties can still bring in large sums. Advances can be quite reasonable, from $500-2000 per design, and more if you get a reputation in this market.

This area should only be tackled when you have confidence in your art and are producing work of a high standard. Each series of plates needs to have a theme or story so that it can be marketed as a set.

The age range of the buyers is usually 35–65 (the average age being 50), and most are female. Keep this in mind from the outset. Does your work appeal to that market?

Study the plate market carefully before approaching these companies. It's best to have a track record and some recognition, but not always necessary. This helps with the hype attached to the marketing side of this product category.

Major companies include Danbury Mint, Bradford Exchange, Hamilton Group and Lenox.

These companies spend a small fortune advertising in the color supplement to the Sunday newspaper.

MISCELLANEOUS MARKETS

Listen to the market. If you give it what it wants, you will be successful.

There are many product categories you can consider. Don't be too ambitious at first. Look carefully at what you do, and relate your work to particular products that will fit your style well. Choose half a dozen companies in each category and target your work carefully.

JIGSAW PUZZLES

There are quite a few manufacturers in this category. Each year, these companies replace a good number of designs. Do your homework at the National Stationery Show or at your local retail stores to see what subject matter manufacturers like.

Jigsaws need to have visual interest throughout the entire layout of the work. Avoid submitting work with large areas of plain sky or sidewalk. Twenty pieces of plain blue sky could make a jigsaw addict quite irritated!

Fees: Advances from $250–1,500; royalties 5-8%.

PUZZLE RESOURCES

American Puzzles
www.americanpuzzles.com

Buffalo Games
www.buffalogames.com

Great American Puzzle Factory
16 S Main St, Norwalk, CT 06854-2981 (203) 838 4240
www.greatamericanpuzzle.com

Hasbro
www.hasbro.com

Ravensburger
www.ravensburger.com

Simple Pastimes
www.simplepastimes.com

White Mountain Puzzles
www.puzzlemaps.com

NEEDLE CRAFT AND STITCH KITS

This market is dominated by a small number of manufacturers. Designs are generally converted by computer these days. Not a big money earner, but a possible source of extra income.

RESOURCES

Dimensions

1801 N 12th St, Reading, PA 19604 (610) 939 9900 www.dimensions-crafts.com
A needle craft manufacturer. Their products are sold in catalogs and craft chains. They work with over 100 artists and review work year-round. They are actively seeking new artists. Submit a portfolio (they prefer color copies or a brochure) for review by mail or e-mail.

Janlynn

2070 Westover Rd, Chicopee, MA 01022 www.janlynn.com

STATIONERY AND GIFT PRODUCTS

Most department stores such as J C Penney, Target, and Macy's, as well as chains such as Papyrus, Hallmark Stores, Borders, and Barnes & Noble, and good gift shops carry a range of stationery, back-to-school items and giftware—mugs, photo albums, calendars, note lets, etc. These product categories offer artists other sources of revenue for their designs, although most of the manufacturing is done in China so it is not as lucrative as it used to be. Manufacturers are also producing more and more of their designs in-house.

TABLEWARE, MATS, TRAYS, COASTERS

This market of mugs, plates, bowls, etc. is notoriously difficult. Many of the manufacturers in this industry produce a lot of their design work in-house. A number of innovative companies make some good artistic products. The greatest opportunities for artists will be in the casual category, including melamine. These products seem to be more trend-forward because they do not have a long shelf-life, sometimes remaining on the market for only one season (Christmas, the summer catalog, etc.) Research products and resources through gift and trade shows as well as visiting the housewares departments in various retail outlets to find one with a "look" or "attitude" that fits your work or style.

WALL COVERING COMPANIES

There are many companies that supply decorative wallpapers for the retail market. Border trims, for instance, are sold in many different types of stores: children's clothing stores, do-it-yourself stores, boutiques, etc. Many manufacturers have in-house designers who take your art and create borders around themes such as

Study the many magazines listed in the back of this book to discover more aspects of the industry.

country, children, and nautical. Work needs to be quite commercial and attention has to be paid to color trends to be selected for this application. Wall covering has fallen out of fashion in the past several years as homeowners respond to the trend of specialty paint finishes and brightly painted accent walls. It can be difficult to know whom to send work to because some manufacturers have several different brands and divisions. The Internet is helpful for finding who owns whom and where inquiries can be directed.

RESOURCES

Chesapeake Wall Covering Corp
401-H Prince George's Blvd, Upper Marlboro, MD 20774 www.cheswall.com

Seabrook Wall Coverings Inc
1325 Farmville Rd, Memphis, TN 38112 www.seabrookwallpaper.com

ROYALTY EXAMPLE

You license your concept for a range of children's T-shirts, to be sold in Target and other retail stores. It's September and the product is for spring of the following year. Trade price for the T-shirt is $6. Initial print run is 5000, with four designs (total of 20,000 T-shirts).

$6 x 20,000	$120,000
Royalty @ 6%	$7200
Advance	$3000
Guarantee	$7000

Guarantee is for the period September - December 31 of the following year (16 months later) and a further guarantee of $7000 for the second full year.
During the year, you will receive a royalty report each quarter. Probably for the first two quarters, your royalties will show a negative balance due to your advance. Once sales have exceeded a certain amount and the royalties earned reach $3000, then you will start to receive a quarterly royalty check. At the end of the year, if there is a shortfall, then the manufacturer will have to pay you the difference between the royalties you've received and the guaranteed amount. Please note that guarantees are increasingly hard to get these days, so you may have to settle for an advance against royalties only.

BOOK COVERS

Many artists' work could be used as cover designs for books. Several fine artists have taken advantage of this venue. Most publishers use the exact artwork for their book-cover design. If the cover is a success, they will want to use another piece, perhaps even commission a special piece. Usually, you create the piece in whatever size you normally do, but preferably in proportion to the size of the book. Then the book publisher sends a photographer to photograph it for reproduction. The exposure your distinct style can receive on a bestselling book cover is phenomenal.

SUCCESS STORY

One artist's first book-cover commission was a bestseller. She became almost as well known as the author! Soon she had 20 book covers under her wings, as well as several children's books, some of which she illustrated and others of which she both illustrated and wrote. This brought her recognition in other venues as well and enabled her to have more control over her career.

LOCATING BOOK PUBLISHERS

▸ Browse through bookstores. Publishers list their contact info near the front of most books.

▸ Attend the annual trade show Book Expo (see Chapter 10).

▸ Mail samples of your work to book publishers (see Chapter 10) to introduce them to your style of artwork.

▸ Review *Literary Market Place* at your library. It lists publishers and the types of books they publish.

▸ The annual *Writer's Market* directory also lists publishers and the types of books they publish.

AGENTS

Many artists find it much more efficient to work through an agent who specializes in book jacket design. Shannon Associates (www.shannonassociates.com) is one of the world's leading agencies for illustration of books and magazines. Study their site. Only artists with a full understanding of the industry and work of the highest standard will be considered for representation.

CHILDREN'S BOOKS

The children's book market is a very specialized field. Most projects pay little compared to other industries. A typical 32-page book could take you eight to 12 weeks to complete—from art roughs to finished art.

If you have your own ideas for children's books:

- ▶ Figure out the age group you are targeting.

- ▶ Find out the typical page-count a publisher prints for that age.

- ▶ Design a layout.

- ▶ Produce a cover.

- ▶ Mock up two to three pages, with the rest of the book as pencil sketches. Using a computer, lay out the book as you think it might look. This will help you pace the words with the illustrations (often overlooked).

ROYALTIES

- ▶ Often, only a flat fee is offered for doing a cover or illustration.

- ▶ A 10% royalty is usually agreed upon, but this would be split if there were a writer and an illustrator. Book contracts will also include various royalty rates for overseas sales, book clubs and special editions.

- ▶ Advances against royalties are often given.

RESOURCES

Children's Writer's & Illustrator's Market
(800) 289 0963 www.fwpublications.com

Society of Children's Book Writers & Illustrators/SCBWI
(323) 782 1010 www.scbwi.org

ArtNetwork
www.artmarketing.com
A list of book publishers available on mailing labels

ANIMATION

Revenues can be huge if an animated series is a success.

Ideas for an animated TV series can come from a variety of sources—books or comic strips as well as ideas developed specifically for the market. Picture storybooks, such as Peter Rabbit, were such a success that licenses were sold to manufacturers to produce baby's and children's products, selling to an entire generation of mothers who read the stories to their children and who, in many cases, had actually read them as children themselves. Cartoon strips like "Peanuts," "Dennis the Menace" and "Garfield" eventually became animated series. In the above cases, major merchandise programs were created, generating millions of dollars' worth of merchandise.

TV series featuring Arthur, Barney and many, many more were also created from an idea for a character who captured the imagination, who in turn was gradually turned into a successful property through determination and good marketing.

Creating a property for animation is a long, arduous process, sometimes taking several years to broadcast! There are no simple, set rules in this industry, and no two deals are the same.

An original animated series generally begins by creating:

▸ a style guide

▸ a synopsis

▸ character studies of each character

▸ various story outlines for the series.

It also includes background scenes and images, which show how the characters relate to each other or their environment. Most animation series are 13, 26 or 52 episodes; the episode length can be approximately five, 15 or 30 minutes, although the actual running time is less due to advertisements. A quarter-hour episode is usually 11-13 minutes long.

The more detailed the style guide, the better the chances of attracting interest. Interest can come from animation production studios, broadcasters, agents and investors. Quite often, it can be a combination of several people.

Creating a pilot can cost anything from a few thousand dollars to $100,000 and more. Once a pilot is made, it doesn't necessarily mean the series will be created. At this stage, the idea has to be sold to broadcasters in order to finance the $4 million it will probably cost to make an initial series.

If the project has merchandise possibilities, then several months or a year ahead of broadcast, license deals are negotiated for toys, games and a host of other merchandise.

Quite often, creators assign their rights to a production company or development company, as many of these companies will not invest the large amounts of money

required unless they have complete control. If this is the case, you need a good intellectual-property lawyer who is in the entertainment business to help you in the negotiations.

RESOURCES

Animation World Network

6525 Sunset Blvd #8, Hollywood, CA 90028 (323) 606 4200 www.awn.com
This organization publishes *Animation World Magazine* and *How To Succeed in Animation*, has career connections, discussion forums, school directory and more.

International Animation Association/ASIFA

www.swcp.com/~asifa

Animation

www.animation.com

Pixar

www.pixar.com
Keep up-to-date on the latest animation developments.

Aardman Associates

www.aardman.com
An award-winning production studio that produced *Wallace & Gromit* and *Chicken Run*.

Kidscreen

www.kidscreen.com

Animation Magazine

www.animationmagazine.net

STAMPS

by Constance Smith

Each year the US Postal Service receives over 40,000 consumer requests for new subjects to appear on postage stamps. From those requested, approximately 30 subjects are chosen, utilizing an average of 100 designs. (One subject matter may be depicted on several stamps.) The final selection of subjects is made by the Citizens' Stamp Advisory Committee/CSAC. Subjects are selected three years in advance of issuance.

The total commission for a completed stamp design or illustration is $3000. The artist is given $1000 upon signing an agreement for concepts. If the work is approved, the artist receives an additional $2000 for the final art.

When approved, the subjects are assigned to the Postal Service Stamp Design staff. The design staff works with five highly qualified, professional art directors in developing the designs.

The US Postal Service continually searches for new creative talent to utilize in its design program. New artists are commissioned each year. Creating stamp designs is not an easy task. It requires unique talent, style and discipline to work within the parameters required to create art for reproduction on such a small scale.

If you think you meet the requirements as a professional designer, illustrator or photographer and wish to be considered for a stamp design assignment, the guidelines are as follows:

▸ All work must be submitted in print form (tear sheets, color copies, etc.) that will be retained by the US Postal Service. They will be made available to art directors in the event a work is approved. Original art or slides will not be accepted.

The US Postal Service will contact you if they are interested in commissioning your service. The US Postal Service will not:

▸ acknowledge receipt of samples by letter or phone

▸ offer reasons for rejection of submission.

The USPS insists on retaining the copyright on all images they use, as well as ownership of the original artwork, which is often deposited either in the Postal Museum or the Smithsonian Institute.

▸ If a stamp is popular, the artist may be asked to sign uncut sheets, which could mean $1-4 per signature depending on the sheet and edition.

US Postal Service Citizens' Stamp Advisory Committee/CSAC
1735 N Lynn St #5013, Arlington, VA 22209-6432 (202) 268 2000
Ask for a guideline on becoming a designer. Designs for US postage stamps are reviewed and accepted by a committee of 11 people, three years in advance of the publication date.

This market is the only exception to the rule of not relinquishing your copyright!

SUCCESS STORY

Remember the artist who had her artwork on the cover of a best-selling novel? Well, her artwork is also on a US postage stamp! The US Postal Service was looking for an artist to do a Kwanzaa stamp. Through detective work on the Internet, they landed at her site.

Though she receives no further royalties for her image (which has been used for over three years now), she sure gets a lot of image PR! Millions of people have seen her artwork over and over again. Though the Postal Service owns the original and the copyright, she is able to make similar pieces into posters, cards and book covers!

UNITED NATIONS

The United Nations Postal Administration/UNPA also runs a stamp program. Fees average $2000 for one image, or if multiple images are used, $1000 per image; maximum fee for a series is $12,000. The UN retains the copyright, but the artist retains the artwork. They try to maintain a global perspective and, thus, are looking for work from international artists.

UNPA
2 UN Plaza, DC 2-622, New York, NY 10017 (212) 963 4329
www.unitednations.com
Search for "stamps" on their web site to see previous editions. They look for themes such as empowering women, etc. Send non-returnable samples (color photocopies or slides) for review. They publish two to three stamps per year.

FOREIGN STAMPS

Inter-Governmental Philatelic Corporation is an agent to foreign governments. They produce postage stamps and related items on behalf of 40 different governments. They work with 75-100 artists each year, preferring artists within metropolitan New York or that tri-state area. Artwork must be focused, four-color and reproducible to stamp size. They prefer air brush, acrylic and gouache. If you send them a portfolio, it should contain four-color illustrations of realistic flora, fauna, technical subjects, autos or ships.

Inter-Governmental Philatelic Corporation/IGPC
460 W 34th St #10Fl, New York, NY 10001 (212) 629 7979 www.igpc.net
Include samples of original artwork reduced to stamp size.

WILDLIFE STAMPS

Wildlife art is big business in the US. Besides posters, there are wildlife stamps. Stamp publishing is considered prestigious in the wildlife art world. State conservation departments and organizations, as well as federal resource agencies, sponsor contests throughout the year.

Wildlife Art Magazine
947 D St, Ramona, CA 92065 (800) 221 6547 (760) 788 WILD
www.wildlifeartmag.com

STOCK PHOTOGRAPHY AND ILLUSTRATION

Royalty-free agencies have eroded this market over the last 10 years, so revenues for artists have declined dramatically.

Stock art is a $200-million-a-year market. Generally, stock images are licensed via buyers' catalogs, a directory, direct mail, CD-ROM or the Internet. The artist grants an agency the right (often exclusive) to re-license selected images of his work for specific jobs: advertising, book covers, brochures, magazines, annual reports and the like.

Artists actually show a small selection to begin with, and, if they are popular, the stock agency will contract more of their work.

Generally, the artist has to bear the full cost of transparencies and duplicates of the images used. This cost can get out of hand if your agency requests 50 trannies of all 50 of your artworks, for instance. Make it clear in the contract where your limits lie.

Stock houses have become large and impersonal corporations, seeking fees from rights to art that may not be in your best interest. An artist often does not have the right after signing with an agency to refuse usage. Sometimes an artist must grant an agency the right to alter, tint, crop or otherwise manipulate images.

Agencies in this genre of licensing are abundant. They can be found in the local *Yellow Pages* or through a directory of illustration such as *The Black Book, The Graphic Artists Guild Directory of Illustration, RSVP* or *The Workbook*.

Fees are generally received by the agency and split 50/50 with the artist.

RESOURCES

The Dynamic Graphics Group
(800) 255 8800 www.dgusa.com

Indexed Visuals
www.indexedvisuals.com

Stockart.com
(800) 297 7658 (970) 493 0087 www.stockart.com

Stock Illustration Source
(800) 4 IMAGES (446 2437) (212) 849 2900 www.images.com

PhotoSource International
(800) 624 0266 (715) 248 3800 www.photosource.com
Publishes a monthly newsletter—"PhotoStock Notes"—that keeps you informed about the stock photography business.

www.pro.corbis.com

www.illustrationworks.com

www.imagesource.com

RECORDS

The record industry uses fine art for CD and cassette inserts. You could propose a particular idea for a CD cover for your favorite entertainer, or show them your style in general.

RESOURCES

Read industry magazines such as *Billboard, Spin* and *Rolling Stone.*

Capitol Records
www.hollywoodandvine.com

Music Connection Magazine
www.musicconnection.com

Recording Industry Association of America/RIAA
(202) 775 0101 www.riaa.com
Reports the latest trends in packaging, format and music sales by genre

Record Labels on the Web
www.rlabels.com

Universal Music Group
www.umusic.com

Rock Art, a book by Spencer Drake, has information on CD design.

SURFACE DESIGN

by Constance Smith

Surface design is a commercial art form in which the final product from the designer is a pattern, usually executed on paper, ready for application to the final commercial product, often fabric for sheets, pillows, wall hangings and other items.

Because of the commercial/industrial nature of surface pattern design, the designer must understand how the fabric or paper is to be printed, how it will be merchandised in a store, and how the final product is to be used by the consumer. Surface-pattern design schools and programs offer curricula that cover the technical aspects as well as the fine-art discipline needed to be a competent designer. Fine-art skills such as drawing, proportion, perspective and color theory are as necessary as technical information regarding repeats, printing and production. Very often, artists from other disciplines can cross the line into this form of design—not, however, without some training and work.

Designs can be for two-dimensional surfaces such as bedding, shower curtains, wallpaper, upholstery fabric, wrapping paper, children's sleep wear, tablecloths, etc. Usually these are printed goods, but they can be woven towels or tablecloths, too.

Designers can work in the surface design industry in a variety of ways:

- In-house staff designer for a company, hired on a full- or part-time basis

- Freelance designers who design originals (sometimes custom work for a specific project) and sell the artwork, sometimes through an art rep

In the textile and surface design industry, licensing agreements are generally negotiated for an entire line or collection. A licensing agreement for domestics would include sheets, pillowcases, duvets, and shams; a license for bath products would include mats, curtains, shower curtains, accessories, and towels.

Figuring out technically how to have a towel match a sheet, how to paint the artwork using fewer colors or screens, is a big task. There are always limitations and product direction to consider, which takes experience and schooling.

ROYALTIES

Royalties generally range from 2-10% of wholesale, the majority being at 5% but some as low as a fraction of a percent (on very high volumes). Advances can be as high as $5000 per program.

- Generally, artists find reps to make their deals.

- Often, artists receive name credit somewhere on the product for their design, for example, on the salvage of the fabric or the label of a sheet.

RESOURCES

Image West Design

PO Box 613, San Anselmo, CA 94979-0613 (415) 482-9856

www.imagewestdesign.com

Owner Teliha Draheim is an industry consultant and offers private consultations and classes. Call for free brochure.

Paisley Group

PO Box 40496, Pasadena, CA 91114 (626) 568 7505 www.thepaisleygroup.org

This is a nonprofit organization of surface pattern designers, textile artists and design representatives, organized for the purpose of providing networking, support, education and information on the issues that impact these professionals.

Surface Design Association

PO Box 360, Sebastopol, CA 95473-0360 (707) 829 3110

www.surfacedesign.org

Publishes a magazine—*Surface Design Journal*. A one-year membership, which includes four issues of the magazine, is $50.

Surtex Show

www.surtex.com

This show allows you to license your work directly to manufacturers.

ACTION PLAN

List frame shops, department stores, gift shops, greeting card stores, home décor outlets to visit to keep abreast of the marketplace:

Products you want to see your work on:

Greeting card publishers to contact:

Print publishers to contact:

Calendar publishers to contact:

RECOMMENDED READING

Art for the Written Word by Wendell Minor and Florence Friedman Minor

Covers & Jackets! What the Best-Dressed Books & Magazines Are Wearing by Steven Heller and Anne Fink

Jackets Required: An Illustrated History of American Book Jacket Design by Steven Heller and Seymour Chast

Chapter 3
Legal Aspects

Less is more.
Mies van der Rohe

COPYRIGHT

You own the copyright to all the work you produce whether you sell the originals or not.

Copyright provides protection for an artist who has created an original work of art—pictorial, graphic or sculptural. Under the copyright law of 1976, any work created on or after January 1, 1978, is protected by common-law copyright as soon as it is completed in some tangible form. You are not even required to put the copyright © symbol on your work to protect it. Anyone (a company, individual or organization) wishing to use the artwork must have the creator's permission in writing, i.e., a license or agreement granting specific rights.

As owner of your copyright, you have exclusive right to do (and to authorize others to do) the following:

- Reproduce the work in copies
- Prepare derivatives of the work
- Distribute copies to the public, by rental, lease, sale
- Display the copyrighted work publicly (include in a motion picture, etc.)
- Transfer the copyright to heirs in your will
- Transfer part or all of your copyright through a sale, gift, donation or trade. You must do this in writing. This is not the same as selling or transferring ownership of an artwork. You can sell a first-reproduction right to one company, say for greeting cards, and a second reproduction right to another, say for a calendar, as long as each contract allows you to do that.

PROVING YOUR COPYRIGHT

Take snapshots or slides and get them printed with a date on the photo. This is some proof, but this will not hold up in a court case. If you don't file copyright FORM VA with the Copyright Office in Washington, DC, you cannot sue someone for infringing your copyright should this be necessary. Only when you officially register your work with the Copyright Office in Washington, DC, do you become eligible to receive statutory damages and attorney's fees in case of an infringement suit.

Copyright registration costs $45 per filing; you can register as many pieces as you wish at one time for this $45 (raised in 2006 50% from $30!), providing they are all similar in style. (The copyright office wants to know they are from the same artist.) Official registration is effective upon receipt of your application.

RESOURCES

Art Law Center

www.artlaws.com

Copyright Office

Library of Congress, Copyright Office, Washington, DC 20559

(202) 707 3000 (information) (202) 707 9100 (to request forms)

www.loc.gov/copyright

Institute of Art & Law

www.ial.uk.com

Starving Artists Law

www.starvingartistslaw.com

Superintendent of Documents

PO Box 371954, Pittsburgh, PA 15250

To study in detail the copyright law, obtain a copy of Copyright Law of the United States of America (Circular '92). $14 (check, Visa, Mastercard)

FILING YOUR COPYRIGHT

It is fine to photocopy the forms on the following pages to file your copyright. You can also go online to www.copyright.gov/forms/formva.pdf and download a 8.5x11″ copy.

For works created after January 1, 1978, copyright lasts for a period of 70 years after the artist's death.

See Chapter 4 in Art Marketing 101 for more details about copyright.

 # Form VA

Detach and read these instructions before completing this form.
Make sure all applicable spaces have been filled in before you return this form.

▓▓ BASIC INFORMATION ▓▓

When to Use This Form: Use Form VA for copyright registration of published or unpublished works of the visual arts. This category consists of "pictorial, graphic, or sculptural works," including two-dimensional and three-dimensional works of fine, graphic, and applied art, photographs, prints and art reproductions, maps, globes, charts, technical drawings, diagrams, and models.

What Does Copyright Protect? Copyright in a work of the visual arts protects those pictorial, graphic, or sculptural elements that, either alone or in combination, represent an "original work of authorship." The statute declares: "In no case does copyright protection for an original work of authorship extend to any idea, procedure, process, system, method of operation, concept, principle, or discovery, regardless of the form in which it is described, explained, illustrated, or embodied in such work."

Works of Artistic Craftsmanship and Designs: "Works of artistic craftsmanship" are registrable on Form VA, but the statute makes clear that protection extends to "their form" and not to "their mechanical or utilitarian aspects." The "design of a useful article" is considered copyrightable "only if, and only to the extent that, such design incorporates pictorial, graphic, or sculptural features that can be identified separately from, and are capable of existing independently of, the utilitarian aspects of the article."

Labels and Advertisements: Works prepared for use in connection with the sale or advertisement of goods and services are registrable if they contain "original work of authorship." Use Form VA if the copyrightable material in the work you are registering is mainly pictorial or graphic; use Form TX if it consists mainly of text. **Note:** Words and short phrases such as names, titles, and slogans cannot be protected by copyright, and the same is true of standard symbols, emblems, and other commonly used graphic designs that are in the public domain. When used commercially, material of that sort can sometimes be protected under state laws of unfair competition or under the federal trademark laws. For information about trademark registration, write to the U.S. Patent and Trademark Office, PO Box 1450, Alexandria, VA 22313-1450.

Architectural Works: Copyright protection extends to the design of buildings created for the use of human beings. Architectural works created on or after December 1, 1990, or that on December 1, 1990, were unconstructed and embodied only in unpublished plans or drawings are eligible. Request Circular 41, *Copyright Claims in Architectural Works*, for more information. Architectural works and technical drawings cannot be registered on the same application.

Deposit to Accompany Application: An application for copyright registration must be accompanied by a deposit consisting of copies representing the entire work for which registration is to be made.

 Unpublished Work: Deposit one complete copy.

 Published Work: Deposit two complete copies of the best edition.

 Work First Published Outside the United States: Deposit one complete copy of the first foreign edition.

 Contribution to a Collective Work: Deposit one complete copy of the best edition of the collective work.

The Copyright Notice: Before March 1, 1989, the use of copyright notice was mandatory on all published works, and any work first published before that date should have carried a notice. For works first published on and after March 1, 1989, use of the copyright notice is optional. For more information about copyright notice, see Circular 3, *Copyright Notice*.

For Further Information: To speak to a Copyright Office staff member, call (202) 707-3000 (TTY: (202) 707-6737). Recorded information is available 24 hours a day. Order forms and other publications from the address in space 9 or call the Forms and Publications Hotline at (202) 707-9100. Access and download circulars, forms, and other information from the Copyright Office website at *www.copyright.gov*.

▓▓ LINE-BY-LINE INSTRUCTIONS ▓▓

Please type or print using black ink. The form is used to produce the certificate.

 ## SPACE 1: Title

Title of This Work: Every work submitted for copyright registration must be given a title to identify that particular work. If the copies of the work bear a title (or an identifying phrase that could serve as a title), transcribe that wording *completely* and *exactly* on the application. Indexing of the registration and future identification of the work will depend on the information you give here. For an architectural work that has been constructed, add the date of construction after the title; if unconstructed at this time, add "not yet constructed."

Publication as a Contribution: If the work being registered is a contribution to a periodical, serial, or collection, give the title of the contribution in the "Title of This Work" space. Then, in the line headed "Publication as a Contribution," give information about the collective work in which the contribution appeared.

Nature of This Work: Briefly describe the general nature or character of the pictorial, graphic, or sculptural work being registered for copyright. Examples: "Oil Painting"; "Charcoal Drawing"; "Etching"; "Sculpture"; "Map"; "Photograph"; "Scale Model"; "Lithographic Print"; "Jewelry Design"; "Fabric Design."

Previous or Alternative Titles: Complete this space if there are any additional titles for the work under which someone searching for the registration might be likely to look, or under which a document pertaining to the work might be recorded.

SPACE 2: Author(s)

General Instruction: After reading these instructions, decide who are the "authors" of this work for copyright purposes. Then, unless the work is a "collective work," give the requested information about every "author" who contributed any appreciable amount of copyrightable matter to this version of the work. If you need further space, request Continuation Sheets. In the case of a collective work, such as a catalog of paintings or collection of cartoons by various authors, give information about the author of the collective work as a whole.

Name of Author: The fullest form of the author's name should be given. Unless the work was "made for hire," the individual who actually created the work is its "author." In the case of a work made for hire, the statute provides that "the employer or other person for whom the work was prepared is considered the author."

What Is a "Work Made for Hire"? A "work made for hire" is defined as: (1) "a work prepared by an employee within the scope of his or her employment"; or (2) "a work specially ordered or commissioned for use as a contribution to a collective work, as a part of a motion picture or other audiovisual work, as a translation, as a supplementary work, as a compilation, as an instructional text, as a test, as answer material for a test, or as an atlas, if the parties expressly agree in a written instrument signed by them that the work shall be considered a work made for hire." If you have checked "Yes" to indicate that the work was "made for hire," you must give the full legal name of the employer (or other person for whom the work was prepared). You may also include the name of the employee along with the name of the employer (for example: "Elster Publishing Co., employer for hire of John Ferguson").

"Anonymous" or "Pseudonymous" Work: An author's contribution to a work is "anonymous" if that author is not identified on the copies or phonorecords of the work. An author's contribution to a work is "pseudonymous" if that author is identified on the copies or phonorecords under a fictitious name. If the work is "anonymous" you may: (1) leave the line blank; or (2) state "anonymous" on the line; or (3) reveal the author's identity. If the work is "pseudonymous" you may: (1) leave the line blank; or (2) give the pseudonym and identify it as such (for example: "Huntley Haverstock, pseudonym"); or (3) reveal the author's name, making clear which is the real name and which is the pseudonym (for example: "Henry Leek, whose pseudonym is Priam Farrel"). However, the citizenship or domicile of the author *must* be given in all cases.

Dates of Birth and Death: If the author is dead, the statute requires that the year of death be included in the application unless the work is anonymous or pseudonymous. The author's birth date is optional but is useful as a form of identification. Leave this space blank if the author's contribution was a "work made for hire."

Author's Nationality or Domicile: Give the country of which the author is a citizen or the country in which the author is domiciled. Nationality or domicile *must* be given in all cases.

Nature of Authorship: Catagories of pictorial, graphic, and sculptural authorship are listed below. Check the box(es) that best describe(s) each author's contribution to the work.

3-Dimensional sculptures: fine art sculptures, toys, dolls, scale models, and sculptural designs applied to useful articles.

2-Dimensional artwork: watercolor and oil paintings; pen and ink drawings; logo illustrations; greeting cards; collages; stencils; patterns; computer graphics; graphics appearing in screen displays; artwork appearing on posters, calendars, games, commercial prints and labels, and packaging, as well as 2-dimensional artwork applied to useful articles, and designs reproduced on textiles, lace, and other fabrics; on wallpaper, carpeting, floor tile, wrapping paper, and clothing.

Reproductions of works of art: reproductions of preexisting artwork made by, for example, lithography, photoengraving, or etching.

Maps: cartographic representations of an area, such as state and county maps, atlases, marine charts, relief maps, and globes.

Photographs: pictorial photographic prints and slides and holograms.

Jewelry designs: 3-dimensional designs applied to rings, pendants, earrings, necklaces, and the like.

Technical drawings: diagrams illustrating scientific or technical information in linear form, such as architectural blueprints or mechanical drawings.

Text: textual material that accompanies pictorial, graphic, or sculptural works, such as comic strips, greeting cards, games rules, commercial prints or labels, and maps.

Architectural works: designs of buildings, including the overall form as well as the arrangement and composition of spaces and elements of the design.

NOTE: Any registration for the underlying architectural plans must be applied for on a separate Form VA, checking the box "Technical drawing."

3 SPACE 3: Creation and Publication

General Instructions: Do not confuse "creation" with "publication." Every application for copyright registration must state "the year in which creation of the work was completed." Give the date and nation of first publication only if the work has been published.

Creation: Under the statute, a work is "created" when it is fixed in a copy or phonorecord for the first time. Where a work has been prepared over a period of time, the part of the work existing in fixed form on a particular date constitutes the created work on that date. The date you give here should be the year in which the author completed the particular version for which registration is being sought, even if other versions exist or if further changes or additions are planned.

Publication: The statute defines "publication" as "the distribution of copies or phonorecords of a work to the public by sale or other transfer of ownership, or by rental, lease, or lending"; a work is also "published" if there has been an "offering to distribute copies or phonorecords to a group of persons for purposes of further distribution, public performance, or public display." Give the full date (month, day, year) when, and the country where, publication first occurred. If first publication took place simultaneously in the United States and other countries, it is sufficient to state "U.S.A."

4 SPACE 4: Claimant(s)

Name(s) and Address(es) of Copyright Claimant(s): Give the name(s) and address(es) of the copyright claimant(s) in this work even if the claimant is the same as the author. Copyright in a work belongs initially to the author of the work (including, in the case of a work make for hire, the employer or other person for whom the work was prepared). The copyright claimant is either the author of the work or a person or organization to whom the copyright initially belonging to the author has been transferred.

Transfer: The statute provides that, if the copyright claimant is not the author, the application for registration must contain "a brief statement of how the claimant obtained ownership of the copyright." If any copyright claimant named in space 4 is not an author named in space 2, give a brief statement explaining how the claimant(s) obtained ownership of the copyright. Examples: "By written contract"; "Transfer of all rights by author"; "Assignment"; "By will." Do not attach transfer documents or other attachments or riders.

5 SPACE 5: Previous Registration

General Instructions: The questions in space 5 are intended to find out whether an earlier registration has been made for this work and, if so, whether there is any basis for a new registration. As a rule, only one basic copyright registration can be made for the same version of a particular work.

Same Version: If this version is substantially the same as the work covered by a previous registration, a second registration is not generally possible unless: (1) the work has been registered in unpublished form and a second registration is now being sought to cover this first published edition; or (2) someone other than the author is identified as a copyright claimant in the earlier registration, and the author is now seeking registration in his or her own name. If either of these two exceptions applies, check the appropriate box and give the earlier registration number and date. Otherwise, do not submit Form VA; instead, write the Copyright Office for information about supplementary registration or recordation of transfers of copyright ownership.

Changed Version: If the work has been changed and you are now seeking registration to cover the additions or revisions, check the last box in space 5, give the earlier registration number and date, and complete both parts of space 6 in accordance with the instruction below.

Previous Registration Number and Date: If more than one previous registration has been made for the work, give the number and date of the latest registration.

6 SPACE 6: Derivative Work or Compilation

General Instructions: Complete space 6 if this work is a "changed version," "compilation," or "derivative work," and if it incorporates one or more earlier works that have already been published or registered for copyright, or that have fallen into the public domain. A "compilation" is defined as "a work formed by the collection and assembling of preexisting materials or of data that are selected, coordinated, or arranged in such a way that the resulting work as a whole constitutes an original work of authorship." A "derivative work" is "a work based on one or more preexisting works." Examples of derivative works include reproductions of works of art, sculptures based on drawings, lithographs based on paintings, maps based on previously published sources, or "any other form in which a work may be recast, transformed, or adapted." Derivative works also include works "consisting of editorial revisions, annotations, or other modifications" if these changes, as a whole, represent an original work of authorship.

Preexisting Material (space 6a): Complete this space *and* space 6b for derivative works. In this space identify the preexisting work that has been recast, transformed, or adapted. Examples of preexisting material might be "Grunewald Altarpiece" or "19th century quilt design." Do not complete this space for compilations.

Material Added to This Work (space 6b): Give a brief, general statement of the *additional* new material covered by the copyright claim for which registration is sought. In the case of a derivative work, identify this new material. Examples: "Adaptation of design and additional artistic work"; "Reproduction of painting by photolithography"; "Additional cartographic material"; "Compilation of photographs." If the work is a compilation, give a brief, general statement describing both the material that has been compiled *and* the compilation itself. Example: "Compilation of 19th century political cartoons."

7, 8, 9 SPACE 7, 8, 9: Fee, Correspondence, Certification, Return Address

Deposit Account: If you maintain a Deposit Account in the Copyright Office, identify it in space 7a. Otherwise, leave the space blank and send the fee with your application and deposit.

Correspondence (space 7b): Give the name, address, area code, telephone number, email address, and fax number (if available) of the person to be consulted if correspondence about this application becomes necessary.

Certification (space 8): The application cannot be accepted unless it bears the date and the *handwritten signature* of the author or other copyright claimant, or of the owner of exclusive right(s), or of the duly authorized agent of the author, claimant, or owner of exclusive right(s).

Address for Return of Certificate (space 9): The address box must be completed legibly since the certificate will be returned in a window envelope.

Copyright Office fees are subject to change. For current fees, check the Copyright Office website at *www.copyright.gov*, write the Copyright Office, or call (202) 707-3000.

Form VA
For a Work of the Visual Arts
UNITED STATES COPYRIGHT OFFICE

REGISTRATION NUMBER

VA VAU

EFFECTIVE DATE OF REGISTRATION

Month Day Year

DO NOT WRITE ABOVE THIS LINE. IF YOU NEED MORE SPACE, USE A SEPARATE CONTINUATION SHEET.

1

Title of This Work ▼ NATURE OF THIS WORK ▼ See instructions

Previous or Alternative Titles ▼

Publication as a Contribution If this work was published as a contribution to a periodical, serial, or collection, give information about the collective work in which the contribution appeared. **Title of Collective Work ▼**

If published in a periodical or serial give: **Volume ▼** **Number ▼** **Issue Date ▼** **On Pages ▼**

2

a

NAME OF AUTHOR ▼ DATES OF BIRTH AND DEATH
Year Born ▼ Year Died ▼

NOTE

Under the law, the "author" of a "work made for hire" is generally the employer, not the employee (see instructions). For any part of this work that was "made for hire" check "Yes" in the space provided, give the employer (or other person for whom the work was prepared) as "Author" of that part, and leave the space for dates of birth and death blank.

Was this contribution to the work a "work made for hire"?
☐ Yes
☐ No

Author's Nationality or Domicile
Name of Country
OR { Citizen of _____
 Domiciled in _____

Was This Author's Contribution to the Work
Anonymous? ☐ Yes ☐ No
Pseudonymous? ☐ Yes ☐ No
If the answer to either of these questions is "Yes," see detailed instructions.

Nature of Authorship Check appropriate box(es). **See instructions**
☐ 3-Dimensional sculpture ☐ Map ☐ Technical drawing
☐ 2-Dimensional artwork ☐ Photograph ☐ Text
☐ Reproduction of work of art ☐ Jewelry design ☐ Architectural work

b

Name of Author ▼ Dates of Birth and Death
Year Born ▼ Year Died ▼

Was this contribution to the work a "work made for hire"?
☐ Yes
☐ No

Author's Nationality or Domicile
Name of Country
OR { Citizen of _____
 Domiciled in _____

Was This Author's Contribution to the Work
Anonymous? ☐ Yes ☐ No
Pseudonymous? ☐ Yes ☐ No
If the answer to either of these questions is "Yes," see detailed instructions.

Nature of Authorship Check appropriate box(es). **See instructions**
☐ 3-Dimensional sculpture ☐ Map ☐ Technical drawing
☐ 2-Dimensional artwork ☐ Photograph ☐ Text
☐ Reproduction of work of art ☐ Jewelry design ☐ Architectural work

3

a Year in Which Creation of This Work Was Completed
This information must be given in all cases.
_____ Year

b Date and Nation of First Publication of This Particular Work
Complete this information ONLY if this work has been published.
Month _____ Day _____ Year _____
_____ Nation

4

See instructions before completing this space.

COPYRIGHT CLAIMANT(S) Name and address must be given even if the claimant is the same as the author given in space 2. ▼

Transfer If the claimant(s) named here in space 4 is (are) different from the author(s) named in space 2, give a brief statement of how the claimant(s) obtained ownership of the copyright. ▼

DO NOT WRITE HERE
OFFICE USE ONLY

APPLICATION RECEIVED

ONE DEPOSIT RECEIVED

TWO DEPOSITS RECEIVED

FUNDS RECEIVED

MORE ON BACK ▶
· Complete all applicable spaces (numbers 5-9) on the reverse side of this page.
· See detailed instructions. · Sign the form at line 8.

DO NOT WRITE HERE
Page 1 of _____ pages

EXAMINED BY	FORM VA
CHECKED BY	
☐ CORRESPONDENCE Yes	FOR COPYRIGHT OFFICE USE ONLY

DO NOT WRITE ABOVE THIS LINE. IF YOU NEED MORE SPACE, USE A SEPARATE CONTINUATION SHEET.

PREVIOUS REGISTRATION Has registration for this work, or for an earlier version of this work, already been made in the Copyright Office?

☐ **Yes** ☐ **No** If your answer is "Yes," why is another registration being sought? (Check appropriate box.) ▼

a. ☐ This is the first published edition of a work previously registered in unpublished form.

b. ☐ This is the first application submitted by this author as copyright claimant.

c. ☐ This is a changed version of the work, as shown by space 6 on this application.

If your answer is "Yes," give: **Previous Registration Number** ▼　　　　**Year of Registration** ▼

5

DERIVATIVE WORK OR COMPILATION Complete both space 6a and 6b for a derivative work; complete only 6b for a compilation.

a. Preexisting Material Identify any preexisting work or works that this work is based on or incorporates. ▼

b. Material Added to This Work Give a brief, general statement of the material that has been added to this work and in which copyright is claimed. ▼

6

a

b

See instructions before completing this space.

DEPOSIT ACCOUNT If the registration fee is to be charged to a Deposit Account established in the Copyright Office, give name and number of Account.

Name ▼　　　　　　　　　　　　　　　　**Account Number** ▼

CORRESPONDENCE Give name and address to which correspondence about this application should be sent. Name/Address/Apt/City/State/Zip ▼

7

a

b

Area code and daytime telephone number　(　　)　　　　　　　　Fax number　(　　)

Email

CERTIFICATION* I, the undersigned, hereby certify that I am the

check only one ▶ {
☐ author
☐ other copyright claimant
☐ owner of exclusive right(s)
☐ authorized agent of _____
　　　　　　　Name of author or other copyright claimant, or owner of exclusive right(s) ▲

of the work identified in this application and that the statements made by me in this application are correct to the best of my knowledge.

8

Typed or printed name and date ▼ If this application gives a date of publication in space 3, do not sign and submit it before that date.

　　　　　　　　　　　　　　　　　　　　　　　　　　　Date _____

Handwritten signature (X) ▼

X _____

Certificate will be mailed in window envelope to this address:	Name ▼ Number/Street/Apt ▼ City/State/ZIP ▼	**YOU MUST:** • Complete all necessary spaces • Sign your application in space 8 **SEND ALL 3 ELEMENTS IN THE SAME PACKAGE:** **1.** Application form **2.** Nonrefundable filing fee in check or money order payable to *Register of Copyrights* **3.** Deposit material **MAIL TO:** Library of Congress Copyright Office 101 Independence Avenue SE Washington, DC 20559-6000

9

*17 *USC* §506(e): Any person who knowingly makes a false representation of a material fact in the application for copyright registration provided for by section 409, or in any written statement filed in connection with the application, shall be fined not more than $2,500.

Form VA　Rev: 07/2006　Print: 07/2006—30,000　Printed on recycled paper

U.S. Government Printing Office: 2004-320-958/60,126

 # Instructions for Short Form VA

For pictorial, graphic, and sculptural works

USE THIS FORM IF—

1. You are the *only* author and copyright owner of this work, *and*
2. The work was *not* made for hire, *and*
3. The work is completely new (does not contain a substantial amount of material that has been previously published or registered or is in the public domain).

If any of the above does not apply, you must use standard Form VA.

NOTE: *Short Form VA is not appropriate for an anonymous author who does not wish to reveal his or her identity.*

HOW TO COMPLETE SHORT FORM VA

- Type or print in black ink.
- Be clear and legible. (Your certificate of registration will be copied from your form.)
- Give only the information requested.

Note: You may use a continuation sheet (Form __/CON) to list individual titles in a collection. Complete Space A and list the individual titles under Space C on the back page. Space B is not applicable to short forms.

1 Title of This Work

You must give a title. If there is no title, state "UNTITLED." If you are registering an unpublished collection, give the collection title you want to appear in our records (for example: "Jewelry by Josephine, 1995 Volume"). Alternative title: If the work is known by two titles, you also may give the second title. If the work has been published as part of a larger work (including a periodical), give the title of that larger work instead of an alternative title, in addition to the title of the contribution.

2 Name and Address of Author and Owner of the Copyright

Give your name and mailing address. You may include your pseudonym followed by "pseud." Also, give the nation of which you are a citizen or where you have your domicile (i.e., permanent residence). Give daytime phone and fax numbers and email address, if available.

3 Year of Creation

Give the latest year in which you completed the work you are registering at this time. A work is "created" when it is "fixed" in a tangible form. Examples: drawn on paper, molded in clay, stored in a computer.

4 Publication

If the work has been published (i.e., if copies have been distributed to the public), give the complete date of publication (month, day, and year) and the nation where the publication first took place.

5 Type of Authorship in This Work

Check the box or boxes that describe your authorship in the material you are sending. For example, if you are registering illustrations but have not written the story yet, check only the box for "2-dimensional artwork."

6 Signature of Author

Sign the application in black ink and check the appropriate box. The person signing the application should be the author or his/her authorized agent.

7 Person to Contact for Rights/Permissions

This space is optional. You may give the name and address of the person or organization to contact for permission to use the work. You may also provide phone, fax, or email information.

8 Certificate Will Be Mailed

This space must be completed. Your certificate of registration will be mailed in a window envelope to this address. Also, if the Copyright Office needs to contact you, we will write to this address.

9 Deposit Account

Complete this space only if you currently maintain a deposit account in the Copyright Office.

MAIL WITH THE FORM

- The filing fee in the form of a check or money order (*no cash*) payable to *Register of Copyrights*. (Copyright Office fees are subject to change. For current fees, check the Copyright Office website at *www.copyright.gov*, write the Copyright Office, or call (202) 707-3000.) — *and*
- One or two copies of the work or identifying material consisting of photographs or drawings showing the work. See table (right) for requirements for most works. **Note:** Request Circular 40a for information about the requirements for other works. Copies submitted become the property of the U.S. Government.

Mail everything (application form, copy or copies, and fee) *in one package* to:

Library of Congress
Copyright Office
101 Independence Avenue SE
Washington, DC 20559-6000

Questions? Call (202) 707-3000 [TTY: (202) 707-6737] between 8:30 a.m. and 5:00 p.m. eastern time, Monday through Friday except federal holidays. For forms and informational circulars, call (202) 707-9100 24 hours a day, 7 days a week, or download them from the Copyright Office website at *www.copyright.gov*.

If you are registering:	And the work is *unpublished/published* send:
• 2-dimensional artwork in a book, map, poster, or print	a. And the work is *unpublished*, send one complete copy or identifying material b. And the work is *published*, send two copies of the best published edition
• 3-dimensional sculpture, • 2-dimensional artwork applied to a T-shirt	a. And the work is *unpublished*, send identifying material b. And the work is *published*, send identifying material
• a greeting card, pattern, commercial print or label, fabric, wallpaper	a. And the work is *unpublished*, send one complete copy or identifying material b. And the work is *published*, send one copy of the best published edition

Copyright Office fees are subject to change. For current fees, check the Copyright Office website at *www.copyright.gov*, write the Copyright Office, or call (202) 707-3000.

Short Form VA
For a Work of the Visual Arts
UNITED STATES COPYRIGHT OFFICE

REGISTRATION NUMBER

VA VAU

Effective Date of Registration

Application Received

Deposit Received
One | Two

Examined By

Correspondence ❑

Fee Received

TYPE OR PRINT IN BLACK INK. DO NOT WRITE ABOVE THIS LINE.

Title of This Work: Alternative title or title of larger work in which this work was published:	**1**	
Name and Address of Author and Owner of the Copyright: Nationality or domicile: Phone, fax, and email:	**2**	Phone () Fax () Email
Year of Creation:	**3**	
If work has been published, **Date and Nation of Publication:**	**4**	a. Date _____ Month ____ Day ____ Year ____ *(Month, day, and year all required)* b. Nation
Type of Authorship in This Work: Check all that this author created.	**5**	❑ 3-Dimensional sculpture ❑ Photograph ❑ Map ❑ 2-Dimensional artwork ❑ Jewelry design ❑ Text ❑ Technical drawing
Signature: Registration cannot be completed without a signature.	**6**	*I certify that the statements made by me in this application are correct to the best of my knowledge.** Check one: ❑ Author ❑ Authorized agent X _____
OPTIONAL **Name and Address of Person to Contact for Rights and Permissions:** Phone, fax, and email:	**7**	❑ Check here if same as #2 above. Phone () Fax () Email

8 Certificate will be mailed in window envelope to this address:

Name ▼

Number/Street/Apt ▼

City/State/ZIP ▼

Complete this space only if you currently hold a Deposit Account in the Copyright Office.

9 Deposit Account #_____

Name _____

DO NOT WRITE HERE Page 1 of _____ pages

*17 *USC* §506(e): Any person who knowingly makes a false representation of a material fact in the application for copyright registration provided for by section 409, or in any written statement filed in connection with the application, shall be fined not more than $2,500.

Form VA-Short Rev: 07/2006 Print: 07/2006 — 30,000 Printed on recycled paper

U.S. Government Printing Office: 2005-320-958/60,126

QUESTIONS ABOUT COPYRIGHT

WHAT HAPPENS IF I SELL AN ORIGINAL? DO I LOSE THE COPYRIGHT?

When an original work of art is sold, the purchaser is buying the actual picture—what is painted on the canvas or paper. No reproduction rights pass to the purchaser.

Transfer of copyright must be made by the owner of the copyright by means of a legal document transferring it to another person or legal entity.

CAN SOMEONE WHO BUYS AN ORIGINAL WORK OF ART REPRODUCE THE WORK AS A GREETING CARD OR A PRINT?

Many artists think that if someone has paid a few hundred or a few thousand dollars for an original, the buyer has a right to use the work for reproduction. This is absolutely incorrect by US law. To publish, print or manufacture anything that reproduces any artwork, there must be a written agreement from the copyright owner granting the interested party the right to reproduce the picture for an agreed-upon fee.

SHOULD I REGISTER MY COPYRIGHT?

As a rule, yes. It is always better to have your work registered, even though it is not absolutely necessary. By law, you own the copyright as soon as the art is produced. However, by registering, you have legal proof that entitles you to levels of compensation should you win an infringement case. You do not have the same benefit if your work is unregistered.

PLAGIARISM AND INFRINGEMENT

If you come across a version of one your artworks that you think has been plagiarized by another artist, first buy a copy of the suspicious piece and compare it with your own. It must be recognizable by a layperson that the infringing artwork could not have been produced had it not been copied substantially from your own work. If this is the case, you need to consult an intellectual-property lawyer to pursue the matter.

By contacting the manufacturer of the plagiarized product first, however, you can possibly resolve the matter without resorting to expensive legal action. It may be that the licensee/publisher/manufacturer has in fact licensed the artwork believing the work to be an original work of art from that artist. The artist has seen your work, possibly obtained a printed sample, copied it substantially, then licensed the work. If this is the case, by informing the publisher that he is also in breach of your copyright, you can ask him to withdraw the offending products and come to some arrangement regarding compensation.

As there are so many factors, it would impossible here to go into what these financial arrangements should be. One way, however, would be to establish the exact value of goods that have been sold and what profit has been made from those goods. You could then request that this profit be your compensation.

If it's a major infringement involving tens of thousands of dollars, consult a lawyer. If there are large sums involved, your lawyer may work on a contingency basis where she gets a percentage of the damages. If she wins, she'll probably get her fees covered by the other side, so it costs you nothing but your time. If it's a small breach and the goods produced are valued at less than $5,000, try to negotiate a settlement. Hiring a lawyer is expensive, and infringements can be quite complex because they often originate outside the US. Infringements that originate in the Far East (China, Korea, etc.) are almost impossible to resolve. You have to look at the scale of the infringement/pirating and how it is affecting your income. More often than not, it will be the licensee who wants to pursue the infringement because it may be his products that are being infringed. In this case, you can become a party to the legal action. Compensation can vary from nothing to 5% of the net proceeds after expenses and legal fees. This can be written into license agreements with each licensee.

Copyright laws are different in other countries. A copyright in the US does not apply internationally. You need another copyright for it to be applicable in China, for instance. Infringements are not worth pursuing if the breach is in China or a similar country. In Europe or the US, it may be worth pursuing an infringement if the infringer is a bona fide corporation and has enough assets to pay the settlement, should you be awarded one.

ISSUING A LICENSE/ INVOICE

Each specific use of an artist's copyright should be transferred separately. The agreement should clearly state that "all rights not specifically transferred remain the property of the licensor."

A license is a document generally issued by the licensor, often in the form of an invoice. It grants a specific right to reproduce a specific artwork for a specific product, for a specific territory, for a specific period of time, for an agreed-upon fee.

Licensees/publishers/manufacturers often issue contracts that are much more detailed than the license/invoice. You can have both a contract and a license/invoice for the same project.

▸ When granting permission for one or two designs or a small group of designs, a license/invoice is usually sufficient.

▸ For a more complicated transaction, where exclusivity and guarantees are required or where there are groups of products and a substantial sum of money involved, a contract is usually necessary.

It is impossible to give you a template here for an all-encompassing agreement. These contracts can be 10-12 pages long and need to be drawn up individually by a lawyer. When you get to that stage, you should really be working with an agent!

LICENSE/INVOICE DETAILS

Reference. Numbers, descriptions or titles of each artwork

Product category. It is important to use very specific terms here. Don't use broad generic terms such as clothing or apparel. Use T-shirt or sweatshirt—these are two separate products. If you say "clothing," you are in danger of a licensee assuming he has rights you don't intend to give him. Use "plastic mugs" or "tin" or "porcelain" so you are free to license these as separate product categories.

Territory. USA only, USA and Canada only, worldwide, etc.

Term. Three years is typical.

Advance. This is the advance payment you have agreed upon to offset royalties earned on product sales.

Royalty. This is the percentage of the product sales you have agreed to accept in return for usage of your art.

The following pages are examples of a license/invoice, front and back. The front side gives details of the artwork licensed, details of the product, territory and term of license. Terms and conditions are printed on the back side, thereby creating a simple contract. The terms state that the license comes into effect as soon as payment is made. If the licensee disagrees with anything, he must tell you before he pays the invoice. This simple format works well for individual artists licensing small numbers of designs for greeting cards, jigsaw puzzles or paper products.

SAMPLE LICENSE/INVOICE

Your Company Name

Address

Telephone

Authorized Buyer

Licensee _____

Address_____

Telephone _____

Web site _____

E-mail _____

Date_____

License/Invoice No_____

I hereby grant the following reproduction rights in accordance with the terms and conditions on the reverse:

Palm Tree Sunset

Yosemite Sunset

Falling Leaves I

Falling Leaves II

Rights granted:

▸ Limited-edition jigsaw puzzles; edition of 950

▸ Three years' world exclusive rights

Royalty payments:

▸ $500 advance for each of four images against a royalty of 8% $2000.00

▸ Royalties to be paid quarterly 30 days from end of each quarter

 TOTAL $2000.00

Payment terms: 30 days from date of invoice

TERMS AND CONDITIONS

These Terms and Conditions constitute an "Agreement" between the "Artist" and the "Client" as to the terms upon which pictures are supplied and what reproduction rights are granted. In this Agreement, "picture" shall mean original art, transparency, drawing, digital scan of picture or any other item that may be offered for the purposes of reproduction.

1. Pictures submitted to the Client by the Artist are on approval only and must be returned within 6 weeks of submission except in those cases where permission is granted by the Artist to reproduce the pictures and a license/invoice is issued. In respect of pictures submitted where a license is granted, pictures should be returned within 6 months of delivery unless otherwise agreed.

2. Return of Pictures. The Client agrees to return all pictures that are not subject to any license that is granted within the agreed time and shall ensure that all necessary protection is given to pictures in transit and a delivery note listing all pictures returned is enclosed with the package.

3. The Client agrees to compensate the Artist for any loss or damage to pictures while in the Client's possession or while under the Client's control, or in the possession of printers. Such compensation shall not be less than any fee for reproduction rights and no more than the cost of recommissioning the original piece of artwork.

4. No use of the pictures may be made for any purpose whatsoever without written consent of the Artist.

a) Reproduction rights (if granted) are restricted to the use, territory and time period specified on the license/invoice.

b) Reproduction rights are personal to the Client and may not be assigned to third parties unless agreed to in writing by the Artist.

c) Any rights granted are by way of license, and no partial or other assignment of copyright shall be implied.

d) Rights granted to reproduce the picture in or on a product do not include the right to use that picture directly or indirectly in any manner in the advertising of the product unless such right is specifically granted.

5. No right will be considered granted for any picture unless the Client has paid in full the license fee. Once a license has been granted by the Artist, cancellation of such license may only be accepted if such cancellation is requested within one month of the date of issue of the license.

6. Royalties. The Client agrees to pay the Artist any royalties due under any license granted and render statements 30 days after the end of each quarter, i.e., 30 days after the last day of March, June, September and December. In the case of monthly statements, 30 days after the end of each month. Any advance paid against royalties paid to the Artist is nonreturnable, but recoupable out of royalties earned.

7. The Client agrees to supply the Artist with a minimum of two (2) copies of any product or reproduction of the picture free of charge within two (2) weeks of publication or manufacture.

8. The Artist warrants that s/he has the right to enter into this agreement and warrants that the Artwork is the Artist's original creation and has not been wholly or substantially copied from any other work or material and that the exercise of the rights by the Client will not infringe the rights of any third party.

9. No variation of these terms or conditions shall be effective unless agreed to in writing by both parties.

10. This Agreement shall automatically terminate if the Client should become insolvent, enter into liquidation or become bankrupt or should have a Receiver appointed in respect of all or any of its assets.

11. The Client agrees to put a copyright line as specified below on any product or reproduction of the picture(s) licensed by the Artist:
© _____date, Artist's name _____

12. No alterations or adaptations of a picture may be made without the express written permission of the Artist.

13. This Agreement shall be governed according to Law, and the parties agree to accept the exclusive jurisdiction of the State of ___.

CONTRACTS

Legal implications must be considered for any type of license in order to avoid problems that may arise should the license not be sufficiently comprehensive. Sometimes the licensee/publisher/manufacturer will issue a contract—a more detailed written agreement—to be signed by the licensee and the copyright owner.

Merchandise licensing can be full of pitfalls for the newcomer, which is why very few artists tackle it long-term on their own. (See "Finding a licensing agent" on page 112, Chapter 6, as well as the list of agents in Chapter 10.) A simple license agreement isn't really suitable for major merchandise licenses as it does not cover indemnities, product liability, sell-off periods, approval procedures, access to accounts for auditing and other such matters.

It is very difficult to advise on contractual issues in any depth, as there are many aspects to consider. In some cases, the publisher's contract or agreement may be quite straightforward. However, too frequently, publishers insert a few "interesting" clauses that, if signed by you, can give them more rights than you intend. Each artist may have special needs. Expert legal advice is essential.

I have included a simple licensing contract that you can use for many licensing deals in the absence of an agreement from the client or where you feel the client's contract is too biased or complicated. This could be a basic template, which you can modify to suit your own particular purposes with the help of an intellectual-property lawyer. This will give you additional rights in terms of access to records in the case of a dispute or when an audit is needed. It is rare, however, for anyone to request an audit for single designs or licenses that generate less than $5,000. Drawing up a contract with a lawyer could be quite expensive, so a simple license/invoice is often more appropriate.

LICENSING AGREEMENTS

The following template for a licensing agreement is intended for simple, straightforward licensing deals for greeting cards, prints and posters, jigsaw puzzles, stitch kits, stationery for single design sales or small groups of images. Licenses that involve more complex issues with figurines, three-dimensional products, art/artist brands, plush toys, characters, etc., need more in-depth agreements that involve indemnities and insurance. You should hire an experienced intellectual-property attorney to deal with this to ensure that you have adequate protection with respect to trademark issues and liabilities, especially with toys. If a child swallows a teddy bear's eye, for example, the licensee should have product liability insurance that covers such issues (usually up to $10 million).

LICENSING AGREEMENT

An agreement must be signed by both parties.

LICENSING AGREEMENT

This is an agreement between _____ (The Licensor) of (address)_____

and _____ (The Licensee) of _____

_____made and entered into as of _____ 2008.

GRANT OF LICENSE

The Licensor hereby grants to the Licensee an ❏ exclusive ❏ non-exclusive license to manufacture, sell and promote certain articles ("The Licensed Products") as defined below in respect of the artwork listed in accordance with the terms of this agreement:

Ref nos: _____

Licensed Products: _____

Territory: _____

Term: _____

Advance: _____

Royalties: _____

Credit line to appear on all products and literature: ©2008 (artist's name) Licensed by _____

WARRANTIES

The Licensor hereby represents and warrants that he has the power and authority to grant to the Licensee the right to reproduce the artwork listed above, to manufacture and sell those types of The Licensed Products as indicated in the territory and for the term as defined above.

The Licensee will make his best efforts to ensure that The Licensed Products manufactured are of a good quality consistent with industry standards and that, where possible, the Licensor is sent samples for approval.

SAMPLES

A minimum of (___) samples will be sent to Licensor of the production run for each product free of charge.

PAYMENTS

The Licensee agrees to pay the Licensor any advances due noted above, which are non-refundable, within thirty days of the signing of this agreement and any royalties that accrue in respect of the sale of The Licensed Products and agrees to submit a royalty report and any monies due within 30 days from the end of each calendar quarter. Checks should be payable to (_____). Licensee also agrees to furnish Licensor with an itemized statement showing all sales (quantities sold for each artwork). Any deductions for returns, volume discount allowances, etc., should be clearly shown.

The receipt or acceptance by Licensor of any royalty statement, or the receipt or acceptance of any royalty payment made, shall not prevent Licensor from subsequently challenging the validity or accuracy of such statement or payment.

ROYALTY AUDIT

The Licensee agrees to keep accurate books and records relating to the sale of all The Licensed Products under this agreement. Licensor shall have the right, upon at least five (5) days' written notice and no more than once per calendar year, to inspect Licensee's books and records and all other documents and material in the possession of or under the control of Licensee with

respect to the subject matter of this Agreement at the place or places where such records are normally retained by Licensee. Licensor shall have free and full access thereto for such purposes and shall be permitted to make copies thereof and extracts therefrom.

In the event that such inspection reveals a discrepancy in the amount of Royalty owed to Licensor from what was actually paid, Licensee shall pay such discrepancy plus interest, calculated at the rate of one and one half percent (1.5%) per month. In the event that such discrepancy is in excess of one thousand dollars ($1,000.00), Licensee shall also reimburse Licensor for the cost of such inspection to include lawyers' and accountants' fees incurred in connection therewith.

All books and records relative to Licensee's obligations hereunder shall be maintained and kept accessible and available to Licensor for inspection for at least three (3) years after termination of this Agreement and in respect of such post-termination audit.

RENEWAL

Ninety days before the expiration of the License hereby granted, the Licensee may request an extension of the license for a further period by mutual agreement.

SELL-OFF PERIOD

The Licensor also grants to the Licensee a Sell-off period of 180 days upon expiration of this agreement. Any extension of this sell-off period must be agreed to in writing with the Licensor.

RIGHT OF TERMINATION

The Licensor reserves the right to terminate the license in the event:

a) The Licensee breaches the terms of the license and does not remedy such breach within 30 days of written notice from Licensor (nonpayment or late payment of royalties being a non-remediable breach)

b) The Licensee fails to manufacture and make available for sale The Licensed Products within 6 months of the date of this agreement.

c) The Licensee ceases to manufacture The Licensed Products.

d) The Licensee ceases or threatens to cease to carry on the business.

e) The Licensee files a petition in bankruptcy or is adjudicated bankrupt or insolvent.

MISCELLANEOUS PROVISIONS

1) Nothing contained herein shall constitute this arrangement to be employment, a joint venture or a partnership.

2) The rights granted are personal to the Licensee and cannot be transferred or assigned without the written consent of the Licensor.

3) No waiver by either party of any default shall be deemed as a waiver of prior or subsequent default of the same or other provisions of this agreement.

4) This agreement shall be construed in accordance with the Laws of the State of _____.

5) This agreement constitutes the entire agreement between the parties and shall not be modified or amended except in writing signed by both parties.

SIGNED BY _____ LICENSOR DATE_____

SIGNED BY _____ LICENSEE DATE_____

DELIVERY NOTE

Below is a basic template for a delivery note to use when sending transparencies or original art to a licensee. Print the terms and conditions from page 70 on the reverse of the delivery note form. Doing this allows you to charge the licensee should she lose or damage your work. It also lays out the terms under which you are sending him the work. List all the reference numbers of work submitted, just as you would in the license/invoice. If you are sending a CD that is not costly to reproduce should it be lost, then a simple letter will suffice.

DELIVERY NOTE

Licensee _____ Artist/licensor_____

Contact name_____ Address_____

Address_____ City/State/Zip _____

City/State/Zip _____ Telephone _____

Telephone _____ E-mail _____

E-mail _____ www. _____

www. _____

Date_____

The items listed below are submitted to you under the terms and conditions listed on reverse.

REF #	DESCRIPTION OF PIECE/TITLE	TRANNY/ORIGINAL	ITEM SENT

Loss/Damage Fees:
Transparencies:_____

Originals: _____

Please return the transparencies or originals within six weeks of delivery-note date if you do not wish to use them.

THE ART OF THE DEAL

Understanding how you arrive at a royalty fee that is fair for you and the licensee/publisher/manufacturer is an important aspect of licensing. You will need some sales information in order to calculate your intended compensation.

CONTRACTS

All the categories noted below are necessary to understand in order to allow you to issue a license for the use of your work. While most publishers have a standard way of figuring this out, it is important that you get this information to enable you to understand the financial aspects of the deal and your potential earnings.

Usage - what product will be manufactured

Selling price of product - the trade or wholesale price for which the item is sold

Print run - initial quantity that will be printed

Territory - where this product will be distributed

Term - how long this product will be marketed

Royalty rate - may be negotiable or fixed by the client

USAGE

This is the product category in which the publisher desires to use your artwork: limited-edition print, calendar, note pad, greeting card, etc. It is important to be very specific with respect to the product so the publisher cannot publish other products without your permission.

SELLING PRICE OF PRODUCT

The selling price of a product is the actual wholesale dollar amount—the wholesale price the publisher receives for selling a product. There could be a published price in the publisher's catalog, say $75 for a particular limited edition, but with discounts the average price could be much less. Posters can be listed at $35 retail with a 50% discount for trade, which brings the price down to $17.50. For large retailers, a discount of 50% less another 50% and perhaps another 40% for a large order can bring the actual net selling price down to as little as $2.00!

If you sell only one or two designs to a card publisher, it may be better for you and the publisher to agree on a flat fee. To administer royalties on just one or two designs may not be cost-effective. From your point of view, it's much better to have your entire fee up front than to receive a check for $5.75 per quarter over a three-year period!

Any flat fee should be based on average sales over the term of the license. For example: Average sale is 12,000 cards over three years at 75¢, or $9,000. At a royalty rate of 5%, the flat fee would be $450; at 6% it would be $540.

As the publisher is paying up front and there is no guarantee that he will sell 12,000, he'll try to settle for an even lower percentage, say 4% or $360. You should negotiate for $400, which is half-way between and fair for both.

Use this flat fee example for any product. Remember, though, that royalty rates vary from product to product, as well as from publisher to publisher. Average sales figures will also vary depending on the size of the publisher. Publishers with big distribution may pay as much as $800 while others will pay as little as $100.

PRINT RUN

This is the number of items that will be published or manufactured initially. If royalties are being paid, then the initial number of items manufactured gives you some idea of what the client intends to sell as a minimum. This figure multiplied by the selling price gives you the initial potential sales of the product. If you then multiply this total by the royalty rate, you will have some idea of what you may be able to charge as an advance, providing the publisher/manufacturer is prepared to pay one.

TERRITORY

The geographic territory covered by your contract is an important factor. In the case of limited-edition prints, the territory would normally be worldwide in order to allow the publisher to sell to any gallery that wished to purchase the print.

Let's use an example of a poster with an unlimited print run. If the publisher's distribution chain is the US and Canada only, the contract should be exclusive to that area, and your license should say exactly that. This allows you to sell this particular artwork as a poster in the UK, Australia or wherever you can find a publisher to license it.

It should be apparent that by limiting territories, it is possible to generate several income streams on one design, not only for different products but for the same product in different territories. This is a crucial point and must not be overlooked. Many publishers try to obtain world rights even if they don't distribute worldwide! You earn far more by licensing the design to a licensee/publisher/manufacturer in each territory.

In the print and poster industry, many companies do, in fact, sell worldwide. It is important to ask them. Don't give away territories unless there are potential sales for the licensee in those territories.

TERM

The term is the length of time you allow the publisher to use the artwork. It is always important to specify this in the contract. Three years is normal. If the licensee/publisher/manufacturer wants more time, she can have an option to renew

for an additional three years or annually after the initial term ends. This way, if you are earning a satisfactory income, you will be pleased to renew her license. If the design is not selling, then the publisher would decline a renewal, leaving the design free and clear. If there is no term set, you have effectively given the publisher indefinite use, which must always be avoided.

Currently, some manufacturers require only 12 months and will then renew if the product remains in their line. Quite often, however, due to retailer pressure demanding new designs each season, designs that are selling well are deleted to make room for "new lines." This has the effect of depressing potential revenue for the artist.

ROYALTY RATE

These vary considerably from product to product. Many companies these days have a fixed royalty rate. However, some have a little flexibility depending on the strength of the designs and how strongly the art director believes in the concept, whether you are a better-known artist or if it has been a highly successful concept for them in the past. (Refer to page 20 for royalty rates.)

ASK POTENTIAL LICENSEES

→ Will they want to buy the original artwork? Try to keep it if possible. The value will increase as the reproduction becomes successful.

→ Will they provide insurance while the artwork is in transit? Pay for shipping?

→ What kind of promotion do they provide? Catalogs? Mailings?

→ How large will the edition be?

→ Number of artist's proofs? How will they be signed and numbered? Does the publisher require any artist's proofs for sale?

→ Number of printer's proofs for use as documentation and for promotion and exhibition purposes? Usually these are not marketed. These proofs can be stamped on the reverse side in large letters to identify them as printer's proofs. Provide for one printer's proof to become the property of the printer pulling the edition. All plates should be preserved in their cancelled states for art historical purposes. The contract should specify whether such plates are to be the property of the artist or the publisher.

→ All trial proofs that are not destroyed should be the property of the artist and be delivered to the artist on or before the date of publication of the edition.

→ Specify return of transparencies to the artist after printing.

→ Provide for delivery to the artist of a cancellation proof showing that the plate has been destroyed or otherwise rendered unusable for further printing.

One absolute rule: Don't sign a contract you don't understand.

LIMITED-EDITION EXAMPLE

If a publisher produces 950 copies of a limited-edition litho using your art, and the print sells for $75 wholesale, the retail price would generally be $150.

If the edition sells out, the publisher would receive 950 x $75. He may, however, give a 10% discount if galleries buy a quantity. If he sells a small quantity to a distributor in Japan or Australia, he will have to sell these at 50% of wholesale ($37.50) to allow the distributor to sell them to a gallery in his own country at the wholesale price to make his profit.

Let's assume the publisher receives 950 x $50 (average sale price) or a total of $47,500. At a royalty rate of 10%, you would receive $4750. With a 15% royalty, your revenue would be $7125. If four editions are produced each year, that would be $28,500—a nice income for four prints.

Don't forget: This is potential revenue. Editions have to sell out for you to receive the full payment.

GREETING-CARD EXAMPLE

The publisher initially prints 5000 cards. The publisher sells each one at 75¢. His potential sales are, therefore, 5000 x 75¢ or $3750. The publisher can initially afford to pay you around $225—6% of $3750. Since greeting-card royalty rates vary from 4-8%, 6% is a good royalty rate.

The publisher may, in fact, sell 10,000 cards in a three-year period. Every publisher will have his own fee system based on his average sales per design. If you sell a group of designs, then a royalty-based fee is by far the best way to maximize your earnings, even if the advance is low. A $200-300 advance is quite normal against 5%.

Greeting-card publishers will require exclusive rights for cards in a territory. Try to stick to the US and Canada only, as many publishers sell very little abroad. The rights could then be sold in the UK and other countries if the work is suitable, giving you additional income. Large corporations, however, may insist on world card rights, as their overseas sales can be substantial.

THE TRUTH OF THE MATTER

One company said that its policy was to buy world porcelain mug rights for a flat fee of $250. A company rep then showed me a design he'd purchased and proudly told me that he'd sold over one million mugs of this particular design. If the mug only sold for $1 wholesale at 5% royalty, that would have given the artist $50,000. No wonder the company didn't want to pay a royalty. And no wonder I wouldn't sell him any designs for a $250 flat fee!

GUARANTEES AND ADVANCES

As a rule, you want to negotiate an advance against royalties. This way, if sales are high, you benefit. If sales are low, the publisher isn't paying out large sums of unearned money.

When you have a range of designs to sell—which means you have put in a great deal of work to create the concept—it is quite normal to ask for a minimum guarantee each year, particularly if these designs are to be used on several products.

ADVANCE AGAINST ROYALTIES

An advance against royalties is the initial fee received against a percentage of royalty payments that will be due as products sell. It should be indicated in the written agreement that advances are *nonrefundable*, protecting you if the product is not marketed well.

Be aware that a product takes time to manufacture. It then needs to be marketed and sold at trade shows. This could take six to 12 months from the date of the license.

EXCLUSIVITY

Let's say a manufacturer wants to produce greeting cards, note lets, magnets, ring binders, journals and one or two other gift items. He needs 24 designs initially, which will be used on greeting cards. Some of these will also be used on other products. Some individual designs may be needed for products with unusual shapes or in landscape format (wider than tall). Since he is producing a major range, he wants to protect his market—he therefore wants exclusivity. He may insist that he is the exclusive licensee in these product categories. This could be good if the product line sells very well, but if it's a flop, how do you protect yourself?

First you need to determine the potential earnings for the entire project. Be quite open about this when discussing the matter with the publisher. If he offers you $10,000 advance against 6%, but wants three years' rights and total exclusivity for your work in these product areas, it may sound like a good deal. If that's all you end up with because the product doesn't sell well, then you've effectively tied yourself to an agreement for three years in several major product categories that only brings in $3333 per year.

There are several ways to negotiate this kind of deal:

▸ If the publisher is confident that she'll meet certain sales targets (let's say $250,000 minimum per year in sales), then at 6% this would give you $15,000 per year in royalties. Suggest this as the minimum guarantee for each of the three years, with an advance of $10,000 at the outset and the balance at the commencement of each year, which includes royalties due above the initial advance. In effect, this guarantees you at least $10,000 a year even if the publisher doesn't meet her target for each year.

Royalties are always based on the net amount the publisher receives, not the retail price the consumer pays.

- ▶ If the publisher will **not** commit to a guarantee, the next best thing is simply to grant exclusivity on those designs he chooses, as opposed to exclusivity on you as an artist in those product areas. This may not be acceptable to him, particularly if the style is easily recognizable. His argument will be that if he spends a great deal on manufacturing product and then another publisher offers you a deal to produce a new range, there could be two similar ranges competing in the marketplace. One way around this predicament is to grant exclusivity on that particular style so as not to cause any conflict. This would leave you free to produce work in different styles and subject matter and license it to other manufacturers.

Ultimately, you need a deal that suits both parties and doesn't tie you into exclusivity (unless the publisher is prepared to give you a minimum guarantee). If you find yourself in the situation described above, it usually means the publisher really likes your work, so don't be bullied into what may sound like a great license only to find that you are locked into a deal that isn't producing income and denies you the right to sell to other companies. This happens far more often than one would think.

QUESTIONS TO ASK

→ What will be the actual selling price of the product?

→ What discounts are given?

→ What is the licensee's return policy?

→ When is the licensee credited for the sale and when is he paid?

→ If the retailer does not pay, is that percentage deducted from the artist's royalties?

To verify that your royalties are being paid properly, within your agreement should be a clause that states that you can examine the licensee's books. Insist on being paid late fees and interest if payments are delayed. (See pages 72-73.)

SUMMING UP

From the information you have gathered, you can assess whether the fee suggested by the publisher is fair. If you are offered $200 for a greeting-card design with an average sale of 12,000 at 75¢ ($9000), then you know that you are being offered only a little over 2%. An educated artist (you!) will know that often is too low.

Negotiating is not an easy job, but using the system laid out here will give you enough information to know why you are negotiating and help you negotiate with confidence. It shows the publisher that you are not someone who can be bamboozled into accepting a lower fee than you deserve. Use common sense. You know what you want—go for it!

Once you get into even more complicated licensing deals and contracts, you might seek the services of a good licensing agent. Remember:

License the exclusive rights only on artwork the publisher wants to use.

→ Get all the information as outlined above (usage, territory, etc.) to determine your fees.

→ Find out if the publisher has a set fee structure, i.e., "She won't budge."

→ Sub-license rights are sometimes included, which in effect give the publisher rights to license your designs himself. Unless you want him to do this, the sub-license rights should be deleted from any agreement.

→ Contracts should always be reviewed by a lawyer who is educated in intellectual-property law. At rates of $150-350 per hour for a good attorney, this is not really cost-effective or practical for a small contract. However, if you are unhappy with an aspect of the contract, it is always safer in the long run to get legal advice rather than commit to something you don't fully understand or agree with.

→ Be careful before signing contracts. Read them thoroughly. Mark any areas you do not understand and get advice or discuss it with the publisher. You must understand fully what you are signing. Feel free to make any amendments that are needed.

→ Do not be afraid to stick to your guns if there is something in the agreement you do not like. In many cases, publishers have an all-encompassing standard contract. If the contract includes rights you don't wish to give to the publisher, then delete these items and initial the deletions.

→ Promotional approvals: Written approval must be given before a licensee can use your image or artwork in any special advertisements featuring your work. It's a good idea to let them do this, but you want to have some say in how it is executed. Obviously, your work can appear in product catalogs automatically.

→ Artist's credit: To guarantee that you receive credit on product as well as in advertising, this point must be specifically included in the agreement.

→ Guarantee: provides the artist with a certain level of revenue in royalties no matter what the amount of sales. Guarantees are often linked to option clauses: The license agreement is for a certain number of years, and if the artist has earned a certain amount of money through royalties, the licensee has the right automatically to extend the term of the license. If not, then renewal is at the discretion of the artist. These options are sometimes called "performance criteria."

→ Quality approval: This is the right to approve a final sample. This is essential in the case of limited-edition prints and products where the manufacturer has to interpret the design in 3-D or print on unusual surfaces. However, on certain

licenses for products such as greeting cards, it is not always practical to have approval procedures for each design. Use common sense. Many publishers produce several new lines each year, so deadlines are crucial. It would be impractical to send out "proofs" for approval on complete new product lines. Big names may demand approval, but most artists have to trust the judgment of the publisher.

→ When your contract ends, it is customary to grant your licensee/publisher/manufacturer a "sell-off" period of three to six months in order to sell stock on hand. After this period he should, however, be made to destroy any stocks he has left, or offer it to you at cost, or renew the license. He may want to negotiate a longer sell-off time in certain instances.

Read your royalty statement carefully. Check for errors—they are made quite often. Make sure you receive a royalty statement every quarter, within 30 days of the end of each quarter. If it doesn't arrive, inquire as to why.

Make your terms (when you require payment on the license/invoice) 30 days from the date of the license/invoice. If you haven't received payment after 30 days, call the accounts-payable department.

ROYALTY STATEMENT

ARTIST ROYALTY STATEMENT

XYZ INC

FIRST QUARTER

1/1/XX - 3/30/XX

000654 ARTIST NAME _____ CONTRACT # XXXC

ADDRESS _____

SERIES	TITLE	DESCRIPTION	TOTAL SALES
STM	567	WHITE CAMELIAS	$3879.02
		ROYALTY AT 10%	387.90
		LESS ADVANCE	250.00
		ROYALTY DUE	$ 137.90
AST	133	SEPIA ROSE	$2899.03
		ROYALTY AT 10%	289.90
		LESS ADVANCE	250.00
		ROYALTY DUE	$ 39.90
		TOTAL ENCLOSED	$177.80

BAD DEBTS

Freelance artists should be paid promptly. If you are having to wait long periods for money due, talk to the art director or your contact at the company and try to explain that if you do work for them, you need to be paid according to the terms that have been agreed upon. If you have to accept 60 days, then it should not be longer. Thirty days should be the norm, however.

If an account goes beyond 90-120 days past due, you should give a final warning.

- ▸ A seven-day written warning

- ▸ A phone call to the accounts payable department

- ▸ If no result, then proceed to put your claim through the Small Claims Court. This avoids lawyer's costs and is a fairly simple process. You fill out a form, attach a copy of the invoice, pay a fee to the court, and they issue a demand for payment. The court will advise you on what to do next if you still do not receive payment.

- ▸ You could consider a collection agency. They will normally take a percentage of the amount collected. This is an alternative to the Small Claims Court and can be quite effective.

Hopefully you will rarely need to do this! You may lose the customer, but who needs licensees who don't pay?

If you are in the unfortunate position of experiencing delays in payments, send a copy of your original license/invoice along with a note similar to the one below.

PAST-DUE NOTICE

My records indicate that my License/Invoice No_____ dated _____ for $300.00 has not been paid. My terms are 30 days from the date of the invoice, and I respectfully request that you send payment by return mail.

TRADEMARKS

Should you invent a name for a concept, cartoon or any other project, it is possible to protect this name by registering it as a trademark. A trademark is essentially a non-generic word or words such as Rug Rats, Teletubbies, etc., which you wish to protect by formal registration through the United States Patent and Trademark Office.

Trademarking is essential if you have a successful merchandise program you want to protect against infringers and pirates. Piracy still exists, and it is impossible to protect your trademarks against such infringements without proper registration.

Most artists find trademark registration a very daunting prospect. Advice is always needed in these matters. It is possible that major clients with whom you are working will share or even pay these trademarking costs. They might wait until the project is assigned to them, however. (Remember: If the items are registered in their name, you no longer own them. Don't let them do this!)

There are search facilities (see below) available through which you can see if your trademark has been registered. You can also search for similar registered trademarks that could conflict with yours. This can be done by yourself or through a patent and trademarks lawyer.

Registration can be quite expensive, as it normally involves various registrations for different product categories. If you want to register the trademark for different countries, there is a fee for each country. Costs depend on the number and nature of countries designated. A typical fee for the UK, for instance, is $650-750; for US $325 for electronic, $375 for paper-mailed application.

United States Patent and Trademark Office
Crystal Plaza 3, Room 202, Washington, DC 20231
(800) 786 9199 (703) 308 4357
Provides information and forms on how to register a trademark

HELPFUL WEB SITES

www.mrtrademark.com
Great research site for questions on trademark

www.uspto.gov
Look under trademark search.

www.patentgov.uk/tm/index.htm
UK information

A trademark attorney is suggested for all UK applications.

ACTION PLAN

❑ Prepare Form VA to register your artwork with the copyright office.

❑ Create a license/invoice form.

❑ Create a delivery note form.

❑ Locate a lawyer knowledgeable in intellectual property

RECOMMENDED READING

Licensing Art & Design by Caryn R Leland will help you figure out what your contract should contain. It's available through your local bookstore or library or directly from the publisher, Allworth Press, at (212) 777 8395.

Chapter 4
Business Practices

Identifying your artwork

Copyright control cards

Keeping clear records

Photographing your artwork

Truth exists; only lies are invented.
Georges Braque

IDENTIFYING YOUR ARTWORK

To stand any chance of success in the industry, you must go about establishing specific business practices to ensure that you don't run into complex problems once your activity starts booming.

COPYRIGHT CONTROL

You must always insist that any goods reproduced using your artwork are marked with a copyright symbol (©), the date, and your name.

<p style="text-align:center">© 2007 John Doe</p>

▸ Make sure this information—© 2007 John Doe—is given to any publisher or manufacturer and is on every item of work, transparency, etc.

▸ Make sure to demand this in your agreement.

CATALOGING ARTWORK

▸ Whether it be the sale of originals via galleries or licensing reproduction rights to fine-art publishers, greeting card publishers, calendar manufacturers, etc., you must establish specific business practices to ensure that you have a simple, easy-to-run system of cataloging your work. A simple way to keep track of each artwork that you produce is using index cards, available in a multitude of colors, to help you color-code your work.

▸ Give each artwork a code, such as JD (for John Doe, i.e., your own initials) plus a number. Start with 01 and work numerically from this point, i.e., JD/01, JD/02, etc.

▸ You will need the title and a general description of the image on the index card as well. Remember that after 11 years, you may not recall every picture. If a picture is returned without its number or caption, you will want to be able to identify it easily and accurately.

▸ Record every artwork you produce. Stick a label on the back of the piece with the reference number, or if on art board or paper, write it on the back. Include the date of completion.

If you are sending transparencies to a licensee or agent, place a copyright symbol with your name on the tranny cover, e.g., © John Doe 2007, the title, reference number (which coincides with the original reference number), address and telephone number. You can also add the words "all rights reserved" if you like.

Purchase a copy of *Art Office* at www.artmarketing.com. It contains business forms and legal documents to help you get and stay organized.

Every time you issue a licence/invoice, *you must*, prior to issuing it, pull out your index card for the piece of work you are licensing. Fill out all the details of the license/invoice as follows:

▸ Date of invoice

▸ Invoice number

▸ Rights granted

▸ Term

▸ Territory

▸ Publisher

▸ Fee charged

▸ Royalty rate

▸ Date license ends

COPYRIGHT CONTROL CARDS

COPYRIGHT CONTROL CARD

Title: Still Life Roses Date of copyright registration 3/4/00 Job #: JD/01

Description: Blue vase with four roses against a pink background on white tablecloth with apple on left and rose petal on right

Medium: Oil on canvas Size: 12x15" Completed: October 1, 2005

Original work sold on _/__/__ to:_____, address _____
_____ tele_____e-mail_____

Usage rights:

Invoice # XXX-123002	Date 12/30/05	World excl. rights
Limited-edition print (350)	No advance	Against royalty of 10%
Martin Publishing		
Invoice # XXX-010802	Date 1/8/05	U.S. rights excl. 3 years
Jigsaw	Advance of $500	Against royalty of 8%
Puzzling Publishers		Expires 1/8/08

KEEPING CLEAR RECORDS

Paper tracking becomes a very important aspect of your business as you receive more and more licensing contracts. It is imperative that you operate a job card system to keep track of all your submissions and contracts.

When you send out transparencies, slides, CDs or scans, send a delivery note (see page 74) with the items listed. This delivery note can act as a job card, which records who has what and when it was delivered. Keep a photocopy of each delivery note in a file separated by month. This way, you can go back the next month and contact licensees/publishers/agents who have not responded to your submission, as well as keep records of their responses.

Transparencies, slides and originals cost money. Not only that, but it takes time to get these prepared. If publishers lose one, they need to be charged an appropriate fee. The delivery note has a space at the bottom so you can fill in the replacement cost before you send work.

Over time, you may, in fact, invoice the same original artwork for different uses by several licensees (as in the sample copyright control card on the previous page). These records are your complete history of the reproduction rights given for each artwork. Can you imagine if things got confused? What a mess! These records also help prevent you from invoicing a reproduction twice and let you know whether the design is available for a particular usage. A publisher may also ask if the design has been used before. Without proper records, this would be very hard to remember. Record keeping, as you can see, is extremely important. Never put it off. Always fill in the copyright control card prior to typing up your invoice—this way you won't make a mistake.

TIP

Filemaker Pro is a great software solution that you can use to create a computerized system. This program can also be used to build a valuable database, which can then be utilized as a search engine to find images. The system can become a valuable asset as your inventory builds because it allows you to find images and records almost instantly on the computer instead of manually.

REISSUING INVOICES

Despite the fact that a design has become free for use after three years (after being used as a jigsaw with Company X), if Company Y wants to use the same design for a puzzle, even though the design is technically available, you must inform Company Y of the previous usage.

▸ Firstly, the design has just been on the market as a jigsaw puzzle. Company Y, the new manufacturer, may have a similar customer base to Company X, in which case Company Y most certainly wouldn't want the design.

▸ Secondly, Company Y may simply not want a design his competitor has used. If he's happy knowing the design has been used previously by a competitor, then there is not a problem. Company Y must have the choice. Some companies are fierce competitors. Ignore this advice at your own peril; this is simply good business practice and proves that you are a professional artist. Licensees will respect you for informing them.

TIPS

→ Don't forget to pull out the copyright control card and cancel the entry if a job is cancelled. This is easy to overlook. A few months or years later, you could end up thinking you've licensed a piece, when in fact you haven't.

→ When you have invoiced a few hundred artworks and have been running your system for awhile, you will also see an additional value to this index card system as artworks become available again. As contracts expire, you can reissue new licenses for the same artwork. It will be easy to recognize when this is about to occur as you review your copyright control card.

WIN-WIN SITUATION

Take your partnerships with licensees and publishers further than the next artist. Build a relationship that is mutually beneficial to both parties.

▸ Stay in contact with your agent if you have one.

▸ Ask what is happening in the marketplace; you already know a bit but are always wanting to know more.

▸ Ask about the latest trends and color palettes.

▸ Find out what they would like to see from you: size, colors, etc.

▸ Get your projects to them early—what a relief that would be to them! You shouldn't be surprised that they then bring you into their business plans more and more.

▸ Tap into their industry knowledge about what they feel will be "hot" for the upcoming years. This is now an important aspect of the retailers' purchasing philosophy and greatly influences buying patterns.

▸ Many manufacturers have a "need" list, particularly if their products are seasonal. Get on their e-mail list so you can be informed on a regular basis of what they need.

▸ Check web sites of licensees regularly. Look at their new releases to see the latest designs they are producing. Usually these will be similar to other manufacturers' current trends.

PHOTOGRAPHING YOUR ARTWORK

Your objective should be to ensure that you protect your future income in case an original is sold, stolen or destroyed. You must have a professional reproduction-quality transparency, scan, slide or photo print of your original work. Publishers generally do not work from a 35mm; they most often work from a scan or transparency. Keep this in mind as you sell your pieces. Before your art leaves your premises, you need a properly taken scan or transparency.

In some cases where the art is being published at a very high standard, the publisher will want to photograph from the original in order to ensure the best possible reproduction of the work. If you send an original (or leave an original with a publisher), be sure to put its full value on your invoice, with a note for its return.

Even if you've sold your original, you should be keeping track of who the owner is. (Note space on copyright control card for such information.) You should also know where the buyer currently lives. (He should be on your invitation/purchaser/client mailing list. Even if he lives in another state, you should be sending him an invitation to your shows; owners will be impressed.) In this manner, you can keep track of him should he move again.

TRANSPARENCIES

Digital capture is now the most convenient way to photograph your work for eventual reproduction. A transparency—"tranny," "four-by-five" or "4x5"—is, however still an excellent way to preserve your work should digital capture be unavailable. It was until recently the format most widely used by publishers for reproduction. The most common and affordable size for a transparency, which allows for printing at up to poster size, is 4x5″. With the advent of digital technology, this method is slowly becoming obsolete.

The most important factor is getting a professional tranny made. Prices for trannies range from around $35-100. You may get a deal as low as $25 if you have several pieces photographed at the same time. Most professional labs in major cities offer this service. Take time to make friends with your local lab. See if you can get a special price by being a regular customer and bringing in batches of at least six pieces at a time.

Store trannies in the sleeves they come in from the lab.

SCANNING

A scan is a computer-generated copy of an original artwork. You need a scan with a final resolution of 300dpi to print to the size of the finished product. (24x36″ for fine art is not unusual.) Be forewarned: This can take up a fair amount of disk space on a computer. For greeting cards and small reproductions, 8x10″ or 10x12″ is ample. Files need to be in RGB mode as well as TIF.

Plastic sleeves are generally made from material that doesn't affect the transparency. Some manufactured sleeves can actually "sweat" and damage the transparency.

DPI = dots per inch

Original work can be scanned digitally (digitally captured) at a photo lab. Doing it without professional equipment can create problems. You need proper studio setup to achieve good results—it's imperative to get the work absolutely square as well as properly lit.

If you have the appropriate computer equipment, you can use reduced-size scans the lab has made to print color copies on your office's color printer. A color laser print can be a cost-effective way to send samples of your work. Ensure that labs use digital 5x4 " camera backs such as Phase One, Betterlight, Anagramm, or Kigamo, preferably with a Zig-Align system to ensure that all four corners of the artwork are in focus. The Cruse scanning system is by far the best.

35MM SLIDES

Less expensive to produce than 4x5 " transparencies, 35mm slides can be used for reproductions for items such as greeting cards and books. While it is possible to reproduce from a good-quality 35mm, it is not advisable. These images do not blow up well when made larger than 8x10 ". Since many prints are much larger than this, you will need to have a scan or a tranny or you might lose a chance of publishing a work.

FILE STORAGE

Scans can eventually take up a great deal of room on your computer. Back up your scans to a CD/DVD. Keep all your CDs/DVDs in a fireproof/waterproof cabinet or in a safe deposit box.

For safe and easy-to-reference file storage, develop a system. The first and most time-consuming step is to copy all your files onto your hard drive. From there you can modify them to jpgs for use on leaflets and email submissions. Make certain you give each file its correct reference number and title. Always use jpg or tif as a file type. As an extra precaution, it is not a bad idea to consider purchasing an external hard drive on which to save a complete back-up set of your files. These are relatively cheap and simply "plug in" to your computer via a Firewire or Ethernet cable. Back up your files each week so you always have a spare copy in the event that your computer crashes. You can, of course, use your external drive for all your computer files because it is by far the least expensive way to store large digital files.

Print File Inc
PO Box 607638, Orlando, FL 32860-7638 (407) 886-3100 www.printfile.com
Sells materials to protect and organize your slides and transparencies

Visual Horizons
180 Metro Park, Rochester, NY 14623 (800) 424 1011 www.storesmart.com
Duplicate slides, produce scans from slides, and more

Scans are either made directly from an artwork or from a tranny of that artwork. Digital scans are required for the actual printing process.

Slides are fine for sending to a publisher as a sample of your work. If you send laser copies that do not need to be returned, note: "Samples only. Do not return."

ACTION PLAN

- ❑ Place a copyright symbol, date and your name on all your artwork.
- ❑ Prepare a job card for every artwork produced, with a reference number, date produced and any other details such as size, medium and a good description.
- ❑ Have artwork digitally captured.
- ❑ Create 72dpi jpgs for web or email usage.

Chapter 5
Presentations

Market research

Presentation know-how

New modes of submission

Telephone contacts

Trade shows

Showing up is 90% of success.
Woody Allen

MARKET RESEARCH

Look smart—study your market.

You might be surprised by how many submissions are sent to publishers and licensees by artists who have given no thought whatsoever to the content of the work and the needs of the company receiving it. Each publisher or licensee is unique. Presentations should be geared specifically to the person or company you are approaching. Before you submit anything, you must understand the market sector you are targeting. Do the basic research.

TREND SPOTTING

Trends can be created by several sources: Fashion and home furnishings are two. These industries plan one or two years in advance. They each have color guides, which originate from market research and forecasts. These color-trend guides are not available to the public and cost hundreds of dollars to purchase. The Color Association (www.colorassociation.com) and Color Marketing Board offer membership and access to their valuable information, but it can be quite costly.

Such guides prove that a great deal of thought goes into fashion trends in the marketplace. Framed prints reflect this thought by being complementary to home furnishing fabrics. Some magazines publish color guides each year, which can be very helpful if you are in the print market.

Other trends just start with an innovative company putting out a range of cards or gift products that catch the consumers' attention. Suddenly there is a rush to follow by many other publishers who want to "ride the wave" before the fad becomes worn out and passé.

TIPS

▸ Choose only half a dozen manufacturers or publishers to pursue at the outset.

▸ Learn the tricks of the trade—what products are "hot," the latest colors, the bestselling artists/designers, etc.

▸ Target your market carefully, and understand the clients' needs as best you can. Look carefully at what you do, and relate your work to a particular product that fits well.

▸ Listen to the market. If you give it what it wants, you will be successful.

Always spend a portion of your time searching for new art buyers, whether it be at trade shows, via the Internet or through art buyer guides. Using a combination of these methods, you'll soon have a great customer list.

Send those companies to whom you choose to market exactly what they want. It's not good to send, for instance, nude figure studies to a print publisher who only prints wildlife. Although this may seem obvious to some, it's amazing how often this type of mistake happens!

Approaching several industries at once may appear rather ambitious to some. Perhaps your subject matter only relates to stationery and greeting cards. If that's the case, then choose publishers from those industries to start.

GET TO KNOW YOUR MARKET

▸ Read magazines on art, fashion and interior décor (listed in Chapter 10).

▸ Read magazines pertaining directly to the licensing market (listed in Chapter 10).

▸ Visit art exhibitions, fashion shows, interior design exhibitions.

▸ Visit trade shows as often as possible (listed in Chapter 10).

▸ Observe current events and sociological trends.

▸ Research licensees and publishers via the Internet.

▸ Visit stores to see what is being sold.

One key to success is research. Study everything you can about the product area you are interested in so that you "know" it. Let it seep into your bones!

You will need to continue market research throughout your career.

Names and addresses of manufacturers are often on the actual product, on the back of greeting cards, in the frontispiece of a book, or on the label of a pillow.

PRESENTATION KNOW-HOW

Having good artwork is not enough to enter the publishing and licensing market. You need to have a concept about how your artwork would be striking on a particular product.

Marketing your work is a matchmaking process.

To have any success in licensing, whether it be in an artist brand, artwork-as-brand, or individual licenses, you will need to have a strategy.

▸ Define your artwork: Is it appropriate for commercial use on products?

▸ Select a product line where your work can best be used. Research companies who currently work with that product line.

▸ Understand your competition; position the uniqueness of your art style into place.

▸ You will need to be willing to let go of your art. Will you be offended if your painting is on a shower curtain? Make sure you understand your psychological limits before you go forward.

▸ You will have to accept commercial standards of reproduction. No reproduction can be exactly like the original. Only so much time and effort is spent on getting a greeting card to be a "perfect" reproduction. More time is spent on getting a limited edition to be "perfect."

▸ Can you take the pressure of a commission—and deliver on time?

▸ Will you be able to accept art direction—perhaps cropping of your artwork?

SERIES

Prepare a series of artwork that you wish to license. To do this, you need to study the market, educate yourself and come up with a series of designs targeted at a particular segment of the market. Focus on a small group of products to begin with, the art for which eventually can be licensed to a small number of licensees. These initial products should be the ones most ideally suited for the art you have produced.

PROTOTYPES

Create some presentation boards of the actual product or ideas for products that you have. This way you can see how the design works on the actual item. It may need a special border, a background, logo, graphics. What about packaging?

By completing this exercise, you may find that your artwork is not strong enough or might not work quite right. It allows you to see what the licensee/publisher/manufacturer has to do to create a product that sells.

You may be saying right now, "Look. I'm not a designer!" That may well be true, but if you want to work in a particular market sector, it behooves you to understand some of the basic principles of product design. It's not just a question of slapping a picture on the product. Background colors, borders and logo—all play an important part in creating a product that is punchier and more saleable. You want it to say "pick me up." You need to know how this is done.

In our own studio, we produced an entire campaign on a particular teddy-bear project we handled. In the studio, the mock-ups looked great, but when they were put next to a range of new Disney products or some new flavor-of-the-moment merchandise such as the Teletubbies, which were all in very vibrant primary colors, our delicate, soft pastels looked lost. Had the product been manufactured, we'd have had an absolute failure on our hands. We therefore increased the intensity of the borders and created a much stronger design concept, which stood up well next to the competition.

MAILERS

In this day and age of computers, color laser copies and inexpensive color printers, it is rather easy to create a simple letter-size (8.5x11") flyer showing examples of your work. All you need is several scans of your artwork at 150-300dpi. If you have slides and no scan, go to a local copy shop or quick-print shop to transfer your slides into a digital format ($4-6 per slide). Have your name, address, phone number and a few details about yourself and the subject matter typeset on the flyer, and you have an inexpensive form of promotional material.

RECIPIENTS' RESPONSE

Keep your presentation simple; show your best work. No-nonsense, straightforward presentations on letter-size sheets seem to show the work in its best light. More elaborate presentations can take several minutes to open—too long for some people! Remember, your main goal is to have the art buyer call or write you to ask to see more.

▸ When sending slides, use a plastic slide sleeve. Slides individually wrapped and taped to a piece of card can take 10 minutes to unwrap and review. Not fun! Avoid sending slides except to known clients, and only as a last resort.

▸ Concertina books, boxes of slides with a little viewer, and tubes with dozens of rolled-up laser prints (rolled so tight they won't lie flat) are perhaps eye-catching but also very frustrating, even a downright nuisance in some cases.

TIPS

→ The content of the mailer/presentation is very important. The art director/buyer may receive up to 10 presentations a day, so you want to ensure that yours stands out.

→ The work must be good and targeted well to the licensee's needs.

Getting the first license is the hardest part; after that you get on a roll.

Letter-size format is by far the best—it fits into files easily.

→ The work needs to be displayed well. If you are aiming at the card market, you could make up card samples, for instance.

BIOS

If you are approaching the commercial market of greeting cards, prints, posters, gift ware, calendars, etc., including a bio in your presentation is not usually necessary. If, however, you've had experience with some big licensees, you might want to mention that in your cover letter. Generally, let the artwork speak for itself. Buyers are really not interested in your history unless it has some great significance, as in the case of limited editions or fine-art publishing.

A SHORT BIO SHOULD INCLUDE:

Date of birth

Art education: only relevant info—no one wants to know how many high school certificates you have or that you once played basketball.

Significant commissions: any clients you've worked for in the past who may be known to the person you're contacting

Collections your work is in: noteworthy galleries, museums or well-known collectors

Statement: your approach to or philosophy of art. Keep it to one short paragraph.

MAILING YOUR PRESENTATION

▸ Keep a current database of all potential licensees, either on computer or in an index card system.

If you are entering the more refined markets, such as fine-art limited editions, a short bio is quite important.

▸ Make sure you have the correct contact person. Before sending out any presentation, telephone the client and ask to speak to the art department/art buyer/art director. If you can't get through to that person, explain to the recipient that you are about to send in some samples of your artwork and you'd like to know to whom to address them.

▸ When you call the art director, ask in what format the company prefers to review submissions, as well as what styles and themes the manufacturer is looking for presently.

▸ Be sure to note your web site address (URL) so they can review your pieces on-line if desired.

▸ Send a letter with your mailer/presentation stating that you are a freelance artist and this is the style/standard of work you produce. If you are able to produce other styles, explain in a simple manner what else you can do. Whatever you

decide to say in your letter, keep it simple and not too long. Remember, this may be the fiftieth presentation the art director has reviewed this week.

▶ Some publishers have buying periods, so it's best to submit during the time suggested or your work could lie in a filing cabinet until the review dates.

When submitting work or making an inquiry, always enclose a SASE (self-addressed stamped envelope) if you want the material returned. Many companies do not return samples or reply if a SASE is not included.

A THREE-PART CONSULTATION

As a licensing management professional, around 90% of the presentations I receive are either poorly prepared, inappropriate for the market or do not have enough focus to attract a publisher or manufacturer. Be sure to do your research and prepare your presentations well; don't waste the licensee's precious time, or yours!

The following three-part consultation is offered to artists who are working professionals or who are producing artwork to a professional standard. The aim of a private consultation is to evaluate your work in relation to the market you wish to enter and to give advice as to how you can make improvements to the artwork as well as the best avenues to pursue in the licensing arena. I will critique the artwork submitted in respect to the market in which you want to license. Should the work be unsuitable, I will suggest ways you can improve what you produce to ensure that your artwork fits current trends and colors. If appropriate, I will suggest clients you may wish to approach once your portfolio is ready.

Part one

Artist submits a presentation either by e-mail or on a CD, showing all artwork available (as low resolution jpgs). If mailing, a SASE should be included if you wish your materials to be returned. Alternatively, you can direct me to your web site.

Part two

After I review your artwork, you will receive a 45- to 60-minute telephone consultation. I will give you advice as to what you should do to create a suitable portfolio. You may pose questions during this consultation.

Part three

You will receive information via e-mail with suggestions, examples of work for inspiration, helpful web sites to view, as well as contacts where appropriate.

To arrange a consultation ($250) call (941) 966 8912 or e-mail michaelwoodward@mac.com.

NEW MODES OF SUBMISSION

The Internet allows for quick communications. You can send images anywhere in the world in seconds!

The Internet has changed, and will continue to change, our lives. As more and more people become computer-literate, the Internet will become the accepted way to view portfolios. Learn as much as you can about the Internet—it means business. Talk to other artists who use the Internet in their business. Find out what mistakes they've made and successes they've had.

WEB SITES

Reviewing artwork via the Internet has become commonplace for art world professionals.

If you're leery of someone downloading and copying your artwork from your site, then this is not the place for you to exhibit! However, if your web designer creates the site properly, you will have reproductions that are only 72dpi jpgs (pronounced jay-pegs). When downloaded, these jpgs do not print very clearly. (Professional printers use 150-300dpi resolution.) Do not use 72dpi jpgs for reproduction purposes. If a potential hijacker tries to download and print them, they will be blurry, not as a final product should be. You can actually "watermark" images with an embedded copyright symbol if you are worried.

▸ Choose an easily understood URL (web address). Match it to your e-mail address or your name as best you can.

▸ Create a simple, easy-to-maneuver web site.

▸ Think how a licensee thinks—in stylistic categories. Divide your web site into stylistic sections: landscapes, abstracts, animals, etc.

▸ Make sure your jpgs do your artwork justice.

▸ Have a link to your e-mail on every page for easy communication.

▸ Images used on web sites should be displayed at 72dpi. This keeps the download time short.

E-MAIL PRESENTATIONS

Licensing agents receive many portfolios each week via e-mail. E-mail presentations can be an easy way to review, and by far the easiest way to send, a portfolio. A simple e-mail message with 10 low-resolution images—jpgs—can introduce a publisher to your work without them doing much at all, except opening their e-mail. It's also easy to respond—by clicking "reply," the publisher can type in a memo and return it to you.

To get their attention (they receive many e-mails from artists and "spammers" daily), be innovative:

▸ Copy and paste your images within the e-mail.

Every artist doing business should have a web site. Don't forget to pick up your e-mail messages regularly. People have come to expect quick responses!

- Include a hyper-link (http://) to your web site address.

- Keep the size of the files to no more than 100K each.

CD PRESENTATIONS

More and more presentations are being sent in CD-ROM format. Before you send a CD-ROM, check with the individual to whom you are mailing it to verify that she is set up for this kind of presentation.

Make sure you put your copyright information on the CD cover as well as within the presentation.

A CD presentation should consist of a simple grouping of designs. If you have different subject matters, have a short menu at the beginning so art directors can choose only those subjects that interest them. Include a printed flyer so clients can see a sample of your work. This flyer also provides some form of reference for their files and encourages them to review the CD to see more.

PowerPoint is a great software tool for creating slide shows. It is available from Microsoft in PC and Mac formats.

TELEPHONE CONTACTS

Any business requires that you know how to communicate on the phone in a comfortable manner. Don't expect magic from your first contacts. One has to learn how to ask the right questions and say the right things.

Plan your contact times well. Have your questions ready. Be in the right mood to chat. Don't fret about the cost of a call—that should be the least of your concerns!

ASK

▸ What style of work does the company use?

▸ What products does the company produce?

▸ Do they like artwork produced in a certain size?

▸ Do they have a requirements list?

▸ Do they have preferred papers or art boards they wish artists to use?

▸ Do they have specific dates for submissions?

POINTERS

→ Be nonthreatening.

→ Don't talk fast.

→ Keep the pitch of your voice low.

→ Do not call if you're in a bad mood.

→ Don't sound overly cheerful.

→ Qualify the person on the other end: Is she the actual person who will be reviewing your work?

→ Be businesslike and professional—try to sound like you've been doing this for years.

POSSIBLE PHONE DIALOGUE

Hi, my name is I am an artist and would like to submit a presentation to the art buyer or art director. Can you tell me that person's name? Is it possible to put me through to that department?

When you are put through:

Hello, my name is I'd like to submit a presentation of my work to you for review. Would you prefer laser copies or can you review a CD presentation or..........?

Ask only a few simple questions if the buyer sounds busy. Respecting her time will get you points.

- Are there any particular subjects you are looking for at present?

- Do you buy art year-round or do you have specific buying periods?

- Do you have a standard fee structure?

- What other products do you produce besides …?

FOLLOW-UP

It's amazing to see how many businesspeople (and not only artists) drop the ball at the follow-up juncture. You may figure that since someone didn't call you back, that someone is not interested. Often it means he is just too busy and needs you to get on his tail!

Follow-up is a critical step: Busy people appreciate it when an artist calls them to follow up. It shows good business sense—and publishers want that in someone they work with. Sure, you will get a "no" quite often, but you will also get your share of "yeses."

- Call and ask for the person to whom you've mailed the presentation.

- Find out if he received it and ask for his opinion.

- If you find you are getting a negative response, tell the art director you'll be happy to do a speculative commission if he gives you a brief. This creates an opportunity to produce a piece of work to the client's needs and may be a way of proving yourself. It may be that an artwork just doesn't fit the requirements but, with a little art direction, you can produce a piece he would buy. Working with some licensees in the beginning in this speculative manner can help create a good relationship. In effect, they are helping you produce work that is more saleable for their product range.

TRADE SHOWS

Trade shows are the place to see and be seen. An excellent way to meet people in the industry is to stay at a hotel that the trade show recommends—most of the exhibitors attending will be staying there too. When you ride on the jitney to the show, you will be able to chat with them in an informal manner and learn lots of information.

If the show has a gala opening event, be sure to attend it. The tickets might cost a bit, but the contacts you make will be worth it. People are much more open and chatty after hours.

Trade shows are a major source of research, so don't ignore them when exploring your marketplace. Many of the big shows take place in New York City, but you will also find some important ones in Atlanta, Chicago, and Los Angeles, as well as other major cities. (See Chapter 10 under Trade Shows.)

THE VISIT

Once you've located a show you think you'd like to visit, call the organizers. If it's early enough (two or three months before the show), ask them to put you on the mailing list for an entry ticket. In some cases, entry will be free if you preregister, whereas if you arrive on the day of the show, you may have to pay a hefty entry fee ($20-50). As these shows are often for the trade only—manufacturers, publishers, agents—don't act like a member of the public when you call. If you have a business name, use that when leaving your address—John Doe Design or Jane Smith Studios. This sounds much more professional and gets you on the mailing list without need for explanation.

Visiting a major trade show such as Surtex or The National Stationery Show, both in New York, can be a daunting task for first-timers.

▸ Book your hotel well in advance. Take advantage of the discounted rates negotiated by the show by checking out the list of hotels on their web site.

▸ Always wear comfortable shoes. You might walk 10-15 miles a day!

▸ Before arriving, try to make an appointment with the art director.

▸ After registering and getting your catalog of exhibitors, sit down for half an hour and go through the catalog. Note companies with whom you'd like to meet.

▸ Write notes on the backs of the business cards you collect—key words that will jog your memory—"Send photos of landscapes by July to Jan Williams."

PROTOCOL FOR ARTISTS ATTENDING TRADE SHOWS

▸ The first thing to remember is that the manufacturers and publishers are there to sell product. The booths are normally manned by salespeople who want to write orders. As a result, several shows limit days that artists can attend.

▸ If you find a company you think may be a good "fit" for your work, ask for the name of the art director. Do not interrupt a sales process to do so, and don't attempt to show work unless asked. If you can get a leaflet or catalog, this can be a helpful future reference. Catalogs are sales tools and expensive, so don't presume you can simply take one. Always ask.

At the end of the day you will be tired, and a little bewildered, but you will have met a few dozen potential clients and have lots of business cards. When you return to your studio, you can follow up with mail presentations and phone calls where appropriate.

STATIONERY SHOW

▸ Educate yourself several months in advance on the greeting card industry. Browse stores and specialty shops. What style of artwork is being printed on cards these days?

▸ Take a taxi right to the door of the Jacob Javitts Convention Center in Manhattan. Save your energy for the show. If you are staying at one of the hotels cooperating with this event, you can take a jitney bus to the show for free. They go to and fro all day. (Even if you're not staying at the hotel, you can catch the bus for free if you know which hotels have stops.)

▸ If you find a card that has artwork close to your style, write down the publisher's name for your in-house mailing list.

▸ Have a goal—are you looking for an agent, publishers of greeting cards, just getting an introduction to the business?

▸ Familiarize yourself with the show rules. It is essential that you follow protocol. Recently, the Stationery Show stopped artists from attending the show on the first three days because numerous exhibitors complained that artists were becoming a nuisance.

▸ Scan the aisles, looking for your style of artwork. The show can be overwhelming. It's huge and has hundreds of exhibitors.

▸ Walk down the center of the aisles so everyone doesn't stop you.

▸ Stop at a booth where you feel the art style fits yours or if there is a sign saying "Artists Welcome."

▸ Dress in layers—the Javitts Center can have sections that are too warm and others that are quite chilly.

▸ The show has strict rules about not allowing wheeled cases on the show floor. If you have materials to carry, make certain you have a bag that you will be able to carry all day.

▸ Besides greeting card companies, you will find stationery companies and other potential licensees of interest that use images for a variety of products.

▸ Bring plenty of business cards, post cards, photos or anything that you can leave with a potential publisher. Carry a small portfolio of your work, but it must be simple to review and need little or no explanation. Show it only when asked.

The publishing/licensing world is very competitive. Timing is of the essence. Publishers need to find the "right" artist before the next publishing house does.

AN ARTIST'S ROAD TO LICENSING ART

by Rene Griffith

I'd like to state up front, I'm not a licensing guru. I'm an artist with a vision and dream. What I've learned about licensing in the last two-and-a-half years, I've learned one step at a time—by reading, attending workshops, going to shows, exhibiting at shows, talking with vendors, and asking a lot of questions. Sometimes I have felt like a puck in an old-fashioned pinball machine—being bounced from peg to peg, lights flashing, buzzers sounding, ideas flying, and bells ringing when I make a few good hits, but ultimately ending up nowhere and losing my quarter. Now, with a few licensing contracts under my belt, I'm beginning to see more positive results. It's become a little easier but it's always challenging. It's a journey I intend to stay with, pushing myself to higher and higher levels. In this article I will tell you some of what I've learned along the way, perhaps saving you some time and frustration.

Become aware of trends

The licensing industry is driven by trends—style, subject as well as color trends. As an artist delving into this market, you will need to study these trends. One of the best ways to survey the latest trends in style, subject and color is to "walk a show." Walking a show—a licensing trade show, gift show or home decor show—can help answer many questions: Is your particular style viable for licensing? After showing your portfolio, are there companies who express an interest? Did you see other artwork similar to yours? Is your subject matter popular? Is your color palette compatible with today's trends? Are you ready to begin licensing your artwork?

There is also an organization you should know about (www.colorassociation.com) that forecasts color trends in apparel, architectural and interior design, and decorative home accessories.

Walking a show

I decided to go to New York and walk both Surtex—a licensing show—and the National Stationery Show (they occur simultaneously). I spent three days walking those shows from 9-6. I was able to see firsthand how other artists displayed their work, how publishers promoted their stable of artists, as well as study some of the players in the game called licensing. I talked to as many art publishers and greeting card companies as I could (keeping in mind that they were there to do business, not talk to artists). I also attended a seminar on licensing and some other networking events. I left with business cards of 22 companies and the names of their creative or licensing director. Within three months, I had my first contract with a greeting card publisher.

Exhibiting at a show

I've been an exhibitor at the San Francisco International Gift Fair where I sold my framed photography. This was a good experience to learn about selling a wholesale "product" to gift stores, small galleries, and souvenir shops. Prior to the show, I had substantial expenses such as booth design, booth rent, signage, catalogs, order forms, business cards, as well as manufacture of the samples I would be selling. In addition, I would be working the booth for three days. Gift shows are "order-taking" shows. After the show, you fill the orders and ship your product to customers. A month after that show, I decided it was far too much work for too little money. I didn't break even, but the lessons I learned were invaluable—it's really difficult to be artist, manufacturer, graphic designer, salesperson, bookkeeper, and shipper in the wholesale market, or for that matter in any market.

This past year I decided have a booth at Surtex to see what kind of contacts I could make by showcasing my photography. After three days, I left with business cards of 26 companies who had stopped by the booth and showed an interest in my artwork. To date, I have not gotten any licensing deals from that show. However, I am still pursuing follow-up with these companies by sending out e-mails, promotional materials and portfolios.

I have decided to exhibit at Surtex again this year. From the feedback that I've received from other artists who have exhibited at Surtex, most say that manufacturers don't take you seriously until they've seen you exhibit at the show for at least a couple of years. They want to work with artists who are reliable and committed to pursuing this business. This year, I will be displaying prints and posters of photographs that are already being published by fairly large companies. I will be looking for manufacturers of products such as paper goods, puzzles, calendars, note cards, and textiles who would be interested in using the same imagery for their products. Now that I have a track record, this might be more viable.

Follow-up

Sometimes follow-up can be the toughest part of marketing. Don't neglect this. Licensees are busy and they appreciate someone following through with a contact from a show. I usually follow up with a short e-mail reminding them of our meeting at the show. I attach a couple of small jpgs of my artwork to refresh their memory. More often than not, I get an e-mail response. If they seem interested in viewing more images, I may call to find out exactly what imagery they want to review. If they're not interested at this time, I ask them if I can keep them on my e-mail list. Remember, even if you get a rejection at this point, it doesn't mean "No," it only means "Not at this time." Being tenacious is a good quality to have in this industry!

Learning from a rejection

Getting a rejection letter after submitting artwork to a company that you feel your work is quite appropriate for should not be taken personally. Sometimes we think it means our artwork isn't good. Most often, it means that the artwork isn't what they're looking for presently. Perhaps it's not in keeping with the latest trends. Creative directors often have a "shopping list" of the types of images and colors they are seeking for their next catalog. If they are seeking coastal imagery, especially in cobalt blues and seagrass greens, and you send them wildlife images in natural tones, you will likely get a standard "thanks, but no thanks, please continue to send new work" letter. Keep that contact in your database and from time to time send them new imagery and a short note. You never know when they may have a "hole" in their catalog of images they need to fill, and that hole may be filled with your art.

Submitting artwork

Often companies post guidelines for submitting artwork on their web site. Make sure that you follow their requests to a T. If you have questions, call or e-mail to ask for clarification. Printed art pieces in a portfolio? Low-resolution jpgs? A PDF slide-show presentation? How many pieces would they like submitted? Should they be grouped by theme? Also, try to find out whether they have an upcoming project or art review meeting so that your materials arrive in time for their review cycle.

Artist and author Rene Griffith creates photographic art using vintage Polaroid and digital cameras. Currently she is writing a book about licensing art from the artist's perspective. Read more about Rene's licensing experiences on her blog at www.renegriffith.blogspot.com and view her artwork at www.renegriffith.com. ©2007 Rene Griffith. All rights reserved.

ACTION PLAN

❑ Compile a database of six potential licensees with contact names and what each does. Add information about their fee structure, royalty rates and buying periods.

_____ _____

_____ _____

_____ _____

_____ _____

_____ _____

❑ Prepare a list of trade shows to visit. Get your name on their mailing lists for brochures.

_____ _____

_____ _____

❑ Prepare a leaflet with examples of your work for promotional purposes.

❑ Prepare a portfolio.

❑ Send 20 mailers out each month.

❑ Try to allot a time each day or at least twice a week to make follow-up calls.

❑ Visit several web sites each week to see what's happening. You can visit art galleries' sites, art publishers, greeting card and stationery companies. Just type in a product or a subject at a search engine and surf around.

Chapter 6
Licensing Agents

What is a licensing agent?

The interview

Fee structures

What to do when accepted

Overseas markets

I shut my eyes in order to see.
Paul Gauguin

WHAT IS A LICENSING AGENT?

Having an agent frees you up to concentrate on what you do best—produce new art.

A licensing agent is a matchmaker between an artist's work and an appropriate licensee (publisher or product manufacturer). She negotiates business arrangements and legal contracts in relationship to licensing and publishing for the artist. A licensing agent is always looking for the perfect "marriage" in the marketplace for the artist and product.

Getting an agent takes time, effort (attending a licensing show, calling agents), money (buying a directory) and also the appropriate art for a particular niche market.

Agents often work with a specific product line or property sector (see "Property Sectors," page 21), i.e., some only work with celebrities or entertainment properties, some only with art and design. Having an agent is well worth the commission you pay. Agents are more aware of the marketplace, thus, able to get more licenses. Being your own agent in this field is a full-time job that you may not want to do.

Choosing an agent to approach is not difficult if you follow some simple rules. Use the reference section in the back of this book to find a list of agents.

FINDING A LICENSING AGENT

Visit sites listed in the back of this book to get an idea of what styles agents deal with. Be sure to follow any procedure they request regarding submitting your work.

The agency you will be dealing with may have several staff members, each dealing with certain types of artwork. Until they actually see what style you produce, they may not know who you will be working with. Only a certain amount of time is dedicated to talking with artists—those artists who the agent feels have the quality and standard of work, as well as subject matter and style, that he can sell.

Agents receive many submissions a week and may already have artists they work with who have a style similar to your own. If that's the case, they might not want two artists of the same style competing within their company, even though your work is good.

FACTORS AGENTS ARE LOOKING FOR IN AN ARTIST

A good agent tries to develop a comprehensive line of products that can be merchandised.

- ▸ Is your work commercial and saleable?

- ▸ Are you easy to work with?

- ▸ Can you meet deadlines?

- ▸ Are you reliable?

- ▸ Can you execute a specific design request?

- ▸ Is the standard of your work consistent?

▸ Are you easy to contact?

▸ Do you specialize in a limited field or are you flexible and versatile?

▸ Have you any previous experience?

ADVANTAGES OF HAVING A LICENSING AGENT

▸ An agent has far greater expertise and experience in the industry than most
artists.

▸ An agent has many connections with licensees. As an artist, if you are with a good
agent, you stand a far better chance of having your work seen by manufacturers.

▸ Agents are likely to get higher fees for you. They understand what value the art
has to the licensee. They are often more skilled in negotiating.

▸ Agents can help you fine-tune your projects and offer art direction and ideas to
pursue.

Most licensing agents require exclusivity in the art licensing industry. However,
it should be no problem excluding book illustration, editorial, magazine and
advertising work from the agreement so that you are free to set up representation in
these other fields if you so wish with an appropriate agent.

Agents vary considerably, from one-person companies to small businesses with up
to half a dozen staff, to large companies who have overseas connections handling art
and design, entertainment properties and brand licensing.

Choose an agent who has experience in the product with which you feel your art
will work well, and who has been in business a few years so that he already has a
good number of licensees as clients.

Fine-art publishers often act as agents for their artists, showcasing their work at licensing shows.

An agent has spent many years nurturing his licensees. The last thing he wants to happen is to let a licensee down by late arrival of artwork or substandard work.

STRATEGIES FOR SUCCESS

▸ Offer exclusives to retailers.
▸ Start with work-for-hire agreements, then move to licensing.
▸ Brand yourself.
▸ Offer diversity, but within your brand.
▸ Consider doing it yourself; get a good coach.

THE INTERVIEW

Interviewing with an agent can be daunting; being nervous is not unusual. It is important that you make a good impression; after all, agents can make an artist's career through their contacts and knowledge. Don't be hesitant to ask questions about how the agent operates. In fact, a good agent will appreciate that you are concerned about your career.

QUESTIONS TO ASK

→ What are their commission rates?

→ What are their major markets?

→ At what trade shows do they attend or exhibit?

→ Ask to review their agency agreement.

→ Ask to review their standard licensing agreement.

→ Ask for references from their client list.

YOUR PRESENTATION

In a portfolio, the agent is looking for talent, creativity and quality. Be very discerning and specific in what you show in your portfolio.

The idea is to "knock him out" with your portfolio so he really wants to sign you up. Make your portfolio impressive. (See *Art Marketing 101* for details on how to develop a portfolio.) Make it unique, a specific style, and easy to review.

▸ If you meet in person, hand the portfolio to the agent and allow him to go through it at his own pace. Often, artists want to explain each image in detail. This is totally unnecessary. Only answer questions.

▸ Show your very best work—no mediocre pieces.

▸ Leave out material that doesn't relate to the commercial market.

TIP

→ A general guide to submission procedures to licensing agents can be found at www.out-of-the-blue.us. Go to the "Art Submission" heading.

Each agent's terms will vary considerably from another's. Following are some guidelines as to the kinds of arrangements that can be agreed upon.

→ Agents' fees vary from 25% to as much as 75% of your part of the royalty. The norm, and a fair rate, is 35-50%.

→ Some agents may charge extra on overseas work (up to 60%), especially if they are making overseas telephone calls and shipping work abroad. Although this may appear high, think of what it would cost you to set up deals with manufacturers in Europe, Australia or Japan! Usually, the sales you receive from overseas licensing deals are in addition to those in the US, so be happy with your 40%.

COMMISSIONS

If you are lucky enough to be taken on by a reputable agency, ensure that whenever you take on a commission, you:

→ understand the intent of the commission fully

→ accept the deadline for sketches

→ deliver the artwork on time, every time.

FEE STRUCTURES

If you want to generate a good income from licensing, agents are the best path. They can accomplish more in a shorter period of time—that's their business.

AGENCY SERVICES CAN INCLUDE

- Education: coaching, client management
- Strategic planning
- Creative development
- Legal
- Sales
- Accounting
- Manufacturer account management

WHAT TO DO WHEN ACCEPTED

To ensure that your agent can do his job in promoting you and generate sufficient income, it is imperative that you listen to his advice.

Maintain a steady flow of work. Keep producing new series or new "looks" and submit them by e-mail or by CD. Quite often artists who have a reasonable-size portfolio sit back and wait to see what happens before producing more work. This is a fatal mistake.

By keeping fresh ideas flowing to your agent, he can solicit valuable feedback from clients, and this can affect your overall success positively. A couple of new images for prints can spark off a new series or attract the attention of a publisher who loves your style and subsequently wants to use you on a regular basis.

If you have an "artist's block," don't hesitate to call or e-mail your agent and ask for guidance or ideas. He will do what he can to help get you back on track or through a period where your creative juices seem to be lacking.

EXCLUSIVITY

Exclusivity is very important. It is not good for an agent building up a healthy licensing program and new commissions to discover that you're too busy doing jobs for other people.

You also need to be careful, however, with the idea of exclusivity. If you want to do book jackets or book illustrations and the agent doesn't work in that field, exclude book illustration from your contract. You can then work with another agent in this field.

Two- or three-year contracts are quite standard. Make sure there is a reasonable termination clause so that if you are not satisfied with the agent's work, you can terminate the contract without problems.

ARTIST/AGENT RELATIONSHIP

→ Needs to be a good business partnership
→ Agents fees range from 35-50%
→ Many agents charge an initial development fee in addition to commissions
→ Legal, production and travel fees are often in addition to commissions

THE IMPORTANCE OF BEING TIMELY

I got a call on a Friday afternoon from the art director of a major licensee who wanted 200 designs for greeting cards in four weeks—an almost impossible task. We acted without delay. All the commission agreements were sent out in writing to our artists, along with a phone call to explain what was required. Sketches were required within three to four days. Then, on approval, the artists had approximately three weeks to complete up to six pieces of artwork.

The deadline arrived. One artist's work was missing. An urgent phone call was placed to chase down the artwork. When found, the artist quite calmly told us that he'd finished three pieces but hadn't been able to finish the rest—his family had turned up unexpectedly and he just hadn't had time.

You can imagine my reaction, knowing that the publisher's printer was waiting to print a sheet of 16 designs with three designs missing. The repercussions were enormous: Not only had the printer's time been prearranged to print, but the printer also had to proof, print, cut, trim, film wrap, box and deliver each design (5000 cards of each) by a specific date.

A delay like this can cost thousands of dollars. Retail groups have specific buying periods and delivery dates so that they can get the cards into their selling system, sales conferences and product catalogs. Can you imagine the chaos that can be caused by a delay of this kind? The artist is just a few days late in his mind, while the art director and printer are thinking about throwing themselves off the nearest skyscraper!

The consequences of not delivering artwork on time can be disastrous. Avoid delays at all costs. If you are ill, or, for some reason, are unavoidably delayed, let the agent know as soon as you think there could be a problem. Don't wait until the last minute.

Another example is a delay on a finished piece of art for a collector plate. In this instance, the manufacturer had booked space in one of the Sunday magazines at a cost of around $15,000. This was to be a test ad showing a new plate design.

You can imagine the manufacturer's response when the art for the plate wasn't ready. Not only did they lose the space, but the ad was then delayed for months until another suitable slot and date could be arranged.

Quite often, ads are chosen to appear at specific times, avoiding certain days or weeks due to holidays, major events, etc. These dates are carefully selected and important. Missing a certain time slot could delay a project by weeks or even months.

Very rarely do artists realize the full implications of delays. Miss an important deadline at your own peril. Not only does the agent lose confidence in you, but the licensee can lose confidence in the agent. A major loss of faith by a manufacturer could mean thousands of dollars of lost business for you.

RESOURCES

See Chapter 10 in this book under Art Licensing Agents (pages 158-159).

Attend licensing trade shows (see pages 177-178).

Read trade magazines (see pages 175-176).

Network with artists in the licensing industry.

Artist's and Graphic Designers Market
F&W Publications, 4700 E Galbraith Rd, Cincinnati, OH 45236
(800) 289 0963 (513) 531 2222 www.fwpublications.com
An annual directory with lots of resources

Art World Mailing Lists
www.artmarketing.com
250 licensing agents as well as a variety of other categories are available for direct mail: greeting card publishers, calendar publishers, art publishers, book publishers and more.

Licensing Pages
www.licensingpages.com
Click on "Directory" and then go to "Licensing Agents" for a list of agents around the world. This company also produces a directory—Retail Buyers Guide for the UK market.

Licensing Resource Directory: The Who's Who of the Licensing Industry
Available from LIMA (see Chapter 10)

Agents often have booths at trade shows. See the list of trade shows in the resource section of this book.

SUCCESSFUL LICENSING ARTISTS

→ Trend watchers
→ Good work ethics and timely
→ Can work under extremely demanding deadlines
→ Are capable of learning the business of licensing
→ Have a variety of design capabilities
→ Have a unique art style

DO YOU NEED A COACH?

by Jeanette Smith

Are you a "do-it-yourself" artist—you want to get into the licensing arena but don't want to be "handled" by an agent? This is certainly possible to do. Somewhere along the way, however, you are going to need some good advice, perhaps even a coach.

A licensing coach helps with:

→ Management of licensing contracts, including the financial aspects
→ Development of strategic planning and marketing
→ New business development
→ Negotiating and developing contracts (but not giving legal advice)
→ PR development
→ Web site development
→ Keeping you current on trends
→ Financial forecasting and budgeting
→ Strategic product planning, development and approvals
→ Creative branding and brand identity
→ Trade show participation

The difference between a coach and an agent

Coach	Agent
→ Works behind-the-scenes to assist artist	→ Works up-front with licensees
→ Teaches artist to manage her own licensing business: what needs to be done, when to do it, where to find it, how to do it, why it is important!	→ Manages the licensing business for the artist and does the work
→ Lower cost to artist: Works on a fee basis or at a reduced fee and commission	→ Agent receives 35-50% of royalties

Do you need a coach to make your licensing efforts more effective?
Utilizing a licensing coach is not for every artist. It's very important to acknowledge whether you possess all the skills needed to license your artwork on your own and keep track of all the business aspects—contracts, trends, trade shows and more. For those who have "left-brain" capabilities and the desire to do the work, there are some great benefits.

continued on next page→

Benefits

Coach	Agent
→ Learn to manage your own business, including the finances	→ Finances are handled by agent and pass through agent to artist
→ Less expense over the long run, with much smaller percentage commission	→ Less upfront money required
→ More control of business	→ More time to spend on creative aspects
→ Artist learns what he is capable of and interested in doing; then can find appropriate support professionals to provide business services as needed	→ Experienced agent is not as vulnerable in industry as an artist

One of my recent clients had six licenses after three years of diligent efforts. Within the first nine months of our working together, she signed an amazing 16 new deals! Now, she is closing in on 30 licenses.

◆

Jeanette Smith, of J'net Smith Inc, has more than 25 years' experience in the publishing and licensing fields. She is the marketing powerhouse behind the multi-million-dollar Dilbert phenomenon. Contact her at 2310 NW 192nd Place, Shoreline, WA 98177 (206) 533 1490 jnet@artlicensingcoach.com
www.artlicensingcoach.com

OVERSEAS MARKETS

The UK is by far the easiest foreign market for American artists to approach; however, you need to know whether your style of artwork will sell in the UK. If it's too "American," it may not work, just as some "English" designs don't work in the US.

You may have a style of artwork with potential in Europe, Japan or Australia. It is possible to enlist the services of an agent in a particular country. However, the simplest way to deal with the overseas marketplace is to let your US agent handle those sales, working directly or through foreign agents. While you will be paying two commissions if deals come through another agent, the hassle of dealing with it yourself could be far more costly in time and money. The US agent might, for instance, have arrangements with a Japanese agent who will work on a 40% commission on any sales he produces. The Japanese agent will remit what is due to your US agent, who will normally charge his usual commission rate just as he would for a US publisher. He still has to send the work out to the foreign country, as well as negotiate the fee and do all the usual paperwork. This can be more costly to administer than a sale in the US.

If you do, however, decide to work directly with overseas agents, then attend Licensing International in New York in June. It is the best place to find direct representation. A number of UK and European agents have booths there. You also might attend trade shows such as Surtex or ArtExpo (both in New York City) to find agents. Major foreign companies often have a sales office in the US.

Approach major international foreign publishers. They will speak English and will be used to dealing with artists in different countries. Working with the smaller companies can be problematic due to language difficulties. If you do have a problem with a smaller company, it can be difficult to resolve it from 4000 miles away.

Delayed payments, lack of information and bad communication are common problems. You can avoid these by having a US agent deal with a foreign agent or licensee.

If your agent's standard commission is 50%, then on a $1000 deal generated by the Japanese agent, your own agent will receive $600 net and you will receive $300.

ACTION PLAN

❑ Research agents' web sites to see who works with which markets.

❑ Compile a list of 12 potential agents to call.

❑ Prepare a list of trade shows to visit.

Chapter 7
Self-Publishing Prints

Advantages and disadvantages

Limited editions

Giclées

Costs

Exhibiting at trade shows

Promotion

Success is what sells.
Andy Warhol

ADVANTAGES AND DISADVANTAGES

There are two basic methods of getting your work into print:

▸ Having an established art publisher print and market; you receive a royalty, as explained in the previous chapters.

▸ Publishing it yourself; you pay for printing and you market the printed pieces.

If you are having no luck finding a publisher, self-publishing can be a way to start. In the long run, however, a good publisher has developed a customer base through a large distribution channel with the retailers and framers and on-line galleries. Thus, he generally has a lot more connections than you do.

Self-publishing is not something you should consider lightly. You need three to four years of hard work to stand any chance of achieving regular sales figures. It can take several years to build up a good collector base. Many artists make the mistake of jumping into self-publishing without thinking about the marketing efforts it takes.

For some artists, self-publishing is the right direction to go. If you already have outlets at which to sell prints—outdoor shows, galleries in which your originals hang, tourist shops, etc.—then the marketing has already been set in motion to some extent.

ADVANTAGES OF SELF-PUBLISHING

▸ You have total control of the production of your image.

▸ If you sell at outdoor shows, self-publishing can be a boost to your sales.

▸ You increase exposure to other economic levels that can't be reached with your originals.

▸ If your prints begin selling, your originals can become even more valuable.

▸ People who like your work and originally buy a $100 print will often return as collectors and buy another print or an original.

DISADVANTAGES OF SELF-PUBLISHING

▸ Output of money for prints and marketing

▸ Output of time: You must do all the research, marketing, etc. You might be able to locate a distributor, but this also takes time and searching.

▸ You personally have to sell 50 times the number of an original (if you print limited editions of 50). How many originals have you sold?

▸ Your competitors are established publishers and other artists who have distribution channels built up over many years.

The key to self-publishing is to start small and build up distribution gradually.

RESEARCH

You'll need to start your marketing by doing lots of research. This research is not dissimilar to the research you may have done to locate appropriate publishers.

- Become familiar with the current print market.

- Go to print and poster galleries and ask them what sells.

- Get brochures from big publishing houses.

- Look at magazines to see what is advertised.

Spend some focused time thinking about the marketing of your prints before you actually commit to printing. You need to have a detailed marketing plan in position before you spend money on giclées or any other form of printing. If you have been refused over and over again by publishers in the business, have you asked them why?

Fashions and tastes can be fickle. Many popular prints are plagiarized remorselessly to the extent that a top-selling style is often emulated by several publishers who get their artists to produce similar versions. These versions do not necessarily infringe copyright, but they look similar enough to the uneducated eye. This often has the effect of killing off a particular popular style sooner than the original publisher of the art would want.

It is an indication that you have good potential to sell prints when your originals are selling well and at good prices. If your prices reach $1000 or more, then this could be the right time to produce and sell prints.

Become familiar with the four-color printing process. Some colors in your original artwork may be difficult to reproduce: fluorescent, oranges, some teals and purples, reds.

LIMITED EDITIONS

Personalize it: Sign it, repaint on it, frame it uniquely.

Don't even think about producing open-edition litho prints (i.e., editions with no limit). The prices of open editions at wholesale can be so low that you would have to sell 10,000 prints or more to have any success. Leave this to the big publishers who have established large distribution.

Limited editions vary from around 95 to 950 for large publishers. For you—an individual artist—a first-time limited should have a run of 25-95. If you sell out within one or two years, great! Your new work can be published in a higher-numbered limited edition, say 95-195. Slowly increase the quantity of prints each run. You want to set about creating a collectors' market.

▸ Stick to giclée prints on paper or canvas.

▸ When you produce a limited-edition print, you must keep track of each print that is taken out of the studio, whether on consignment, to be framed, sold (note the collector's name and how much she paid), or for an exhibit. Use your job cards to keep track of this.

▸ The market for a limited-edition print is regulated by law in a number of states, including California, Illinois and New York. Extensive disclosures or disclaimers may have to accompany limited-edition prints sold in these states, verifying print run, etc.

CREATING A COLLECTORS' MARKET

The whole point of selling limited-edition prints is to create a collector base, i.e., buyers who love to collect your work. By having small editions, you stand a greater chance of selling out of a particular edition, which is exactly what you want to occur. To be able to say "sold out" is great. This is what creates demand, eventually raising prices of both originals and prints. Collectors who love collecting don't want to miss out on your next edition.

Top publishers love this to happen to their artists, as it creates a secondary market where galleries sometimes buy back prints to satisfy important collectors who are willing to pay a lot more just to get a copy of a print they've missed. Some "sold-out" editions from big names can fetch thousands of dollars.

▸ The key is to emulate what the top publishers do but on a smaller scale, keeping the editions small, of high quality and reasonably priced.

▸ It's a no-no to produce an open-edition print and a limited-edition print of the same artwork. Many artists do this, but it is frowned upon by serious collectors. The idea of having a limited edition is that it is limited to that print run—no more are produced. Therefore, to print a cheaper version defeats the purpose.

When you mail postcards about your newest edition to your collectors, it's important to emphasize to them to "buy now to avoid missing this edition."

MARKETING YOUR LIMITED EDITION

▸ Take photos of several pieces you will be printing to frame shops in your area. Ask the owners which pieces they like the best. Print from the results of your research. Go back to these same shops and sell the prints.

▸ Do a test by making a photo print of your piece; mat it and take it to your next art show. Find out what price you can ask and what quantity you can sell. Is anyone nibbling? What size would sell best? If you decide to do a limited edition of this test piece, do not sell this open-edition piece! Discard it.

▸ You need to know your printing costs (get quotes from several printers), who your target market is, and the number of prints you must sell to break even.

▸ Make contacts with distributors, approach possible free promotional sources and design your marketing materials.

▸ Go door-to-door to stores, galleries, restaurants and businesses.

▸ Perhaps you can get financing from former buyers or collectors by offering them the first print in the series. You'll be gathering the necessary money and selling prints at the same time.

▸ Some printers use coatings to protect the finished work. You'll need to familiarize yourself with types of coatings.

▸ Create a Certificate of Authenticity (page 98 in *Art Office*) that states how many prints you've published.

Compose a brochure with all the prints you publish in it. Put "sold out" next to those that are no longer available.

ARTIST'S PROOFS

The publishing industry's norm is to produce no more than 10% of the edition as artist's proofs. In the early days, this part of the edition was reserved for the artist. This, however, was when editions were handmade originals. These days, artist's proofs are a way the publisher can produce extra copies to sell. The artist can expect to get five to 10 proofs of an edition. If you can negotiate more, then great. The rest of the proofs go to the publisher. This should be agreed upon at the outset and put in the written and signed agreement.

A number of collectors only collect artist's proofs. Some actually collect particular numbers. Selling to these buyers at a higher price can prove quite valuable to the publisher. The artist's royalties on these prints will be a little higher.

GICLÉES

Giclée means "ink spray" in French.

You need to remember that different batches of inks create slightly different tones. Prints created at different times could vary in color.

Stockpiling an inventory of prints is no longer necessary. The newest method of printing that has enabled many artists to self-publish due to its affordability is the giclée print.

Giclées originally were produced by an Iris printer, which was, in fact, used as a proofing machine. It was due to the foresight of rock musician Graham Nash and a colleague that this technology was then developed to produce artists' prints. Companies such as Epson, Roland, Hewlett-Packard and Colorspan are all producing ink jet—giclée—machines. There are, in fact, so many machines of varying quality that it is impossible to cover all the processes in any depth.

The Iris Graphics Printer was first presented at a trade show in 1987. Designed for color accuracy, it did not at that time find its way into the fine-art market, mostly due to the lack of archival longevity. Through the years the archival quality has improved. Since 1994, Iris printers have been on the market for fine-art reproductions. The Iris printer is a four-color, continuous-tone printer that can accurately reproduce multiple color transitions in intricate detail. Print quality is as good as, and some say better than, screen printing or traditional lithography. Iris printers create images by spraying microscopic droplets from a nozzle onto a substrate that is attached to a drum. These droplets, indistinguishable to the naked eye, build a lush and vivid surface at 1200-1800dpi, making this method of reproduction quite good for hard-edged paintings or fine-grained photographs.

PRINTING STEPS

Photography - Initially, a digital file is required for reproduction purposes. Giclée printing requires a final resolution of 200-300dpi at the size of the final reproduction. Many giclée studios now use digital camera backs on 5x4″ studio cameras. Betterlight is said to be the best, but Phase One, Anagramm and Kigamo are alternates. By far, the best digital capture is with a Cruse dedicated system. If a Cruse system is not available, ideally a Zig-align system with a 5x4″ digital camera (as above) should be used to ensure that all four corners are in focus. It is always best to use a professional giclée atelier and have some basic understanding of the process so that your art is photographed correctly.

Digital file - Time invested in reworking a good digital file will influence the printing of the image forever. Color corrections and retouching are completed to ensure that all flaws are eliminated. When a digital version is finalized, the printing process begins. Color management and proofing are very technical and are best left to the provider in order to create a file that will print out consistently over a period of time. This will ensure that the first print in the edition will match the last one.

Media - Paper and canvas are the most common media. You'll need to become knowledgeable about the many paper choices available.

Inks - Archival inks are a must.

Printing - This should be a collaborative process involving the artist and printer. A proof is made for the artist's approval.

Finishing - Trimming, cutting, hand-torn edges and coatings are some options.

Archiving - Save your final computer digital file for future printing; you are only printing part of your limited-edition run at any given time. This archiving will be done by the giclée atelier.

Shipping - Tubes and boards are needed for secure shipping.

Reordering - When you need additional prints, you can order from your giclée atelier by fax or telephone.

WORKING WITH A GICLÉE ATELIER

▸ Each atelier prices and works differently with its artists.

▸ Get a quote in writing so there is no confusion in the future.

▸ You might want to have the printer add to his quote, "No additional images are printed for any reason whatsoever without the explicit written permission of the artist."

▸ It is good to have a "Note of Verification," which states, "I guarantee that the above information is correct and that no other proofs or impressions exist that are not part of this documentation sheet." This should be signed by both printer and artist.

▸ Documenting these prints is important. Note artist, title of work, medium, image size, paper size, paper type, print run, edition size, number of proofs and pertinent dates.

Giclée printing is a vast subject and there are many companies offering this service. Do your homework so that you understand the process. Having expensive equipment is one thing; having the knowledge to get great results is another. A recommendation from an established artist producing quality giclées is always better than choosing a giclée provider out of the Yellow Pages. Look at some of the work each provider produces and, if possible, visit at least three ateliers before making your decision.

GICLÉE SERVICE BUREAUS AND ATELIERS

ArtSource Studio
1644 Hawthorne St, Sarasota, FL 34234 (941) 366 7033
www.artsourcestudio.com

Coupralux Fine Art Printmaking and Gallery
1444 Oak Lawn Ave #612, Dallas, TX 75207 (800) 270 4177
www.coupralux.com

Fine Print Imaging
1306 Blue Spruce Dr, Fort Collins, CO 80524-2067
(800) 777 1141 (970) 484 9650 www.fineprintimaging.com

Gamma One Conversions Inc
315 W 39th St #403, New York, NY 10018 (212) 925 5778
www.gammaoneconversions.com

There are also opportunities to add value to giclées by "remarquing"—a process reserved essentially for higher-quality giclées, whereby the artist can work on the actual print with paint or other media to enhance the print and its value, making it an "original."

A GICLÉE PRIMER

You've seen them at shows and galleries. You've heard people talking about them. You've read articles about collectors snapping them up. Every art magazine runs ads for them. So now, you are ready to take the leap and have your artwork reproduced as a giclée.

Not all giclées are created equal

Some printers use archival pigmented inks; some use dye-based inks with a wide color range but shorter life span. Some printers have no apparent "digital signature" (posterization, pixelization, dot pattern, etc.); others leave a distinctive dot pattern. Which printer model you choose depends on which factors are most important to you as an artist—color accuracy, ability to capture subtle gradations in color/tone, choice of papers, maximum size, price. Once you've prioritized your needs, you can then begin to look for a service bureau whose equipment and expertise best match your needs.

Quality of image

Scanners determine a good portion of the printing quality. Start with a premium scan and you're in for fewer problems.

Image stability

How long will a print last before noticeably fading? Both ink and paper must be considered. Some desktop printer inks only last two years, while others claim to last 100. Most inks used by fine-art printers last a minimum of 15 years, some last 70, and some pigmented inks last over 100. It is the combination of ink and paper that determines archival qualities. How the print is stored and displayed also affects image stability. To insure that your print will last as long as possible, inform your purchasers how to care for it.

Sizes

Small prints (up to 13x44 ") can be printed on an office printer (Epson Stylus Pro 5500) with the help of PhotoShop. For larger sizes, you will need an established giclée service bureau with an Iris or other large-format printer.

Price

Some fine-art printers charge per square inch, some per sheet. Some charge a higher setup fee with lower print prices, some the opposite. Most end up falling into a similar price range. If you find a bargain-price printer, chances are your prints will be bargain-price quality.

Paper

Choice of paper or canvas is a decision that should be based on the artist's preference, the artwork to be reproduced and the market where the giclée will be sold.

You need personal guidance and assistance from experienced staff when deciding how to print your giclées. Once you have found a service bureau whose equipment matches your needs and whose technicians are knowledgeable and skilled, you are most of the way to getting the best-quality print. The quality of anything you sell will determine repeat customers—clients telling their friends about your product. If you're going to do a giclée, do it right. Make a statement. Sell for a lifetime.

೮

Author Kate Dardine is a customer relations specialist at Fine Print Imaging, a giclée printer. She welcomes questions about printing and marketing fine-art reproductions. Contact her at 1306 Blue Spruce Dr, Fort Collins, CO 80524-2067 (800) 777 1141 (970) 484 9650 www.fineprintimaging.com

COSTS

The beauty of printing a giclée is that you don't have the huge up-front costs or storage problems associated with litho editions—you can print small quantities or just one at a time, called "on-demand printing."

A typical cost for producing the first of a series of giclée ranges from $170-350 (20x40″ image) on watercolor paper with UV coating. Subsequent reorders will cost less. Ten prints will cost an average of $60 each.

PRICING FOR PROFIT

▶ There should be some relationship between the cost of your originals and the cost of your prints. Limited-edition giclée prints generally run between 5-20% of the price of an original piece.

▶ The retail price should be at least four to five times your actual cost. When calculating the cost, figure out the entire run's cost.

EXAMPLE

The first print costs $300, which includes the pre-print costs of scanning, etc. The next 49 prints each cost $60. Total for all 50 prints will be $3240. Divided by 50 prints, this brings the cost of each to $65. Five times the cost of $65 is $325; four times is $260.

Are your originals selling for $3250 (10%)? If your originals are selling for $1900, can you sell this print for $325 (about 17%)? Perhaps if it is large enough, there will be no problem. If your work is selling for $1500, $330 is probably too much. Your print price should be closer to $150-200. You could make your print edition larger (but perhaps never sell out). As your original work rises in price, there is more likelihood that a buyer will pay $330 for a limited-edition of 50.

Ultimately, you can sell your prints for whatever you like. You want to make a profit in line with work quality and value.

Inkjet prints can be produced for much less than $60 using less expensive equipment. Always check the image stability and always use archival inks. This is a way to get started, but it is definitely the amateur level.

EXHIBITING AT TRADE SHOWS

The first three years an artist displays his prints at a trade show can be the toughest ones. The distributors are checking artists out during these first three years. They want to make sure the artist comes back and is still producing quality work.

Tips

→ Hire a rep to assist with your first trade show. A rep can show you the ropes and introduce you to distributors.

→ Prepare a written list of details for getting ready to go to the show. Follow it!

→ Prepay for electrical hookup, table rentals, etc. To order these items after the show starts, it will cost twice as much.

→ Stay in the hotel where the show has its headquarters so as not to miss out on networking opportunities.

→ Set up the day before the show starts.

→ Smaller shows seem to attract local frame shops and galleries that are looking for new work. They tend to buy on the spot.

→ Start with local shows, then expand to the big one in Atlanta—the National Showcase.

Decor Expo
www.decor-expo.com
Sponsors two shows: New York in March and Atlanta in September. They also publish *Decor Magazine*.

PROMOTION

So you've begun printing limited editions, you have sold only a couple and you need to expand your market.

- If you have galleries selling your originals, they might want to have a different price point to sell.

- If you have a private exhibit, or if you do outdoor shows, this is the perfect place to sell limited editions.

- Specialty shops and poster galleries are your next best bet.

ADVERTISING AND PUBLICITY

An artist from Northern California stated that the most important aspect of selling prints is getting your name out there.

- Create a distinctive advertising campaign and logo design so people will remember you.

- Plan a good publicity schedule.

- If you advertise, be sure to do repeat advertising. Your image and logo must be repeated over and over.

Advertising is expensive. If you have a specialized subject such as marine, trains, wildlife, equine, etc., then advertising in a specific genre magazine might pay off.

Where possible, try to get publicity—PR. Compose a good press release with a reproduction of your print. Magazines like *Art Business News* or *Decor Magazine* might feature your piece free of charge in their editorial section. Though it can take a lot of legwork and persistence, it's much less expensive than paid advertising. It also warrants much more interest than an ad.

- Send press releases to local newspapers.

- Try to get an article by presenting a complete story to an editor (they love that), be persistent with phone calls (but not pesky) and you could become famous locally!

TIPS

→ Local advertising is probably the best place to start. Most towns have a tourist or shopping guide that usually includes a gallery section. Try offering the use of your latest artwork on the cover of the magazine. Be sure they give you proper credit, i.e., your name, phone number, web site and e-mail.

→ Check with your local Chamber of Commerce. They usually publish an annual business and tourist guide.

RESOURCES FOR PROMOTING YOUR PRINTS

Art Business News
6000 Lombardo Center Dr #420, Seven Hills, OH 44131 (216) 750 0361
www.artbusinessnews.com

ArtNetwork
www.artmarketing.com
Mailing lists: print distributors—sales reps selling prints wholesale to poster and frame galleries, specialty shops such as zoos, florists, etc. and more.

Art World News
Wellspring Communications, 143 Rowayton Ave, Rowayton, CT 06853
(203) 854 8566

Clicart
(888) 969 9977 www.clicart.com

Decor Magazine
Pfingsten Publishing, Gabriel Kiley, Managing Editor
1801 Park 270 Dr #550, Maryland Heights, MO 63146 (800) 867 9287
(314) 824 5506 www.decormagazine.com

MasterPak
145 E 57th St #5Fl, New York, NY 10022-2141 (800) 922-5522
www.masterpak-usa.com
Retails shipping and packaging supplies

Producing and Marketing Prints
Sue Viders, 9739 Tall Grass Cir, Lone Tree, CO 80124 (800) 999 7013
www.sueviders.com
This is a great book that takes you through all the steps of self-publishing. Also, *The Artist's Organizer*, a book that helps artists keep track of their prints, and the people and places that can help them.

www.wilhelm-research.com
Technical information about different machines and inks

www.flaar.org
Information about digital files and printing technology

ACTION PLAN

❑ Do market research for creating a limited edition.

❑ Calculate the cost of printing a giclée. First calculate print and pre-press costs: Next the cost for 49 prints, if printed four at a time.

❑ Calculate the price at which you will retail these pieces.

5-20% of original =

4-5 times cost of print =

List your retail buyers:

List your wholesale buyers:

List PR possibilities:

List advertising venues:

RECOMMENDED READING

How to Profit from the Art Print Market by Barney Davey

Chapter 8

Self-Publishing Cards

Greeting card market

Costs

Card reps

Handmade cards

They gave it to me for an un-birthday present.
Through the Looking Glass, Lewis Carroll

GREETING CARD MARKET

Reproduction of original art into greeting cards offers artists the opportunity to participate in a $7.5-billion market. Of course, the bulk of this market is captured by the very large card companies, but an estimated $1 billion is left to individual artists. Consumers purchase over seven billion cards each year.

- Of all cards purchased annually, roughly half are seasonal and the rest are for everyday occasions.

- Of the seasonal cards, 60% are Christmas.

- Valentine's cards are 25% of the seasonal sales.

- Birthday cards account for 60% of everyday sales.

- Each household in the US purchases an average of 35 cards every year.

- 80% of cards are bought by women.

- There are 2,000 card publishers in the US.

Greeting cards have many uses for artists. Besides the added sales at your shows, they can provide an excellent self-promotion tool: announcing shows, advertising for commissions and introducing new work, either originals or prints.

Depending on your style of art, consider direct sales to historical and tourist attractions, as well as fundraising ideas for churches, civic organizations, nonprofits and school groups.

Think of a *new idea* to bring to the greeting-card industry. One lady makes cards with buttons attached. Another artist makes fragrant cards, another Braille cards. What is your niche?

Each line, however popular it may be, will need to continue to add new designs and concepts. Once you start a line, you want to expand it by creating cards for a variety of occasions and seasons so both your rep and stores remain happy. No one-year marketing plans here! You will need a well-created, five-year business plan to succeed.

TIME-LINE

Often a card has only an eight-month life span, similar to products in the fashion industry. Of course, there are exceptions. Some cards and designs, especially those with well-known characters, will be seen year after year.

The wholesale greeting-card industry has a high and low season. The quieter wholesaling seasons are November-February, when all the Christmas orders have been taken, and indeed the Valentine orders, too. New lines are being prepared for the Spring Stationery Show in New York in mid-May.

TIPS

→ Cards are put on shelves with the top one-third showing. In most cases, create your design and wordage with this in mind.

→ Store buyes often avoid cards on uncoated stock because they become dirty and crumpled from handling.

→ Most buyers want cards to state the occasion on them, so make your cards specific. Close to half of the market is birthday cards; the next largest market is Christmas cards (partly because they're purchased by the box); then Valentine's Day, Easter, Mother's Day, Father's Day, Graduation, Thanksgiving, Halloween.

→ Make your card appeal to both sexes. If you have to create for one sex, keep in mind that 80% of all cards are purchased by women.

→ Front color is very important.

→ Colored envelopes can be catchy but should not be too dark—the writing won't be legible.

→ Organize your card inventory so you can keep records easily. Each style will probably have a set of 12-16 cards. For coding, put the style, name, and year it was printed on the back as part of your code.

→ The back of the card should have the name of your card line, logo, artist's name, identification number (you make this up), price, copyright year, and "Printed in (country)" if imported.

→ Get a copy of Artist Guidelines from the Greeting Card Association (see Chapter 10). It is written by my colleague Joanne Fink, who has incredible knowledge and experience in this industry and does much to help artists. This guide is an essential tool for the card market whether you're self-publishing or freelancing.

MOCK-UPS

One surefire way to gauge whether you've got a potential winning range of cards is to produce a set of mock-up cards. Use the standard format of 5x7″. You will also be able to show this to potential publishers, friends and family. Keep in mind that friends' feedback can be misleading: Many friends don't want to upset you, so they say your designs are cute or lovely. Whatever testing you do—unless it's full-scale market research—is at best an educated guess.

Follow the industry and attend the best trade show—The National Stationery Show held in New York City in May—to allow your product to be seen by as many of the retail outlets as possible. The minimum cost for a booth will be $2500-3000. (See more info on trade shows, pages 177-178)

It's a good idea before renting a booth at a show to check it out as a consumer. Is it the correct show for your goals?

COSTS

Let's say you print 24 designs; any fewer is not really viable.

You sell 1000 of each of the 24 designs at 75¢ wholesale: $18,000. (They are usually sold in groups of 10.) After printing costs, envelopes, a leaflet or brochure, and exhibit costs totalling $9000, you will be left with $9000 gross profit. The $9000 covers your time, as well as the basic overhead costs—heat, light, telephone, gas, etc. You can see that you have to sell a lot more than 24,000 cards to make a good profit.

On the other hand, if you sell an average of 3000 of each of 24 design—a $54,000 gross revenue (overhead around $22,500), the figures look a little more appealing.

If you have a range of 48 designs, the profit potential increases, but so do your outlay and risk. You can't really survive on one show per year unless you are prepared to visit lots of customers. You can try to get sales reps throughout the country. This is not easy and you'll have to pay a commission of 10-20%.

PRICING

Greeting cards are sold wholesale by the dozen (in groups of 10). For instance, a card that you want to retail at $2.50 will sell wholesale for $15 per dozen (12 x $1.25). Your rep would get 20% or $3 per dozen. The minimum order is generally $100 (i.e., 7 designs x $15 per dozen = $105). Stores don't want to order less than $100 as it's too much trouble. Stores pay the shipping costs.

GUARANTEED SALES

"Guaranteed sales," if in your contract, allows a retailer to return unsold goods after a specified time. You don't want this! Soil, tears and marks will make your cards unusable after they are returned. Only large companies can deal with the cost of returns, so don't agree to guaranteed sales under any circumstances. Guaranteed sales is similar to consignment, which you don't want either. Consignment is unheard of in the greeting card industry, so don't even offer it to local stores if you are doing the selling yourself.

PRINTING GREETING CARDS

A large part of your financial output will be the cost of merchandise. Get quotes from several print companies. You'll be amazed at the variations in prices among printers. Different presses have different limitations, so the quotes you receive can vary as much as 100%.

Digital printing is now a reality. There are printers who can print small runs—even as low as 250 cards. Sample costs: a 5x7" folded card—250 @ 40¢; 500 @ 33¢; 1000 @ 26¢.

As you can see, the more you print the cheaper it gets. However, be cautious. Start with 250. If you sell out quickly and need to reprint, you will be better able to gauge your sales volume. You may order 500 for your second printing. Remember, some cards will sell poorly while others could be bestsellers.

GET TO KNOW THE PRINTER

Get samples of printers' previous work. Ask for, and call to verify, referrals. Have questions ready when you call the referrals:

- Did the printer meet your deadline?

- Did he have any hidden costs?

- Did he answer questions promptly during the printing process?

ONLINE PRINTING

Doing your promotional or card printing with an on-line service can save time and money. Most on-line printers send hard-copy proofs, so you are able to make last-minute changes and avoid costly printing mistakes. You should also be able to request samples from them to help you select the weight of paper, type of gloss, etc., that will work best for your needs.

Color Q
2710 Dryden Rd, Dayton, OH 45439 www.colorq.com

PS Print
www.psprint.com
Step-by-step instructions on-line with templates for each size of card

PRIVATE-ISSUE STAMPS

Custom, full-color stamps on dry-gummed paper, with authentic pin-hole perforation, from your artwork or photos. No postal value, but a unique attention-getter on your envelopes, letterhead, business cards, etc.

One stamp x 500 copies = $160
Block of 3 stamps x 500 copies = $575, x 1000 copies = $725
Block of 6 stamps x 500 copies = $925, x 1000 copies for $1150
Contact Anna Banana, 3747 Hwy 101, Roberts Creek, BC Canada V0N 2W2 (604) 885 7156
www.annabananastamps.ca

CARD REPS

Greeting-card reps expect you to have a minimum of 18 varieties of cards before they will rep you.

▸ They are independent contractors who represent several artists or companies, by whom they are paid a commission.

▸ They write orders for accounts in their assigned territory and send them to the manufacturer—the artist—to be filled.

Most large card companies sell their cards through reps. These reps often attend trade shows around the country as well as sell directly to stores.

▸ Reps take orders and get a commission from you on the orders they pass on to you. You fill the order, ship it and pay the rep.

▸ Reps generally receive 20% of their gross wholesale orders.

▸ Reps are paid 20 days after you ship to the customer.

▸ Reps generally have exclusive sales territories. They also may have a specific industry—florist industry, children's accessory stores, etc. A greeting-card company often has two to eight reps in one area covering all the various markets.

A small company will need 1000-2000 accounts. (Schurman Design, as an example, has 15,000 accounts, which are handled by their own in-house reps.) An example of your income would then be: 1000 accounts x $100 sales (the minimum) = $100,000 in wholesale sales for the year. When you work on your five-year plan, you will try to anticipate future income and expenses by taking into account the number of reps you anticipate having.

Once you have a rep, be sure to remain in contact. It will mean more sales. If you have a rep who exhibits at stationery and gift shows, see if you can assist at the exhibit in some manner. Make it a win-win situation.

FINDING A CARD REP

▸ Stationery and gift shows, where reps set up booths, are good places to talk to them.

▸ Ask your local stationery store who their reps are.

▸ Your local interior design center might be a place where reps have set up shop.

QUESTIONS TO ASK A POTENTIAL REP

▸ What territory does he cover?

▸ Number of reps in the company?

- How many lines does she carry? Do they mix well with yours?

- What is the percentage of cards versus gift lines that she carries?

- Does the rep do any trade shows? If so, what does it cost you?

- Types of accounts he has—boutiques, gift stores, galleries

- What is her commission?

- Ask for business references.

WHAT A CARD REP NEEDS FROM AN ARTIST

- Sample of cards

- Catalogs to exhibit cards

- Order forms

- Continuous updates on any discontinued items

- Incentives offers

- New product release at least twice a year; three to four times is more common

- Timely shipping

- Timely paying of commission

TRADE SHOWS

You will not need stock for shows. You will only show samples of the different lines for which you will be taking orders. It's best to have 24-48 designs for customers to choose from. Representing yourself at shows is a costly venture that has paid off for many artists. You could also rent a space cooperatively with a group of artists.

Try to find some niche market shows to attend, such as florist shows, dog shows, etc. One lady had an entire booth of cards at an outdoor art show. She was doing a whopping business selling her cards from $3 up.

National Stationery Show
www.nationalstationeryshow.com
The main show for the US market, held in New York annually in May

ORGANIZATIONS

Gift Association of America
115 Rolling Hills Rd, Johnstown, PA 15905-5225 (814) 288 1460
www.giftassn.com
Members are generally retail store owners, wholesalers and affiliates.

Greeting Card Association

www.greetingcard.org

Directory of Greeting Card Sales Representatives lists over 160 companies and individual sales reps in the US. A variety of other useful books is available.

MAILING LISTS

ArtNetwork

www.artmarketing.com

350 greeting card reps available on pressure-sensitive labels for direct mail

DIRECTORY

Spoor & Associates

1712 Sebring Hills Rd, Henderson, NV 89052 (800) 770 7470

www.spoorconsultants.com

No more hunting for names and phone numbers of rep groups to sell your products. This company publishes the *National Rep Group Directory* with hundreds of reps at your fingertips. Some of the many markets included are: gift, cards and paper, home décor, trend, decorative accessories, children's accessories, tabletop, gourmet foods, souvenir, toy, plus many more. Also includes: gift show calendar, international show calendar, gift mart directory, trade publication listings, industry associations, an expanded Canadian section, and listings of worldwide foreign trade offices.

CARD SUPPLIES

Clear Solutions

PO Box 2460, W Brattleboro, VT 05303 (800) 257 4550 (603) 256 6644

www.cleardisplays.com

Manufacturer of racks for cards. Custom and stock designs.

Impact Images

4949 Windplay Dr #100, El Dorado Hills, CA 95762-9621 (800) 233 2630

(916) 933 4700 www.clearbags.com

Plastic sleeves for greeting cards and original artwork—cards look great peering through.

WORKSHOPS AND CONSULTING

Cheryl Phelps

(212) 533 8236 www.cherylphelps.com

Cheryl does one-day workshops and consulting on the greeting card and art licensing business.

HANDMADE CARDS

BY CONSTANCE SMITH

Many artists are starting their own greeting card businesses by making beautiful handmade greeting cards—indeed, beautiful enough to frame. Bookstores, paper stores, gift shops, museum stores, children's stores and private individuals are just the tip of the iceberg for possible markets for handmade greeting cards.

Unlike printing cards by the thousands, the low financial risk of handmade cards offers more flexibility. You will need to do lots of research, however, before you actually hit the marketplace with your creations.

BENEFITS

- You can make and sell cards from your home.

- Low initial investment—mostly time. Eventually you might see that you want to go into printing cards because they are so popular.

- Because of their unusualness, they can be easy to sell to stores. In some cases you'll see a pin on a card as part of the design—an easily-purchased and not too expensive gift or thank-you.

ASK YOURSELF

- Are there other cards similar to yours on the market already? How do they sell?

- How are yours different enough for a store to want to carry them?

- Can you come in at a competitive price?

- What paper seems to be used most?

- What price ranges do you find most common?

- What sizes are the cards?

- What's "hot" on the market?

TIPS

- Verify that your card is mailable; if it has something attached like a button or pin, will it break in the mail? Your envelope may need to say in large letters, "Hand Stamp." There could be an added expense to package and mail.

- Package fewer cards in each box to make your overall price lower—for example, eight cards instead of 10 or 12.

- On the back of the card, put a blurb about how it was made—tell a story, make it more interesting. Customers love reading about artists.

Handmade cards, which can run from $3-10 retail, are sometimes sold individually rather than by the dozen.

145

PRICING

Calculate the labor costs from a test run of 20 pieces. An hour is based on a 50-minute time frame. Retail needs to be 6-10 times the actual cost.

Sample budget for 1,200 greeting cards (100 dozen)

Envelopes @ .05	$ 60
Bags/boxes @ .05	$ 60
Photocopy/paper	$ 40
Cutting	$ 10
Hand-coloring	$144
Total cost	**$314**

Let's take the example above. Outside costs are at $314 or $3.14 per dozen. Multiply this $3.14 x 10 to get retail price of $31.40 per dozen or $2.62 per-card retail. Not a bad price for a handmade card!

THE MAKE-UP OF A $2.62 CARD

Use these quantities when compiling a budget for your prospective company.

50%	Store markup	$1.31
10%	Rep commission	.26
10%	Production	.26
10%	Overhead	.26
7.5%	Promotion	.20
7.5%	Profit	.20
5%	Artwork	.13

BUSINESS START-UP COSTS

You will need to consider: paper, supplies such as glue and paint, envelopes, packaging (bags or boxes), inserts, labeling, printing, assembling, labor, company business cards, catalog sheets for advertising, trade journal ads, travel to trade shows. When you make your five-year business plan, be sure to include all these factors.

If you are going to print cards in four-color in small quantities, the costs will skyrocket. 1000 cards would be around 38¢ each ($380). Perhaps photocopying and hand-painting is better. You can still call them handmade cards.

One artist I know hires disabled workers to help her assemble pieces that have to be created repetitively. Call your local Salvation Army for referrals.

MARKETING

Some reps sell handmade cards, but not many do. You probably will have to do most of your marketing. Try to find unusual outlets for your unusual cards: coffee houses, hospital gift shops, restaurants, garden shops, record stores, florist shops, beauty salons, frame shops, health food stores, children's stores, quick-stop stores, zoos, museums, hotel shops, bookstores, New Age shops, tourist shops, etc. Find your niche market and go for it!

Merchandise Mart Properties

www.merchandisemart.com

United Association of Manufacturers' Reps

www.uamr.com

See the list of magazines in Chapter 10.

ACTION PLAN

- ❏ Investigate what greeting cards are being sold at several local stores.

- ❏ Attend a trade show to study the market.

- ❏ For handmade cards, think about your target niche market: Is your card made from 100% recycled materials? Hemp? Vintage buttons? Beads or fabric?

- ❏ Research mailing requirements for your handmade cards, then label your envelopes accordingly.

- ❏ Will your cards contain text? Do you need to find a writer?

RECOMMENDED READING

The Complete Guide to Greeting Card Design & Illustration by Eva Szela

Chapter 9
Self-Publishing Calendars

Planning

Design

Printing

Marketing and distribution

We all name ourselves. We call ourselves artists. Nobody asks us.
Nobody says you are or you aren't. Ad Reinhardt

PLANNING

A store has only three main months to sell to individuals. Calendar sales are dead after March 1.

As you know from your own household and office, most people have a multitude of calendars. Many people give calendars for Christmas presents; theoretically, one-third of calendars purchased are given as gifts, wall calendars being the most popular style.

Marketing a calendar is one of the most difficult tasks you could assign yourself. Planning a calendar alone is a long and arduous project. Adding marketing on to your task makes it monumental.

I highly suggest that you attempt to find a calendar publisher to produce your calendar. To give you an idea of what it takes and to understand what an established calendar publisher risks, we will proceed in the following pages through the calendar publishing process.

REASONS TO SELF-PUBLISH A CALENDAR

▶ You have a huge client base from selling your art for years. You have the addresses in your database.

▶ You are working with an art organization or company who is guaranteeing sales of a certain quantity.

▶ You have a particular group of retailers (tennis pro shops, equine shops) to whom to wholesale.

Though you might be printing a much smaller quantity than the established publishers, your retail price needs to be in line with theirs. Without a distributor, it means a lot of knocking on doors.

▶ Who is your target market?

▶ Can you find a distributor?

▶ Do you know what packaging (and the cost) you will need?

▶ Is your design a similar size to most standard calendars so it will display on store shelves easily?

Calendar print-runs of less than 10K are considered small.

Look at competitors' calendars. What works? What don't you like? Where are they distributed: bookstores, newsstands, gift shops, department stores, catalogs? Go to a neighboring city to see what they have displayed.

WHAT COMPRISES A GOOD CALENDAR?

It's a must for a self-published calendar to be "different." The large calendar publishers and distributors have the market for commonplace distribution. Yours must be exotic in some manner. Check out today's calendar themes in bookstores, specialty shops, museum stores and boutiques. Think of a theme that you can build on year after year. Once you develop a calendar, you'll want to continue.

▸ Depending on what your calendar's theme is, you will want to list some of the special events related to it on the daily spaces. Do a bit of research. Make your calendar thorough and unusual. Be forewarned: Too many listings in the squares make for a hectic-looking calendar.

▸ Many calendars incorporate moon phases into their boxes. You'll need to do a bit of research if you want this on your calendar.

▸ What is the most common size and format for a calendar?

▸ Which sizes, styles get best position on sales racks?

▸ What are the most common types of paper used? How does that affect sales?

▸ Are there a lot of other calendars with the same theme as you are planning?

▸ Make a list of prices of various calendars.

MOCK-UP CALENDAR

▸ To select the final 12 images (the cover is repeated inside), you will need to start with about 20-25 possibilities.

▸ Make a mock-up of your final choices. Review it for awhile. Don't make any rash decisions. Pass it around to friends as well as local business professionals—people who will eventually buy. Listen to their comments. Get their opinions. Study their reactions. It's a good introduction to taking their orders later.

BAR CODES

You might have noticed that almost every item you buy has a barcode on it these days. Calendars require a different style of barcode than groceries or toys. These codes make it easy for an item to be scanned in a retail outlet. In the case of calendars, the bar codes are created from the numbers assigned to publishers.

DESIGN

ISSN numbers are used for serials or periodicals—such as calendars and magazines. Contact <issn@loc.gov> for more information.

PRINTING

PRODUCTION SCHEDULE

Artwork needs to be ready for a calendar 18 months in advance of selling date.

Fall (year prior to sales): Mock-up starts.

Winter (year prior to sales): Material is ready 11 months in advance.

December (year prior to sales): Mock-up is finalized.

Spring: Mock-ups are shown at shows. Orders are taken.

Summer: Printing is finished. Orders are sent.

October/November/December: Calendars are in the stores for three months.

Depending on your final quantity, overseas printing can save lots of money. Review all your quotes, both US and overseas, to see when it would be financially wiser to print abroad. Sometimes a job is half the cost that it would be if printed in the US. In this day and age with e-mail and overnight deliveries, it is as simple to work with a printer in the Orient as it is working with a printer on the "mainland." The only step that takes longer is the shipping. The trip by boat can take four to six weeks. Add on time for clearing customs (one week) and for shipping to your offices (another week) for a total of two months.

PRINTING PREP

▸ You can use 35mm slides for reproduction if the piece is not larger than 8x10 ". Use a tranny if reproduction will be larger than 8x10 ". Digital at 300dpi is even better and more common these days.

▸ Check the tranny/scan carefully for color match and clarity.

▸ Separations can be a large part of the final printing cost, ranging from $45-125 for each piece. No seps are needed if you use digital layout and tifs.

BUDGET FOR SMALL RUNS

With digital on-demand printing, you can now order calendars in runs as low as 250 @ $8.29, 500 @ $4.39 and 1,000 @ $2.75 each.

With a retail price of around $14.95, you can see that your profit margin increases dramatically as your print runs increase. You may start with a test the first year and only print 250. While profits are low, your risk is limited. Each subsequent year, as demand grows, you can increase your print runs. As you do this, your profit margin will rise.

TIPS

→ Be fussy about the color but don't be ridiculous. Save your energy for promoting your calendar.

→ Keep your printing costs down with a common size of calendar—9x12". This size gives the user plenty of space to write notes in the squares, an important feature of any calendar. If you keep the size and layout the same year after year, it will be much easier to lay out annually.

→ When creating your art, consider using a 9x12" size (twice the size of a card) or even 18x24", which reduces and fits perfectly.

→ Sell at arts and crafts shows, local bookshops, gift shops and boutiques. Perhaps this can be your foot-in-the-door for originals as well as prints.

→ Eventually contact reps for distribution. Prints or cards to go along with a calendar always make it more financially profitable and thus, easier for you to find a rep.

CALENDAR PRINTERS

InterPress
Laura Jaffe, 143 Lobelia Rd, Augustine, FL 32086 (888) 338 7726
(877) 747 1775 Fax www.interpressglobal.com
Laura is a rep for a Hong Kong printer—excellent printer and very easy to work with. We've worked with them for six years. Best prices too!

PS Print
www.psprint.com

What will you do with returns? Maybe you can send them to corporate art consultants or interior designers to promote your original work.

MARKETING AND DISTRIBUTION

As a self-publisher, more than likely you will need to become a self-distributor. Unless you have an outlandishly original and super-hot idea for your calendar, your efforts to promote your singular calendar will probably prove difficult.

DIRECT MAIL

If you have a very specific targeted market—tennis players, golfers, abstract-art enthusiasts, etc.—you could possibly be successful through direct mail. With such a low-cost item and high-cost promotion, your percentage of purchasers has to be high. If you have previous customers who have purchased your originals, or signed your guest book at an outdoor show, those are good potential buyers.

If you are going to market a calendar, you must plan to do this for consecutive years—even if the first year is not as successful as you had hoped. Each year you will find more customers, more interest, and you will get more PR. If your calendar is trendy enough, you might even be able to get on a radio or TV talk show. It really helps at that point if it is selling in the mainstream stores (which means having a mainstream distributor) where people will most easily find it.

▸ You will also need to be able to accept credit cards.

▸ You might need someone to answer a phone—probably an 800 number.

▸ You will need proper envelopes to ship.

PROMO TIPS

▸ Keep the weight of your mailer under an ounce.

▸ Have the final size of your mailer fit the USPS standard mailing size, no longer than 11.5″ and no higher than six inches. Dimensions that are unique might cost you more to mail. Always check with the post office before you print. For instance, if you design a 6x6″ card, it could cost 51¢ to mail; a 10x6″ could cost 49¢.

▸ Use a self-mailer—there will be no envelope costs and no sealing time.

RETURN POLICIES

It's better for small publishers (yourself!) to work with specialty stores rather than bookstores, due to bookstores' return policies. Many bookstores have large quantities of returns. With a dated item such as a calendar, this is no good!

You could donate returned calendars to organizations: school, charity, nursing home, hospital, Scout troop. Indeed, this might lead to sales in the future and shows you're a "good citizen."

▸ Offer a money-back guarantee. It makes purchasers feel more secure.

WHOLESALING

If you wholesale half of your calendars, you will make more money. Selling more ups the print run and lowers the cost per piece.

Baker & Taylor
www.baker-taylor.com
Book and calendar wholesalers

Ingram
www.ingrambook.com
Book and calendar wholesalers

Publishers Weekly
245 W 17th St, New York, NY 10011 (212) 463 6758 www.cahners.comm
Has an annual issue serving the calendar industry.

Try to get a non-returnable agreement if you sell to stores directly by giving them a slightly bigger discount. Expect to sell 10-20 calendars in any given store.

ACTION PLAN

❑ Calculate the costs of printing your calendar.

Retail buyers: _____

Wholesale buyers: _____

PR possibilities: _____

Advertising venues: _____

Possible themes: _____

Niche markets for your selected themes: _____

Chapter 10
Contacts

Art licensing agents

Artist's reps

Fine-art publishers

Greeting card publishers

Calendar publishers

Stationery publishers

Book publishers

Children's illustration agents

Character, artist brands, corporate brands and entertainment licensing agents

Resources

Art is really a battle.
Edgar Degas

Applejack Licensing International
PO Box 1527 Rte 7A, Manchester Center, VT 05255
800/969-1171 802/362-3662 www.applejackart.com

Art Makers International Inc
Leslie Brewin
PO Box 48225, St Petersburg, FL 33743
727/343-2799 www.artmakersintl.com

Artists of Kolea Licensing Group
206/784-1136 www.kolea.com

Bon Art & Artique
281 Fields Ln, Brewster, NY 10509 800/228-2989
www.artiq.com

CBH Licensing
540/552-4499 www.cbhlicensing.com

Cop Corp
Rob Postal
1350 Broadway #1004, New York, NY 10018
212/947-5958 www.copcorp.com
Retail consultants/agent/international licensing

Courtney Davis Inc
415/772-9000 www.courtneydavis.com

Creatif Licensing Corp
Marcy Silverman
31 Old Town Crossing, Mt Kisco, NY 10549-4030
914/241-6211 www.creatifusa.com

Creative Connection Inc
Laurie High
PO Box 253, Gibson Island, MD 21056 410/360-5981
www.cciart.com www.creativeconnectionofmd.com
Licenses 20 artists

Cypress Fine Art Licensing
1500 Union County Parkway, Union, NJ 07083-1737
908/964-4053

D Parks and Associates
Ayako Parks, PO Box 836, San Juan Capistrano, CA 92693
949/248-9924 www.art-licensing.com

Fran Seigel Artists and Licensing
PO Box 237058, New York, NY 10023 212/712-0830
www.fsartists.com

Galaxy of Graphics Ltd
20 Murray Hill Pkwy #160, East Rutherford, NJ 07073
800/464-7500 201/806-2100 www.galaxyofgraphics.com

Grace Licensing
Janie Seltzer, 7218 Durango Cir, Carlsbad, CA 92011
888/603-8851 www.gracelicensing.com
Mark Timm, 7796 N Cty Rd 100 E, Bainbridge, IN 46105
877/210-3456 www.gracelicensing.com

Image By Design
www.imagebydesign-licensing.co.uk

Image Source
www.image-source.co.uk

Intercontinental Licensing
176 Madison, New York, NY 10016 212/683-5830
www.intercontinental-ltd.com

Lifestyle Licensing International
Box 25487, Honolulu HI 96825 808/394-0438
www.lifestylelicensing.com

Linda McDonald Inc
5200 Park Rd #104, Charlotte, NC 28209 704/370-0057
704/370-0058 www.lindamcdonald.com

Looking Good Licensing
Tim Good
15 N Sawyer Hill Rd, New Preston, CT 06777
860/868-1075 www.lookinggoodlicensing.com

MGL
5 Risborough St, London SE1 OHF UK
www.mgl-uk.com

MHS Licensing
11000 Wayzata Blvd #550, Minneapolis, MN 55305
952/544-1377 www.mhslicensing.com

Mosaic Licensing Inc
925/934-0889 www.mosaiclicensing.com

Out of the Blue
Michael Woodward, Maureen May
7350 Tamiami Trl #227, Sarasota, FL 34231
941/966-4042 www.out-of-the-blue.us

Painted Planet Licensing Group
507/835-8009 www.viking-publications.com

PM Design Group Inc
PO Box 1485, Bethlehem, PA 18016 610/867-1771
www.pmdesigngroup.com

Porterfield's
Lance Klass
5 Mountain Rd, Concord, NH 03301
603/228-1864 www.porterfieldsfineart.com

Rick Yearick Inc
PO Box 530596, St Petersburg, FL 33747-0596
727/864-6191 www.rickyearick.com

Rights International Group
453 First St, Hoboken, NJ 07030
201/239-8118 www.rightsinternational.com

Rosenthal Represents
3850 Eddington Ave, Calabasas CA 91302 818/222-5445
www.fauxpawproductions.com

Synchronicity
19 Main St, Kennebunk, ME 04043 207/985-4400
www.synclicensing.com

Teaming Pond
5775 NW 21st St, Ocala, FL 34482 800/404-6091
352/840-0034 www.teamingpond.com

The Buffalo Works
PO Box 621, Wayzata, MN 55391 952/475-3013
www.thebuffaloworks.com

Artist's Representatives

This is a list of professional artist's representatives. They sell work to magazines for advertising and editorial. These are not licensing agents. Look at their web sites to view the standard and style of work.

Ad Finem
295 Greenwich St #143, New York, NY 10007
212/791-1477 www.adfinemagency.com

American Artists
353 W 53rd St #1W, New York, NY 10019
212/682-2462 www.aareps.com

Art Agency
2405 NW Thurman St, Portland, OR 97210
503/203-8300 www.theartagency.com

Donna Rosen
2532 Sutcliff Terrace, Brookeville, MD 20833
301/570-0860 www.donnarosenartists.com

Glick, Ivy & Associates
1865 Stratton Cir, Walnut Creek, CA 94598
925/944-0304 212/869-0214 www.ivyglick.com

Helen Ravenhill Represents
1215 W 67th St, Kansas City, MO 64113
816/333-0744 www.ravenhill.net

Indigo Gate
Gifford B Browne II
1 Pegasus Dr, Colts Neck, NJ 07722-1490 732/577-9333
www.indigogate.com

Joanie Bernstein
756 8th Ave S, Naples, FL 34102
239/403-4393 www.joaniebrep.com

Joanne Hedge
1415 Garden St, Glendale, CA 91201-2716
818/244-0110 www.hedgereps.com

Jennifer Vaughn
1927 Grant Ave, San Francisco, CA 94133
415/666-3447 www.jenvaughnart.com

Arts Uniq' Inc
PO Box 3085, Cookeville TN 38502
800/223-5020 www.artsuniq.com

Aura Editions
4943 McConnel Ave #1, Los Angeles, CA 90066
310/305-3900 www.auraeditions.com

Bentley Publishing Group
Donovan Weaton
1410 Lesnick Ln, Walnut Creek, CA 94596-2737
925/935-5201 www.bentleypublishinggroup.com
Poster publisher as well as licensing for artists. Target market
is chain stores and mass framers. Work with over 200 artists,
publishing a wide variety of styles. Review art daily. Contact
by submitting a portfolio for review by mail or e-mail. Prefer
to review slides, photos, or jpgs. Include a SASE if you are
mailing.

Billiard Library Company
Darian Baskin
1570 Seabright Ave, Long Beach, CA 90813-1131
562/432-7997 562/432-1884 www.billiardlibrary.com
Publisher of posters. Also distribute prints and handle
licensing for artists. Target market is billiard suppliers and
billiard halls. Artists can submit portfolios for review by mail
or e-mail.

Canadian Art Prints
6311 Westminster Hwy #110, Richmond BC V7C 4V4
Canada 604/276-4551 www.canadianartprints.com

Classic Collections Fine Art
1 Bridge St, Irvington NY 10533 914/591-4500
www.classiccollections.com

DeMontfort Fine Art Ltd
DeMontfort House, Europa Way, Lichfield Staffs
WS149NW UK www.demontfortfineart.net

Directional Publishing Inc
2812 Commerce Sq E, Birmingham, AL 35210
205/951-1965 800/922-2810 ext 102
www.directionalart.com
Unlimited editions

Editions Limited
4090 Halleck St, Emeryville, CA 94608
510/923-9770 www.editionslimited.com

Eurographics Inc
9105 Salley St, Montreal, Quebec H8R 2C8 Canada
800/663-0461 514/939-0310 www.eurographics.ca
Prints, posters, puzzles, greeting cards

Gango Editions
351 NW 12 Ave, Portland OR 97209
503/223-9694 www.gangoeditions.com

Grand Image Ltd
3201 First Ave S #201, Seattle, WA 98134
206/624-0444 ext 114 www.grandimage.com

Haddads Fine Arts
3855 E Miraloma Ave, Anaheim CA 92806-2124
714/996-2100 www.haddadsfinearts.com

Hadley House Company
Debbie Borchardt, Licensing Representative
1157 Valley Park Dr #130, Shakopee, MN 55379
800/927-0880 952/943-8474 www.hadleyhouse.com
www.hadleylicensing.com
Publish prints, posters, limited editions and giclées.
Also handle licensing for artists and distribution for self-
published artists. Main focus is realism. Products are sold
mainly in galleries and frame shops.

Image Conscious
147 10th St, San Francisco, CA 94103 415/626-1555
www.imageconscious.com

Image Maker Enterprises
12348 W Ginger Creek Dr, Boise, ID 83713
208/378-4417 www.imagemaker.org
Publish limited editions, giclées, greeting cards, as well as distribute prints in all styles. Work with about 200 living artists.

Kennebeck Fine Art
535 Manorwood Ln, Louisville, CO 80027 888/786-8814
303/665-5549 www.fineartpublisher.com

Long Shot Posters
5432-B W Crenshaw St, Tampa, FL 33634 813/884-7484
www.longshotposters.com

New Era Publishing
Nick Nichols
2101 E St Elmo Rd #1A, Austin, TX 78744 512/928-3200
www.newerapublishing.com
Publish giclée prints. Also handle licensing for artists. Products are sold to corporations.

New York Graphic Society
129 Glover Ave, Norwalk, CT 06850 800/677-6947
www.nygs.com/index.php

PGM Artworld
Carl-von-Linde-Str 33, 85748 Garching, Germany
www.pgm-art-world.de

Posters International
1200 Castlefield Ave, Toronto, Ontario M6B 1G2 Canada
416/789-7156 ext 223 www.postersinternational.net

Red Oak Publishers
Ellis Felker
14872 Creek Ln, Muscoda, WI 53573
800/601-8893 www.redoakcards.com
Publish greeting cards and posters that are sold in gift shops, bookstores, etc. Work with about 50 living artists.

Rosenbaum Fine Art
150 Yamato Rd, Boca Raton, FL 33431
561/994-4422 www.rosenbaumfineart.com

Sagebrush Fine Art
3065 S West Temple, Salt Lake City, UT 84115
800/466-5136 www.sagebrushfineart.com

Schiftan Inc
1300 Steel Rd W #4, Morrisville, PA 19067
215/428-2900 215/295-2345
www.schiftan.com
Products are sold in furniture stores, specialty shops, department stores. Also handle licensing for artists.

Top Art LLC
6490 Mar Industry Pl, San Diego, CA 92121
www.topartweb.com

Webster Fine Art Ltd
1003 High House Rd #101, Cary, NC 27511
919/388-9370 www.websterfineart.com

Wild Apple Graphics
Gretchen Grey-Buchanan
526 Woodstock Rd, Woodstock, VT 05091-7702
802/457-3003 www.wildapple.com
Publish posters, distribute prints and handle licensing for artists they represent. View the web site to see styles of art. Products are sold in Pier 1, Z Gallerie, Bombay, BB+B, etc.

WinnDevon Art Group
PO Box 80096, 6015 6th Ave S, Seattle, WA 98108
206/763-9544 www.winndevon.com

ORGANIZATION

Art Publishers Association
www.artpublishers.org

Abacus Cards
Gazeley Road, Kentford, Newmarket Suffolk CB87RH
UK www.abacuscards.co.uk
Works with traditional and contemporary paintings of
classic male-oriented subjects (cars, planes and sports
themes), floral, still life, landscapes, gardens, animals
(particularly cats, ducks and horses), Christmas-themed
images (wintry scenes, robins and seasonal interior scenes);
photography such as floral close-ups, garden or panoramic
landscapes, floral still life; contemporary illustrations and
designs. Always on the lookout for talented illustrators/
designers, with original but commercial styles and ideas for a
variety of commissions.

Allport Editions
2337 NW New York, Portland, OR 97210-2112
503/223-7268 www.allport.com

American Greetings
One American Rd, Cleveland, OH 44144
216/252-7300 www.amgreetings.com
Greeting cards, party goods, calendars, stationery

Artful Greetings
PO Box 52428, Durham, NC 27717 800/638-2733
www.artfulgreetings.com
Multicultural

Artists Cards Ltd
The Old Flour Mill, 5 Queen St, Emsworth Hampshire
PO10 7BT UK www.artistscardsltd.com
Fine art cards

Artists to Watch
2431 S Shore, White Bear Lake, MN 55110
651/222-8102 www.artiststowatch.com

Avanti Press
6 W 18th St #6FL, New York, NY 10011 212/414-1025
www.avantipress.com
Mainly photography

Backyard Oaks Inc
3916 N Potsdam, Sioux Falls, SD 57104 800/456-8208
www.backyardoaks.com

Barton Cotton Inc
1405 Parker Rd, Baltimore, MD 21227 800/348-1102
www.bartoncotton.com

Blossoms and Bows
Sandall Rd, Wisbech Cambs PE13 2RS UK
www.blossomsandbows.co.uk

Blue Sky Publishing
6395 Gunpark Dr #M, Boulder, CO 80301 303/530-4654
www.blueskypublishing.net
Contemporary greeting cards. Nature, joyful images dealing
with relationships, pets.

Brushdance
165 N Redwood Dr #200, San Rafael, CA 94903
415/259-0900 www.brushdance.com
Greeting cards, bookmarks, calendars, journals, magnets.
Inspirational art

Colors By Design
7723 Densmore Ave, Van Nuys, CA 91406 818/376-1226
www.colorsbydesign.com
Online store for invitations for weddings, baby showers, etc.

Courage Center
888/413-3323 www.couragecards.org
Nonprofit organization; traditional, winter, nostalgic,
religious, ethnic and world peace

Crown Point Graphics
PO Box 3172, Carmel, IN 46082-3172
317/575-9975 www.crownpointgraphics.com

Design Design Inc
PO Box 2266, 19 La Grave SE, Grand Rapids, MI 49501
616/774-2448 www.designdesign.us
Humorous and traditional cards, stationery, address books,
tabletop, etc.

Editions Du Desastre
21 Rue Visconti, 75006 Paris, France www.desastre.com
Contemporary cards and stationery products

Freedom Greeting Card Co Inc
774 American Drive, Bensalem, PA 19020
215/604-0300 www.freedomgreetings.com

Gallery Graphics Inc
PO Box 502, Noel, MO 64854 417/475-6191
www.gallerygraphics.com

Gemma International Ltd
6 East Portway, Andover Hampshire SP10 3LU UK
www.gemma-international.co.uk
Licensed characters mainly, but some art products

Graphique de France
9 State Street, Woburn, MA 01801 617/935-3405
www.graphiquedefrance.com

Great Arrow Graphics
2495 Main St, Buffalo, NY 14214 716/836-0408
www.greatarrow.com
Silkscreen greeting cards

Hallmark
2501 McGee, PO Box 419580, MD 287, Kansas City, MO
64141-6580 816/274-7497 www.hallmark.com

Kristin Elliott Inc
6 Opportunity Way, Newburyport, MA 01950
978/526-7126 www.kristinelliott.com
Christmas cards, boxed notecards and correspondence cards

Lang Companies
514 Wells St, Delafield, WI 53018 262/646-3399
www.lang.com
Bookmarks, cards and calendars

Leanin' Tree Inc
PO Box 9500-W, Boulder, CO 80303 800/777-8716
www.leanintree.com

Ling Design Ltd
The Studio, The Old Brewery, Bradford-on-Avon, Wilts
B15 1NF UK www.lingdesign.co.uk

Marian Heath Greeting
9 Kendrick Rd, Wareham, MA 02571 800/338-3740
www.marianheath.com

Mixed Blessings
Elise Okrend
PO Box 97212, Raleigh, NC 27624-7212
919/847-7944 www.mixedblessings.com

Nobleworks Inc
PO Box 1275, 123 Grand St, Hoboken, NJ 07030
201/420-0095 www.nobleworksinc.com
Humorous card line

Paper House Group
Waterwells Dr, Gloucester Glos GL2 4PH UK
www.paperhouse.co.uk

Paper Rose Ltd
Mabel St, Nottingham NG2 3ED UK
www.paperrose.co.uk
Leading UK card company

Paperpotamus Paper Products Inc
Box 310, Delta, BC V4K 3Y3 Canada 604/940-3370
www.paperpotamus.com
Advance 5%

Papyrus
500 Chadbourne Rd, Fairfield, CA 94533
www.papyrusonline.com

Recycled Paper Products
Gretchen Hoffman, John LeMoine
3636 N Broadway St, Chicago, IL 60613-4488
800/777-3331 773/348-6410 www.recycled.com
Contact by submitting greeting card ideas. Looking for the
art and text. Always looking for new freelance card creators.
Prefer to review greeting card mock-ups.

Red Farm Studio
1135 Roosevelt Ave, Pawtucket, RI 02861 401/728-9300
www.redfarmstudio.com
Everyday greeting cards, coastal collection

Ronnie Sellers Productions Inc
81 W Commercial St, Portland, ME 207/772-6833
www.rsvp.com
Books, calendars, greeting cards, stationery. Hobbies, classic
cards, nature, florals, city scenes.

Sole Source Greetings
63820 Clausen Dr, Bend, OR 97701 541/389-0360
www.solesourcegreetings.com

Sparrow & Jacobs
6701 Concord Park Dr, Houston, TX 77040
719/579-9011 www.sparrowandjacobs.com
Business greeting cards for real estate. Homey, traditional,
humor and sweet animals.

Sports Spectrum
Pat Fox
324 S Pacific Coast Hwy #201, Redondo Beach, CA 90277
800/752-9426 310/543-0501
www.sportsgreetingcards.com
Publish a variety of styles

Sunrise Greetings/Interart
1145 Sunrise Greetings Ct, PO Box 4699, Bloomington, IN
47402-4699 800/457-4045 ext 2922
www.interartdistribution.com

Tree-Free Greetings
PO Box 687, Keene, NH 03431 603/876-9300
www.tree-free.com

Woodmansterne Publications Ltd
1 The Blvd, Blackmoor Ln, Watford Hertfordshire, WD18
8UW UK www.woodmansterne.co.uk

Avalanche Publishing
6262 Katella Ave, Cypress, CA 90630
714/898-2400 www.avalanchepub.com
High-quality calendars and gift books

Bottman Design
1081 S 300 W #A, Salt Lake City, UT 84101
www.bottman.com
Calendars, cards, gifts, recipe cards, some photography, lots
of whimsical

Brown Trout
PO Box 280070, San Francisco, CA 94128-0070
www.browntrout.com
Lots of photography. Also produce books, journals,
keychains, etc.

Fotofolio
J Galant
561 Broadway, New York, NY 212/226-0923
www.fotofolio.com

Harry N Abrams
100 Fifth Ave, New York, NY 10011 212/206-7715
www.abramsbooks.com

Nouvelles Images
22 Eagle Rd, Danbury, CT 06810 203/730-1004
www.nouvellesimages.com
Lots of photography

Pomegranate
PO Box 808022, Petaluma, CA 94976-8022
www.pomegranate.com

Portal Publications
201 Alameda del Prado #200, Novato, CA 94949
415/884-6268 415/884-6200 www.portalpub.com
Submit calendar ideas Nov - March. Lots and lots of
variety in images: traditional and abstract fine art, wild and
domestic animals, gardens, florals, bouquets, scenic travel,
decorative and contemporary art, landscape, photographs
both humorous and whimsical. Framed prints, cards,
calendars, matted prints, posters and more.

Tide Mark
176 Broad St, Windsor, CT 06095 800/338-2508
www.tide-mark.com

Trends International
5188 W 74th St, Indianapolis, IN 46268
www.trendsinternational.com
Lots of calendars in a large variety; also posters and doodle
activity kits

Willow Creek Press
PO Box 147, Minocqua, WI 54548 800/850-9453
www.willowcreekpress.com

Wyman Publishing
37 McArthur Ave, Carleton Pl, Ontario K7C 2W1
Canada 613/253-2224 www.wymanpublishing.com

Antioch Company
PO Box 28, 888 Dayton St, Yellow Springs, OH 45387
937/767-6286 www.antioch.com
Bookmarks, bookplates, journals, diaries, address books, etc.

C R Gibson
404 BNA Dr Building 200 #600, Nashville, TN 37217
800/243-6004 Ext 2851 www.crgibson.com
Stationery, gift products, gift books

Colorbok Paper Products
2716 Baker St, Dexter, MI 48130 734/426-5300
www.colorbok.com

Current Inc
1005 E Woodman Rd, Colorado Springs, CO 80920
719/594-4100 www.currentinc.com
Direct-mail products

Galison Mudpuppy
28 W 44th St, New York, NY 10036 212/354-8840
www.galison.com

Leapyear Publishing
45 Osgood St, Methuen, MA 01844 978/681-9691
www.leapyearpublishing.com

Legacy Publishing Group
75 Green St, PO Box 299, Clinton, MA 01510
978/368-8711 www.legacypublishinggroup.com
Bookmarks, calendars, gifts, journals, stationery, etc.

Pratt & Austin Company Inc
Dept AGDM, 642 Summer St, Holyoke, MA 01040
413/532-1491 www.prattaustin.com
Modern woman and children's items, bright and cute

Quality Artworks Inc
2262 N Penn Rd, Hatfield, PA 19440 800/523-2306
215/822-0125 www.qualityartworks.com

Riverleaf
6761 Thompson Rd N, Syracuse, NY 13211
800/481-5323 www.riverleaf.com
Notecubes

Wellspring
339 E Cottage Pl, York, PA 17403 717/846-5156
www.wellspringgift.com

Andrews McMeel Publishing
4520 Main St, Kansas City, MO 64111 816/932-6700
www.andrewsmcmeel.com
Calendars, books, seasonal greeting cards, mugs, journals

Art Direction Books Inc
Kevin Lopez, Don Barron
456 Glenbrook Rd, Glenbrook, CT 06906 203/353-1441

Bandanna Books
Brian Newborn, Sasha Newborn
1212 Punta Gorda #13, Santa Barbara, CA 93101
www.bandannabooks.com
Need cover art and B&W book illustrations. Contact us by submitting a non-returnable portfolio for review by mail; prefer to review photoprints. Tips for those contacting: If we think your art will fit a cover, then we will consider it and call you.

Books Are Fun
1680 Hwy 1 N, Fairfield, IA 52556 800/864-4941
www.booksarefun.com

Brownlow Corporation
6309 Airport Freeway, Fort Worth, TX 76117
800/433-7610 www.brownlowgift.com
Inspirational stationery and gift products

Cartwheel Books/Scholastic Inc
Edie Weinberg
555 Broadway, New York, NY 10012-3999
212/343-4404 212/965-7940 www.scholastic.com
Youthful, bright, graphic, colorful images

Chronicle Books
85 Second St #6Fl, San Francisco CA 94105
415/537-4424 www.chroniclebooks.com

Dawn Publications
12402 Bitney Springs Rd, Nevada City, CA 95959
800/545-7475 www.dawnpub.com

Fort Ross Inc
Dr Vladimir Kartsu
26 Arthur Pl, Yonkers, NY 10707 914/375-6448
www.fortrossinc.com
Need realistic, romance, sci-fi, and fantasy styles of art. Target market is Europe. Tips for contacting: Pay attention to detail.

Graduate Group
Mara Whitman
PO Box 370351, West Hartford, CT 06137-0351
860/233-2330 www.graduategroup.com

Judson Press
Wendy Ronga
588 N Gulph Rd, King of Prussia, PA 19406
610/768-2223 www.judsonpress.com
Target market is Christians, educators and children. Tips for contacting: A good presentation is really important. We look for concept artists and people who draw people well.

Laughing Elephant
3645 Interlak Ave, Seattle WA 98103 800/354-0400
www.laughingelephant.com
Ephemera, giftbooks, notecards, Christmas

Loompanics Unlimited
Gia Cosindas
PO Box 1197, Port Townsend, WA 98368 360/385-2230
www.loompanics.com
Target market is readers of books considered unusual or controversial. Tips for contacting: Keep it simple. An e-mail address for contact. A web site is a fine way to show your work.

Meadowbrook Press
Peggy Bates
5451 Smetana Dr, Minnetonka, MN 55343 952/930-1100
www.meadowbrookpress.com
Target market is parents, adults, children, humor, party, and infants. Prefer to review samples to keep and file.

Modern Publishing
Edward Lenk
155 E 55th St, New York, NY 10022-4038
212/826-0850 www.modernpublishing.com

Mondo
Don Curry
980 Avenue of the Americas, New York, NY 10018
212/268-3560 www.mondopub.com
Target market is picture books and juvenile novels. Artists can contact us by submitting a portfolio and bio for review by mail or e-mail. Tips for contacting: Send a broad sampling of work. If you want something returned, send a SASE.

Oregon Catholic Press
Jean Germano
5536 NE Hassalo, Portland, OR 97213
503/281-1191 www.ocp.org
Books and records

Peachtree Publishers
Loraine Joyner, Melanie McMahon
1700 Chattahoochee Ave, Atlanta, GA 30318-2112
Tend to need painterly and realistic fine art. Target market is children and young adults. Prefer to review color photocopies. Tips for contacting: Send only via postal service, not via e-mail.

Publications International Ltd
7373 N Cicero Ave, Lincolnwood, IL 60712
847/676-3470 www.pilbooks.com

Random House Juvenile
Jan Gerardi
1540 Broadway, New York, NY 10036 212/782-8408
212/782-9698 www.randomhouse.com/kids
Need realistic as well as stylized art, but not abstract—should be suitable for children's books. Target market is children to 12 years of age. Contact by submitting samples for review by mail (no originals). Prefer to review color printouts or photoprints. Tips for contacting: Send samples for children's books; art that can be kept on file. Do not send original art.

Robert Frederick Ltd
4 North Parade, Bath NE Somerset BA1 1LE UK
www.robert-frederick.co.uk

Spartacus Publishing
Casey C Clark
3906 Grace Ellen Dr, Columbia, MO 65202
www.spartacuspublishing.com
Tend to use B&W line art. Target market is 18-35-year-olds. Prefer to review photocopies. Tips for contacting: Be patient.

The Speech Bin Inc
J Binney
1965 25th Ave, Vero Beach, FL 32960 www.speechbin.com
Need B&W realistic illustrations. Target market is speech-language pathologists, special educators, and rehab. Freelancers are needed for books and educational game development.

W Publishing Group
Tom Williams
545 Marriott Dr #750, Nashville, TN 37214
www.wpublishinggroup.com
We tend to use traditional styles of artwork. Artists can contact us by e-mailing a portfolio. Tips for those contacting us: No calls—use mail or e-mail.

Wright Group/McGraw-Hill
Chris Wangelin
220 E Danieldale Rd, Desota, TX 75115 800/648-2970
www.wrightgroup.com
Target market is educational—pre-K to adult.

Artist Network
Melissa Turk
9 Babbling Brook Ln, Suffern, NY 10901
845/368-8606 www.melissaturk.com

Artworks
352 W 38th S #1605, New York, NY 10018
212/239-4946 www.artworksillustration.com

Asciutto Art Representatives Inc
1712 E Butler Cir, Chandler, AZ 85225 480/899-0600
www.phylliscahill.com

Bookmakers Ltd
PO Box 1086, 40 Mouse House Rd, Taos, NM 87571
505/776-5435 www.bookmakersltd.com

Carol Bancroft & Friends
4 Old Mill Plain Rd, Danbury, CT 06811 800/720-7020
www.carolbancroft.com

CATugeau
Chris Tugeau
309 Margaret James Ln, Williamsberg, VA 23185
203/438-7307 www.catugeau.com

Christine Prapas
503/658-7070 www.christineprapas.com

Contact Jupiter
5 Laurier Street, St Eustache, Quebec J7R 2R5 Canada
450/491-3883 www.contactjupiter.com

Cornell & McCarthy Representatives
2-D Cross Highway, Westport, CT 06880 203/454-4210
www.cornellandmccarthy.com

Craven Design Studios
1202 Lexington Ave, Box 242, New York, NY 10028
212/228-1022 www.cravendesignstudios.com

DAS Grup
Carrie Perlow
409 N Pacific Coast Hwy #474, Redondo Beach, CA 90277
310/540-5958 www.dasgrup.com

Deborah Wolfe Ltd
731 N 24th St, Philadelphia, PA 19130 215/232-6666
www.illustrationonline.com

Dilys Evans Fine Illustration
509 Johnson Ln, Santa Fe, NM 87501
www.dilysevansfineillustration.com

Dwyer & O'Grady
PO Box 790, Cedar Key, FL 32625-0790
www.dwyerogrady.com

Evelyne Johnson Associates
201 E 28th St, New York, NY 10016 212/532-0928
www.evelynejohnsonassociates.com

Gwen Walters Artist Representative
1801 S Flagler Dr #1202, West Palm Beach, FL 33401
561/848-3362 www.gwenwaltersartrep.com

Hannah Represents
Hannah Robinson
14431 Ventura Blvd #108, Sherman Oaks, CA 91423
818/378-1644

Harriet Kastaris & Associates
6483A Chippewa, St Louis, MO 63109
314/752-2227 www.kastaris.com

Herman Agency
715 Enterprise Dr, Oak Brook, IL 60523
212/749-4907 www.hermanagencyinc.com

HK Portfolio
Mela Bolinao
10 E 29th St #40G, New York, NY 10016 212/689-7830
www.hkportfolio.com

Irmeli Holmberg
3 Quay Ct, Bay Park, NY 11518
www.irmeliholmberg.com

Jane Feder
305 E 24th St, New York, NY 10010 212/532-6051
www.janefeder.com

Judy Goodwin-Sturges
146 W Newton St, Boston, MA 02118
617/262-0591 www.studiogoodwinsturges.com

Kirchoff/Wohlberg
866 United Nations Plaza #525, New York, NY 10017
212/644-2020 www.kirchoffwohlberg.com

Laurie Lambert & Associates
7904 Hackney Cir, Maineville, OH 45039 513/336-0555
www.lambertassociatesinc.com

Levy Creative Management
300 E 46th S #8E, New York, NY 10017 212/687-6465
www.levycreative.com

Lindgren & Smith
630 Ninth Ave, New York, NY 10036 212/397-7330
www.lindgrensmith.com

Liz Sanders Agency
2415 E Hangman Creek Ln, Spokane, WA 99224
509/993-6400 www.lizsanders.com

Lori Nowicki
310 W 97th St #24, New York, NY 10025 212/243-5888
www.lorinowicki.com

Maggie Byer Sprinzeles
5800 Arlington Ave #16C, Riverdale, NY 10471
718/543-9399 www.maggiebyersprinzeles.com

Marlena Agency Inc
145 Witherspoon St, Princeton, NJ 08542 609/252-9405
www.marlenaagency.com

Morgan Gaynin Inc
Vicki Morgan and Gail Gaynin
194 Third Ave, New York, NY 10003 212/475-0440
www.morgangaynin.com

Neis Group
11440 Oak Dr, PO Box 174, Shelbyville, MI 49344
616/672-5756 www.neisgroup.com

Pema Brown
22284 Ave San Luis, Woodland Hills, CA 91364
818/340-4302

Portfolio Solutions
Bernadette Szost
PO Box 74, Billings, NY 12510-0074 845/226-8401
www.portfoliosolutionsllc.com

Remen-Willis Design Group
Ann Remen Willis
2964 Colton, Pebble Beach, CA 93953 831/655-1407

Renaissance House
9400 Lloydcrest Dr, Beverly Hills, CA 90210
310/358-5288 www.renaissancehouse.net

Rita Gatlin Represents
415/924-7881 www.ritareps.com

Shannon Associates
333 W 57th St #810, New York, NY 10019
212/333-2557 www.kidshannon.com

Sheryl Beranbaum
75 Scenic Dr, Warwick, RI 02886 401/737-8591
www.beranbaum.com

S I International
43 E 19th St, New York, NY 10003 212/254-4996
www.si-i.com

Storybook Arts Inc
Janet DeCarlo, Artist Agent
PO Box 672, Dover Plains, NY 12522
845/877-3305 www.storybookartsinc.com

Studio
216 E 45th Street, New York, NY 10017
212/661-1363 www.studionyc.com

Suzanne Cruise Creative Services
7199 W 98th Terr #110, Overland Park, KS 66212
913/648-2190 www.cruisecreative.com

Thorogood Kids
5 Dryden St, Covent Garden, London WC2E 9NW UK
www.thorogood.net/kids

Tugeau2 Artist Representatives
Nicole and Jeremy Tugeau
2225 Bellfield Ave, Cleveland Heights, OH 44106
216/707-0854 www.tugeau2.com

Wanda Nowak
231 E 76th St #5D, New York, NY 10021 212/535-0438
www.wandanow.com

WendyLynn & Co
Janice Onken and Wendy Mays
504 Wilson Rd, Annapolis, MD 21401 410/224-2729
www.wendylynn.com

Wilkinson Studios
901 W Jackson Blvd #201, Chicago, IL 60607
312/226-0007 www.wilkinsonstudios.com

ORGANIZATIONS

Artist's Reps
www.digitaldirectory.com/reps.html

Association of Authors' Representatives/AAR
www.aar-online.org

Beanstalk Group
28 East 28th St #15Fl, New York, NY 10016
212/421-6060 www.beanstalk.com
World's leading brand agency

Bradford Licensing Associates
209 Cooper Ave #1, Upper Montclair, NJ 07043
973/509-0200 www.bradfordlicensing.com

Brand Central
11040 Santa Monica Blvd #220, Los Angeles, CA 90025
310/268-1231 www.brandcentralgroup.com

Capital Licensing Group
12702 Via Cortina #700, Del Mar, CA 92014
858/755-0095 www.capitallicensinggroup.com

Creative Brands Group Inc
125 S Market St #700, San Jose, CA 95113
408/907-9940 www.creativebrandsgroup.com
Thomas Kinkade, Lassen, Swirlygirl, Rachael Hale, Scanlan,
Cristina Ferrare, Ann Geddes Japan

HIT Entertainment
1133 Broadway #1520, New York, NY 10010
646/277-5208 www.hitentertainment.com

Licensing Group Ltd
8455 Beverly Blvd #508, Los Angeles, CA 90048
323/653-2700 www.thelicensinggroup.com

Licensing Link Ltd
1333 Broadway #1018, New York, NY 10018
212/244-5465 www.licensinglinkltd.com

Wildflower Group
27 W 24th St #702, New York, NY 10010

BOOK AND DIRECTORY PUBLISHERS

Allworth Press
10 E 23rd St, New York, NY 10010 212/777-8395
www.allworth.com
Publishes legal books, among them *Licensing Art & Design* by Caryn R Leland, as well as a variety of other books, including web and marketing information.

ArtNetwork
PO Box 1360, Nevada City, CA 95959 800/383-0677
530/470-0862 www.artmarketing.com
Teaching artists how to market since 1986. Books include: *Art Marketing 101, Art Office, Licensing Art 101, Selling Art 101, Internet 101, A Gallery without Walls*; an online gallery, mailing lists of artworld professionals in over 25 categories (consultants, designers, publishers, licensing agents, calendar publishers, greeting card reps and more). Call for free brochure, which covers it all.

Aspen Law Publishers
1185 Ave of the Americas, New York, NY 10036
800/638-8437 800/234-1660 www.aspenpublishers.com
This company publishes a variety of books related to the licensing industry: *The Trademark Handbook, The Licensing Library, Trademark Law* and *The Patent Practice Handbook* plus more.

EPM Communications
Sean McDonald
160 Mercer St #3 Fl, New York, NY 10012-3212
212/941-0099 www.epmcom.com
Licensing Letter Sourcebook is updated annually and has more than 35,000 listings of agents, consultants, manufacturers and others in the licensing industry. Several other publications also.

F & W Publications
4700 E Galbraith Rd, Cincinnati, OH 45236-6190
800/289-0963 513/531-2222 www.fwpublications.com
Artist and Graphic Designers Market; Children's Writer's & Illustrator's Market; and many more

COMPUTER SOFTWARE

MarketingArtist
www.marketingartist.com
Easy and intuitive online business management software for artists, powered by LiveWire. Can use on Mac or PC. Mailing list management, artwork and exhibition documentation and more. Free until certain quantity of usage; then only $4.95 per month.

COACH, LICENSING

J'net Smith Inc
Jeanette Smith
2310 NW 192nd Pl, Shoreline, WA 98177 206/533-1490
www.jnetsmith.com

CONSULTANT, PUBLISHING

Barney Davey
PO Box 25386, Scottsdale, AZ 85255 602/324-9242
www.barneydavey.com

CONSULTANTS, LICENSING

Art Licensing International Inc
Michael Woodward
7350 S Tamiami Trail #227, Sarasota, FL 34231 941/966-8912 www.licensingcourse.com

Jack Revoyr
PO Box 1617, Oak View, CA 93022 805/649-2040
www.tmlicensing.com

INTELLECTUAL PROPERTY LAWYERS

Christine Steiner
10215 Santa Monica Blvd, Los Angeles, CA 90067
310/275-3595 www.csteinerlaw.com
Represents artists, museums, galleries, designers, etc. Copyright advice, licensing and merchandising agreements, commission agreements for public art and multiples. Previously in-house attorney for Getty and Smithsonian.

Intellectual Property Group
Jamie Silverberg, John Mason
1501 M St NW #1150, Washington, DC 20005
202/466-2787 www.artlaws.com

Rebecca Stroder
4520 Main St #1100, Kansas City, MO 64111
816/460-2476

LEGAL ORGANIZATIONS

American Arbitration Association
212/484-4000

Volunteer Lawyers for the Arts/VLA
1 E 53rd St #6Fl, New York, NY 10022
212/319-2787 www.artswire.org/artlaw/info.html
This is the main office—there are many branches in major
cities across the US. You can go online to find one near you.
Following are two:
Ft Mason, Bldg C-255, San Francisco, CA 94123
415/775-7000
251 S 18th St, Philadelphia, PA 19103 215/545-3385

www.lawyers.com
This web site will help you locate an intellectual property
specialist. All you have to do is type in your state and city,
together with "Intellectual property/Trademarks" to locate a
local specialist.

MAGAZINES

You can usually get a free review copy by calling the
subscription department. Lists of online links to magazines
can be found at: www.artmarketing.com/Links/a_pub.html

Accessories Magazine
Business Journals Inc
50 Day St, Norwalk, CT 06856 203/853-6015
www.accessoriesmagazine.com

Accessory Merchandising
847/634-2600

American Craft
72 Spring St, New York, NY 10012-4019 212/274-0630

Apparel Merchandising
425 Park Ave, New York, NY 10022 212/756-5134

Art Business News
6000 Lombardo Ctr #420, Cleveland, OH 44131
888/527-7008 (subscriptions) www.artbusinessnews.com
A must for anyone wanting to get into fine-art publishing

Art Business Today
16-18 Empress Place, London SW6 1TT England
www.fineart.co.uk
Magazine for print and framing market published by the
Fine Art Trade Guild

Brandweek
PO Box 1973, Danbury, CT 06813 800/722-6658
www.brandweek.com

Decor Magazine
Pfingsten Publishing LLC
6000 Lombardo Center Dr #420, Seven Hills, OH 44131
888/772-8926 216/328-9452 www.decormagazine.com
Many publishers advertise in this magazine, so you can
study what types and styles of artwork they print.

Digital Fine Art Magazine
51 Madison Ave, New York, NY 10010 212/689-4411
www.digitalfineart.com

Gift & Decorative Accessories
345 Hudson St #4Fl, New York, NY 10014 212/519-7200
800/309-3332 (subscriptions)
www.giftanddec.com www.cahners.com
Also publish *Gayer's Dealer Topics, Buyers Guide, Playthings
Magazine and Playthings Directory, Who Makes It* and *Where*

Gift & Tablewares
1450 Don Mills Rd, Don Mills, Ontario Canada
416/422-2068 www.gifts-and-tablewares.com

Giftware News
20 N Wacker Dr #1865, Chicago, IL 60600
800/229-1967 ext 50 312/849-2220
www.giftwarenews.net
$8 for sample issue

Greetings
4 Middlebury Blvd, Randolph, NJ 07869-1111
973/252-0100 973/252-0100 (subscriptions)
www.edgellcommunications.com
The magazine for the greeting card and stationery market.
Also publishes *Selling Christmas Decorations*.

Home Accents Today
PO Box 2754, High Point, NC 27261
www.homeaccentstoday.com

Home Décor Buyer
www.homedecorbuyer.com

Home Textiles Today
245 W 17th St, New York, NY 10011 212/337-6906
800/395-2329 (subscriptions) www.hometextiletoday.com

How
800/289-0963 513/531-2222 www.howdesign.com
This magazine has articles on book illustration and design.

Informart
Westtown Publishing
PO Box 147, Easton, CT 06612 203/268-5552
www.informartmag.com

License! Magazine
1 Park Ave, New York, NY 10016 888/527-7008
888/527-7008 (subscriptions) www.advanstar.com
This magazine publishes a supplement called *The Art of Licensing* as well as a sourcebook and an e-mail newsletter.

The Licensing Book
1501 Broadway #500, New York, NY 10036
212/575-4510 www.licensingbook.com

The Licensing Journal
PO Box 1169, Stamford, CT 06904-1169
203/358-0848 www.aspenpublishers.com

Licensing Wire
www.licensingworld.com
An online newsletter: $49.95 for one year; $26.95 for six months

Licensing World
www.licensingworld.co.uk

Picture Business
Greater London House, Hampstead Rd, London England
NW1 7EJ www.picturebusiness.uk.co
Trade magazine for the fine-art publishing business

Sunshine Artist
4075 LB McLeod Rd #6, Orlando, FL 32811-5661
407/228-9772 www.sunshineartist.com
Outdoor art show listings—places to sell your prints

MAILING LISTS FOR PROMOTION

ArtNetwork
www.artmarketing.com
Art publishers, licensing agents, calendar publishers, greeting card publishers, print distributors, galleries, consultants, reps, dealers, brokers, museum curators, museum store buyers, interior designers, architects, corporate collections and more, all on pressure-sensitive labels, the easy peel-and-stick type! For counts and prices, view the web site.

ORGANIZATIONS

American Institute of Graphic Arts
164 Fifth Ave, New York, NY 10010 212/807-1990

Artists Rights Society/ARS
536 Broadway #5Fl, New York, NY 10012 212/420-9160
www.arsny.com
Represents artists in publishing, licensing and copyright matters

Association of the Graphic Arts

Diane Chavon

330 Seventh Ave #9Fl, New York, NY 10001

212/279-2100 www.agcomm.org

Giclée Printers Association/GPA

714/279-2312 www.gpa.biz

Graphic Arts Association

1100 Northbrook Dr #120, Trevose, PA 19053-8404

Graphic Arts Guild

90 John Street, New York, NY 10038-3202

800/500-2672 www.gag.org

The main union for illustrators and artists, particularly for those in advertising, book jacket design, magazine illustration. Publishers of the very useful guide *Pricing and Ethical Guidelines.*

Greeting Card Association

1156 15th St NW #900, Washington, DC 20005

877/480-4585 202/393-1778 www.greetingcard.org

The information available through this association is invaluable.

Licensing Industry Merchandising Association/LIMA

350 Fifth Ave #2309, New York, NY 10118

212/244-1944 www.licensing.org

This is the main licensing organization in the US. They have a very useful web site that lists information about licensing as well as agents. Membership provides access to a broad variety of activities, information, sources and benefits. Publishes the *Licensing Resource Directory: Who's Who in the Licensing Industry.*

New York Artists Equity Association/NYAEA

498 Broome St, New York, NY 10013 212/941-0130

www.anny.org

Society of Illustrators

128 E 63rd St, New York, NY 10021 212/838-2560

Visual Artists' and Galleries' Association/VAGA

350 Fifth Ave #6305, New York, NY 10118

212/736-6666

TRADE SHOW ORGANIZERS

Advancestar Communications

7500 Old Oak Blvd, Cleveland, OH 44130 800/827-7170

www.artexpos.com www.advanstar.com

Licensing Show (NY); Licensing Europe (Germany); Brand Licensing, the main event in UK for licensing concepts, TV-based properties and art, is held in October at the Business Design Center in London; ArtExpoNY is held in March and is by far the biggest show of its kind in the US. It is possible for fine artists to take booth space to sell originals and limited-edition prints. A show is also held in California in November and Miami in January.

George Little Management

10 Bank St, White Plains, NY 10606 914/421-3200

www.glmshows.com

Gift shows: Boston, Dallas, Florida, New York, San Francisco and more; Stationery Show held in mid-May in New York City—a major event covering gifts, stationery, greeting cards and many other products (held congruently with Surtex).

TRADE SHOWS

Book Expo

American Booksellers Association

828 S Broadway, Tarrytown, NY 10591 914/591-2665

www.bookexpoamerica.com

Decor Expo

6000 Lombardo Center Dr #420, Cleveland, OH 44131

888/608-5300 216/750-0353 314/421-5445

www.decormagazine.com

These shows are for exhibiting reproductions to the print trade. Long Beach, CA, Jan; Orlando, FL, Feb; NYC, March; Dallas, April

International Housewares Show/NHMA

110 W Hubbard St, Chicago, IL 60610 800/752-1052

847/292-4200 www.housewares.org/ihshow

Held at McCormick Place in Chicago in January

International Juvenile Products Show
609/231-8500 www.jpma.org
Held in Las Vegas.

Licensing Europe
www.licensingeurope.net
Held in Munich in September

Licensing International
203/882.1300 www.licensingshow.com
LIMA sponsors the world's largest trade show and
conference for licensing professionals. The International
Licensing Show is a three-day event each June at the Jacob
Javitts Center in New York City: Meet with licensing agents,
network with key executives in the business, and attend
seminars and conferences. Show exhibitors are licensing
agents representing more than 5,000 properties, including
characters, trademarks, original designs, entertainment,
sports, animation, personalities and more. The Licensing
University Program focuses on all facets of the licensing
industry. This is the show for licensing executives who travel
the globe to see and be seen at this once-a-year showplace of
cutting-edge licensing creativity. Major art-licensing section
available for artists and agents.

National Stationery Show
George Little Management
800/222-SHOW www.nationalstationeryshow.com
www.glmshows.com

New York Home Textiles Show
George Little Management
800/222-SHOW www.glmshows.com
Features the newest in art and design for every home fashion
product. Held mid-October.

New York International Gift Fair
800/272-SHOW www.nyigf.com

Paperworld
www.messefrankfurt.com/global/en/home.htm
Held in Frankfurt in late January. This is the leading
international trade fair for office products, stationery, school
supplies and graphic art materials.

Spring Fair
Trade Promotion Services Ltd
19th Floor, Leon House, High Street, Croydon England
44/208-277-5863 www.springfair.com
Held at the National Exhibition Centre/NEC in
Birmingham, England in February. A major event
covering fine-art publishing, greeting cards, gift products,
housewares, stationery, etc.

Surtex
www.surtex.com
To show surface-design artwork. This show allows you to
license your work directly to manufacturers. Held in May,
concurrently with the National Stationery Show in New
York City.

WEB SITES

www.licensingcourse.com
The Licensing Course is a comprehensive in-depth
mailorder course written by Michael Woodward (author of
this book) for those artists who require further education
about the industry.

www.giftbusiness.com
Wholesale gift industry resource; free information resources
and advertising for reps wanted, lines wanted and a
marketplace page for miscellaneous ads. *Gift Industries Web
Yellow Pages*, an online source for publications, gift marts,
manufacturer's representatives and gift industry associations.
Gift Trade Marketing, A Beginners Handbook is sold for
$18.95.

www.americasgiftshow.com
National trade show that exhibits to retail buyers directly.
Cost to exhibit an image online for six months is $80.

www.spirallicensing.com
This company has an online gallery for artists wanting
to reach licensees and publishers. They work with 300
publishers worldwide and over 1400 manufacturers of other
art-derived products.

BOLD TYPE = COMPANIES, SHOWS AND ORGANIZATIONS

ITALIC TYPE = PUBLICATIONS AND VIDEOS

BOLD TYPE = COMPANIES, SHOWS AND ORGANIZATIONS

ITALIC TYPE = PUBLICATIONS AND VIDEOS

BOLD TYPE = COMPANIES, SHOWS AND ORGANIZATIONS

ITALIC TYPE = PUBLICATIONS AND VIDEOS

ITALIC TYPE = PUBLICATIONS AND VIDEOS

LOCAL PROMO MAILING LISTS

Promote your open studio or exhibition by inviting local art professionals.
Our local promotion lists include the following eight categories:

Art publishers * **Galleries** * **Consultants, reps and dealers** * **Architects**
Interior designers * **Museum curators** * **Corporations collecting art** * **College gallery directors**

Some examples of counts follow. More geographic areas are listed on-line at www.artmarketing.com. Call or e-mail for a quote for your specific needs.

California	2700 names	$200
Northern California	1350 names	$115
Southern California	1350 names	$115
San Diego	200 names	$50
Los Angeles	525 names	$75
San Francisco Bay Area	725 names	$85
San Francisco	350 names	$55
New York City	1200 names	$115
New England	1000 names	$100
Boston	210 names	$50
Chicago	300 names	$50
Illinois	500 names	$65
Florida	600 names	$75
Georgia	245 names	$50
Hawaii	90 names	$40
Michigan	300 names	$55
Mid-Atlantic	650 names	$80
Minnesota	225 names	$50
New Jersey	350 names	$55
New Mexico	350 names	$55
Ohio	250 names	$50
Oregon	275 names	$50
Seattle	225 names	$50
Texas	600 names	$70

ArtNetwork
PO Box 1360, Nevada City, CA 95959-1360 530·470·0862 800·383·0677 www.artmarketing.com

ART WORLD MAILING LISTS

Artists (46,000 names) . $100 per 1000

Architects (650 names) . $60

Art Councils (640 names) . $60

Art Museums (1000 names) . $85

Art Museum Store Buyers (550 names) . $75

Art Organizations (1800 names) . $110

Art Publications (700 names) . $75

Art Publishers (1150 names) . $95

Art Supply Stores (800 names) . $65

Book Publishers (325 names) . $50

Calendar Publishers (100 names) . $50

College Art Departments (2500 names) . $130

Corporate Art Consultants (175 names) . $50

Corporations Collecting Art (475 names) . $60

Corporations Collecting Photography (125 names) $50

Galleries (5500 nationwide names) . $400

Galleries Carrying Photography (320 names) . $50

Galleries/New York (750) (more city/state selections online) $75

Greeting Card Publishers (640 names) . $70

Greeting Card Reps (300 names). $50

Interior Designers (600 names) . $55

Licensing Contacts (200 names) . $50

Public Libraries (1500 names) . $110

Reps, Consultants, Dealers, Brokers (1600 names) $125

All lists can be rented for onetime use and may not be copied, duplicated or reproduced in any form. Lists have been seeded to detect unauthorized usage. Reorder of same lists within a 12-month period qualifies for 25% discount. Lists cannot be returned or exchanged.

Formats/Coding
All domestic names are provided in zip code sequence on three-up pressure-sensitive—peel-and-stick—labels (these are not e-mail lists).

Shipping
Please allow one week for processing your order once your payment has been received. Lists are then sent Priority Mail and take an additional 2-4 days. Orders sent without shipping costs will be delayed. Shipping is $5 per order.

Guarantee
Each list is guaranteed 95% deliverable. We will refund 41¢ per piece for undeliverable mail in excess of 5% if returned to us within 90 days of order. We mail to each company/person on our list a minimum of once per year. Our business thrives on responses to our mailings, so we keep our lists as up-to-date and clean as we possibly can.

ArtNetwork
PO Box 1360, Nevada City, CA 95959-1360 530·470·0862 800·383·0677 www.artmarketing.com

ONLINE GALLERY

NOT READY TO SPEND HUNDREDS OF DOLLARS TO HAVE A WEB SITE BUILT?

Take advantage of ArtNetwork's low-cost, high-exposure home pages. Our two-year plan is economical and allows you to have a professional "spot" on the web to call home.

Our 20 years' experience within the art world has made our site popular among thousands of art professionals. We contact these professionals annually via direct mail—they know us and the quality of artists we work with.

A home page with ArtNetwork will include five reproductions of your artwork (you can get a double page of 10 pieces if you like). Each artwork clicks onto an enlarged rendition, approximately three times the size. Two hundred words of copy (whatever you want to say) are also allowed on your main page, as in above layout.

Artmarketing.com receives between 400,000-500,000 hits per month—an average of 1500 users a day (and rising each quarter). The gallery is the second-most visited area on our site.

- ▸ We pay for clicks on Google for a variety of art genres: abstract, equine, nature, environmental, whimsical and many more.

- ▸ We publicize our site to art publishers, gallery owners, museum curators, consultants, architects, interior designers and more! Your home page on our site will be seen by important members of the art world.

TO SHOWCASE YOUR WORK ONLINE, GO TO WWW.ARTMARKETING.COM/ADS

BUSINESS BOOKS FOR ARTISTS

Art Marketing 101, A Handbook for Fine Artist

This comprehensive 21-chapter volume covers everything an artist needs to know to market his work successfully. Artists will learn how to avoid pitfalls, as well as identify personal roadblocks that have hindered their success in the art world.

Preparing a portfolio * Pricing work * Alternative venues for selling artwork
Taking care of legal matters * Developing a marketing plan
Publicity * Succeeding without a rep * Accounting * Secrets of successful artists

Selling Art 101: The Art of Creative Selling

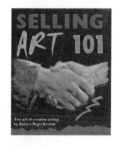

This book teaches artists, art representatives and gallery sales personnel powerful and effective selling methods. It provides easy-to-approach techniques that will save years of frustration. The information in this book, combined with the right attitude, will take sales to new heights.

Closing secrets * Getting referrals * Telephone techniques * Prospecting clients
14 power words * Studio selling * How to use emotions * Finding and keeping clients
Developing rapport with clients * Goal setting * Overcoming objections

Internet 101: With a Special Guide to Selling Art on eBay

This user-friendly guide explains exhibiting, promoting and selling artwork on-line. It also teaches in detail how one artist made $30,000 selling her art on eBay.

Internet lingo * E-mail communication shortcuts * Doing business via e-mail * Meta tags
Creative research on the web * Acquiring a URL * Designing your art site
Basic promotional techniques for attracting clients to your site * Pay-per-click advertising
Search engines * Tracking visitors * Reference sources

A Gallery without Walls: Selling Art in Alternative Venues

This book will lead you to a greater understanding of how to select and then reserve the best space to exhibit your work. It will also teach you how to promote your artwork on a limited budget.

The Sacred Sales Spot * Themed events * The Red Dot Syndrome
Finding alternative venues * Art Teas * Making a penny scream
Promotion on a shoestring

Art Office: 80+ Forms, Charts, Legal Documents

This book contains 80+ forms that provide artists with a wide selection of charts, sample letters, legal documents and business plans . . . all for photocopying. Organize your office's administrative and planning functions. Reduce routine paperwork and increase time for your art creation.

12-month planning calendar * Sales agreement * Form VA * Model release
Phone-zone sheet * Checklist for a juried show * Slide reference sheet
Bill of sale * Competition record * Customer-client record * Pricing worksheet

ArtNetwork
PO Box 1360, Nevada City, CA 95959-1360 530·470·0862 800·383·0677 www.artmarketing.com

WWW.ARTMARKETING.COM

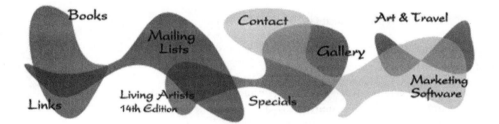

Books

Mailing Lists

Contact

Art & Travel

Gallery

Links

Living Artists 14th Edition

Specials

Marketing Software